SOUTH AFRICA
THE CORDONED HEART

Essays by Twenty

South African Photographers

Edited by Omar Badsha

Introduction and Text by Francis Wilson

Foreword by Bishop Desmond Tutu

SOUTH AFRICA
THE CORDONED HEART

**Prepared for The Second Carnegie Inquiry
into Poverty and Development in Southern Africa**

Published by

The Gallery Press, Cape Town
South African Photographic Gallery Series 3

W.W. Norton & Company
New York and London

In association with

Southern Africa Labour and Development Research Unit
University of Cape Town

Center for Documentary Photography
Duke University, Durham, North Carolina

For those who appear in this book
and others around the world
who struggle for justice, freedom,
and democracy in South Africa

This book is published in conjunction with travelling exhibitions in
Southern Africa, the United States, Great Britain, and Germany.
Exhibitions toured by The Second Carnegie Inquiry into Poverty
and Development in Southern Africa, The International Center of
Photography, New York, Christian Aid, OXFAM and The
Photographers' Gallery, London

Exhibition and book photographs printed in South Africa by Alex Harris

Book designed by Margaret Sartor

Photographs © 1986 Copyright is held by the individual photographers.
Permission to reproduce photographs must be obtained through
Saldru, University of Cape Town, Rondebosch 7700, South Africa
Text © 1986 Francis Wilson Maps © 1986 Farouk Stemmet
Foreword © 1986 Bishop Desmond Tutu. All rights reserved.

Published simultaneously in Canada by Penguin Books
Canada Ltd, 2801 John Street, Markham, Ontario L3R 1B4.

W.W. Norton and Company, Inc., 500 Fifth Avenue, New York, NY 10110
W.W. Norton and Company, Ltd., 37 Great Russell Street, London, WC1B 3NU
The Gallery Press, 2 Briar Road, 7700 Newlands, South Africa.

The poem "The child who was shot dead by soldiers at Nyanga" by Ingrid
Jonker is reprinted with the permission of Jonathan Cape Publishers, London.

Typesetting and reproductions by Hirt and Carter, Cape Town
Printing and binding by Printpak, Cape Town, South Africa
Cover photograph by Omar Badsha
Photographs on pages ii-iii and 2-3 by Wendy Schwegmann

Library of Congress Cataloging in Publication Data

Wilson, Francis.
 South Africa: the cordoned heart

 1. Blacks — South Africa — Economic conditions —
Pictorial works. 2. Blacks — South Africa — Social
conditions — Pictorial works. 3. South Africa —
Economic conditions — 1961 — Pictorial works.
4. South Africa — Social conditions — 1961 —
Pictorial works. I. Badsha, Omar. II. Title
DT763.6.W55 1986 305.8′00968 85-31015

 January, 1986.

ISBN 0-620-09125-8 Gallery Press

ISBN 0-393-02341-9 W.W. Norton and Company

ISBN 0-393-30335-7 PBK · W.W. Norton and Company

1 2 3 4 5 6 7 8 9 0

ACKNOWLEDGMENTS

This book has been shaped by many people associated with the Second Carnegie Inquiry into Poverty and Development in Southern Africa, but ultimately it is the collective effort of the contributing photographers. We are grateful to them and their families for the warmth of their friendship, trust, and assistance throughout this project. We give particular thanks to David Goldblatt and Mike Davies who lent their darkrooms for the printing of all the photographs.

Seven people have worked long hours for weeks on end to make this book possible. Avery Russell of Carnegie Corporation of New York has been a tower of strength throughout: unwavering in her faith in the book, helping to coordinate the work involved in producing it, providing constant encouragement and many fruitful ideas and editing rough South African text. Alex Harris and Margaret Sartor came to South Africa from the Center for Documentary Photography at Duke University and left our shores having made us richer from their experience and identification with our work. Alex undertook the mammoth task of printing six copies of each of the photographs in this book. Margaret's book design is the product not only of great talent but also of work under difficult circumstances. Both also helped with textual criticism and in compiling the biographies. Michael King gave much generous and expert help both in the writing and in the subsequent editing of material throughout the book. Moira Levy undertook the huge task of coordinating last minute corrections by people scattered across two continents. Wilfred Wentzel, also of the University of Cape Town, and Paul Weinberg of Afrapix were likewise invaluable with all their help, especially in the coordination of photographic work.

Another three people who have been deeply involved in the Carnegie Inquiry were most helpful in their criticisms of early drafts. We are grateful, for this and for much else, to Dudley Horner, Mamphela Ramphele, and Lindy Wilson.

Daniel Voll made the original introductions, which proved so fruitful, between photographers involved in the Carnegie Inquiry in South Africa and the Center for Documentary Photography at Duke University. Bruce Payne visited South Africa and stimulated us all with his infectious enthusiasm. He too has been a most helpful critic of both text and photographs.

The Rt. Revd. Desmond Tutu, Bishop of Johannesburg, kindly agreed to write the foreword, meeting an impossible deadline in the process. Farouk Stemmet drew the informative maps. We are grateful to them both.

We thank all those researchers from whose work we have drawn so heavily. While some references to particular papers are cited in the text, many ideas and facts have been included without specific acknowledgement.

We acknowledge, with thanks, permission from publisher Jonathan Cape to reprint the poem "The child who was shot dead by soldiers at Nyanga" from Ingrid Jonker, *Selected Poems*, translated from the Afrikaans by Jack Cope and William Plomer, London, 1968. The original, Afrikaans, version may be found in Ingrid Jonker, *Versamelde Werke*, Johannesburg, Perskor, 1983.

A special word of appreciation is due to our publishers. First, Gallery Press, which has borne the brunt of the ups and downs of creative production and which has kept going through it all. And we are grateful to W. W. Norton and Company for its faith in the book and for much professional assistance.

This book is published in conjunction with a travelling exhibition that is to tour different parts of the world. A number of people have helped to make this possible. We thank them all, including Belinda Bozzoli, Denise Mayo, and Diana Newman of the University of the Witwatersrand; Crispin Hemson of the University of Natal; Sue Davis, Alex Noble and the staff of the Photographers' Gallery, London; John Montague of Christian Aid and Chris Dammers of OXFAM in Great Britain; Hartwig Liebich and Martin Blocher of the Protestant Association for World Mission, Germany. The particular involvement of the International Center of Photography (ICP) in New York has been a great source of strength and encouragment. We thank Cornell Capa, Anne Hoy, and the staff of the ICP for their support.

Finally, we wish to acknowledge our gratitude to Carnegie Corporation of New York, whose imaginative and sensitive generosity has made possible the whole Inquiry of which this book is part. In addition to the financial backing, the understanding and moral support provided both by staff and by members of the board of Carnegie Corporation have been profound and unwavering.

CONTENTS

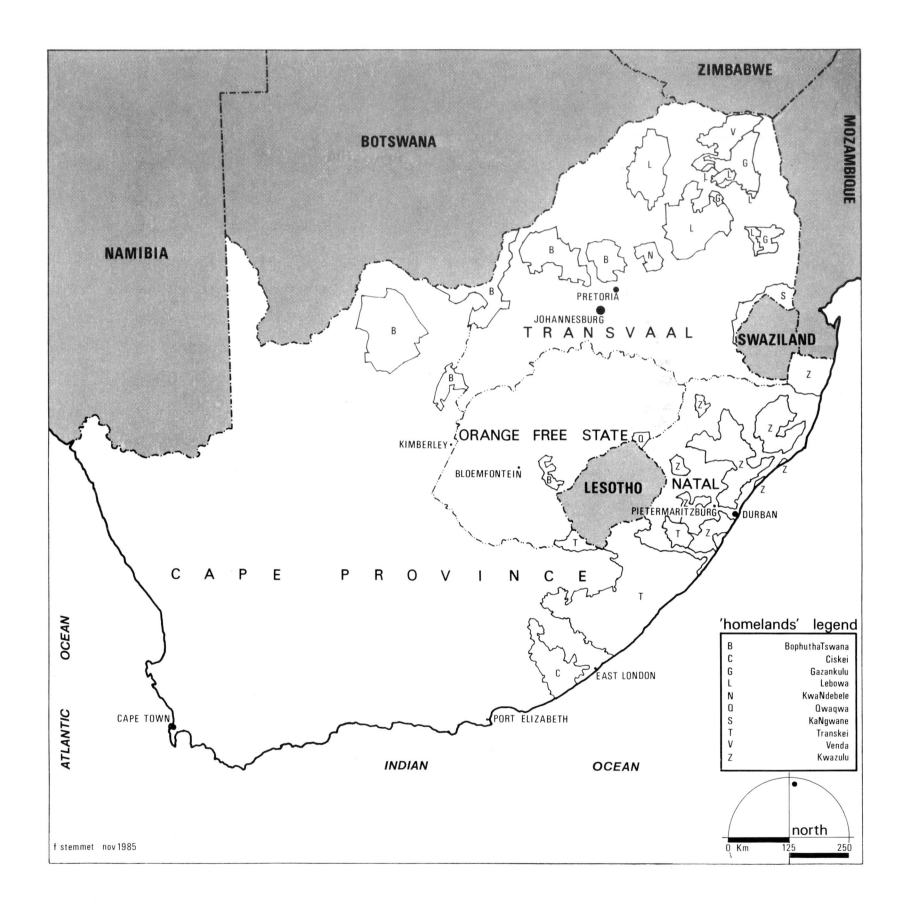

ZIMBABWE

MOZAMBIQUE

BOTSWANA

NAMIBIA

V

L

G

L

L

L

B

B

N

G

PRETORIA

JOHANNESBURG

T R A N S V A A L

SWAZILAND

S

Z

B

B

ORANGE FREE STATE

Q

KIMBERLEY

BLOEMFONTEIN

B

LESOTHO

Z

NATAL

Z

Z

PIETERMARITZBURG

DURBAN

Z

T

Z

CAPE PROVINCE

T

C

EAST LONDON

ATLANTIC OCEAN

CAPE TOWN

PORT ELIZABETH

INDIAN OCEAN

'homelands' legend

B	BophuthaTswana
C	Ciskei
G	Gazankulu
L	Lebowa
N	KwaNdebele
Q	Qwaqwa
S	KaNgwane
T	Transkei
V	Venda
Z	Kwazulu

north

0 Km 125 250

f stemmet nov 1985

x

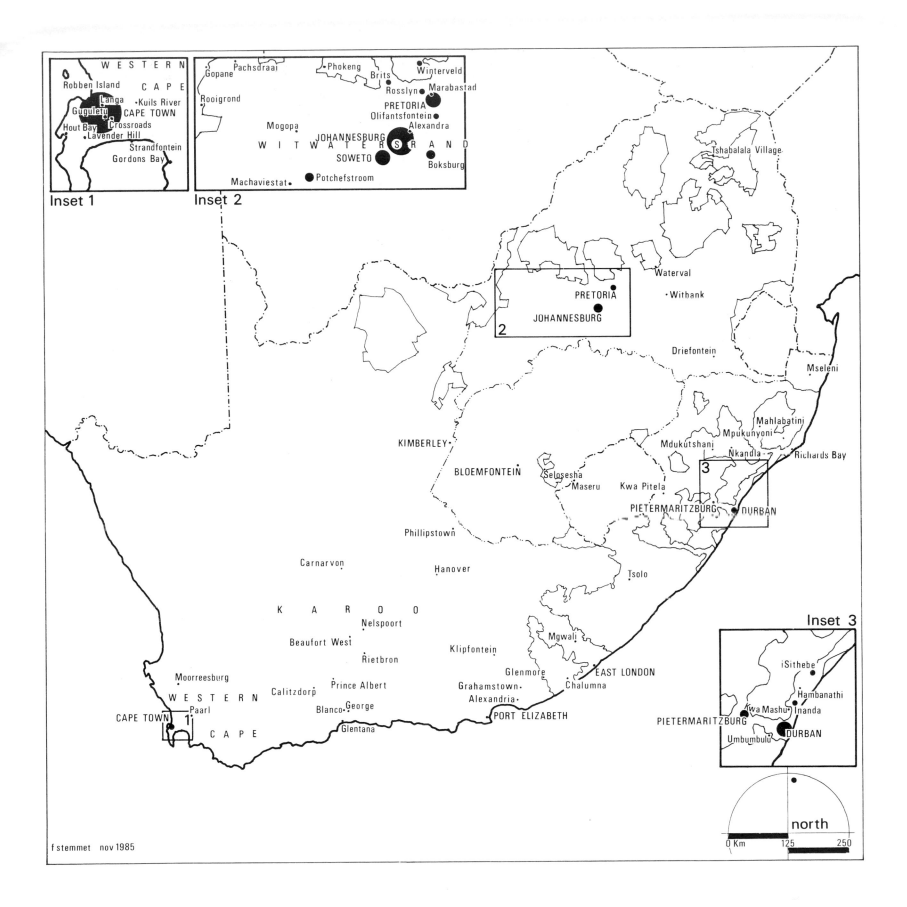

Inset 1

WESTERN CAPE
Robben Island
Langa •Kuils River
Guguletu CAPE TOWN
Crossroads
Hout Bay
•Lavender Hill
Strandfontein
Gordons Bay

Inset 2

•Pachsdraai
Gopane •Phokeng
Brits •Winterveld
Rooigrond Rosslyn• Marabastad
PRETORIA
Olifantsfontein
Mogopa Alexandra
JOHANNESBURG
WITWATERSRAND
SOWETO
Boksburg
Machaviestat •Potchefstroom

WESTERN
CAPE

KIMBERLEY•

BLOEMFONTEIN
Selosesha
Seloses•ha Waterval
•Maseru •Withank
Kwa Pitela
PIETERMARITZBURG Tshabalala Village

Mahlabatini
Mpukunyoni
Mdukutshani
Nkandla• •Richards Bay

Driefontein
•Mseleni

•DURBAN

Phillipstown•

Carnarvon•
Hanover•
•Tsolo

K A R O O
Nelspoort•
Beaufort West• •Mgwali
•Rietbron Klipfontein•
Moorreesburg•
WESTERN Calitzdorp• Prince Albert• Glenmore• EAST LONDON
CAPE TOWN •Paarl 1 Blanco•George• •Chalumna
C A P E Grahamstown•
Glentana Alexandria•
•PORT ELIZABETH

Inset 3

iSithebe•
Hambanathi•
Kwa Mashu• Inanda
PIETERMARITZBURG
Umbumbulu• •DURBAN

north

0 Km 125 250

f stemmet nov 1985

xi

FOREWORD

There is a saying, "Out of Africa always something new." It was presumably coined by Europeans intent on colonising Africa and amazed at all the exotic things they kept on finding in that continent. On the whole I suppose it was meant as a word of praise, having a reasonably positive connotation. I am afraid any use of it in relation to South Africa is not meant in any positive sense. Perhaps it can be used to draw attention to the startling paradoxes of our beautiful but sad land, paradoxes which, like so many of our tragedies in South Africa, are unfortunately homemade.

Look at our country. We led the world in discovering the most sophisticated way of transplanting human organs. We have received accolades as a result of the pioneering work of Prof. Christiaan Barnard, in whose limelight most South Africans have been only too ready to bask. The paradox lies in the fact that a country that boasts such advanced medical technology can be plagued by a disease such as cholera, whose prevention is fairly straight forward—a clean water supply. This country, richly endowed with natural resources, produces the bulk of the world's gold and huge quantities of uranium, diamonds, and coal. Yet we appear unable to put together enough money to ensure that all South Africans have a clean supply of water. Black people in rural areas have to walk long debilitating distances in order to get water that cannot be guaranteed clean, and they have often to pay much more than the average householder in a white suburb. That is why Francis Wilson reminds us of the remark, by one research worker in the Carnegie Inquiry, that poverty can be expensive.

We have a land that until recently had a public holiday, dedicated to the sanctity of family life, called Family Day. Yet our economy is based on the system of cheap migratory labour, a system unlike any other in the world, where the government sets out deliberately to undermine black family life. Even the white Dutch Reformed Church—not exactly noted for its harsh criticism of government policy—in its Cape Synod declared this migratory labour system a cancer in our society.

Incredibly, it is a crime for a woman to be in bed with her husband if he is a migrant labourer who should be staying in a single-sex hostel. Women at the KTC* squatter camp in Cape Town were treated callously by the authorities who day in and day out during 1984 demolished their flimsy plastic coverings. They were left in the cold winter rain, their household effects strewn around their feet and whimpering babies on their laps. Their crime was that they wanted to be with their husbands and the fathers of their children.

This is the only country I know in the world that makes it illegal for a person to look for work because of his or her colour. Influx control measures, which ensure that blacks in the rural areas are locked out of the core economy and swell the numbers of the country's unemployed, only allow a lucky few through to get contracts to satisfy the country's labour needs.

The vast majority of South Africa's inhabitants are being stripped of their South African citizenship and are now aliens in the land of their birth. To achieve the dream of the apartheid ideologues, a time when there would be no black South Africans, the authorities have embarked on a policy of forced population removals. Stable communities have been destroyed by deliberate government policy; sturdy homes, schools, clinics, churches, and shops that the communities have erected at great cost have summarily been demolished. The people have then been packed off to impoverished, arid Bantustan resettlement camps where there has been little work and little food. The father, if he is lucky, works as a migrant, not seeing the family for nearly eleven months while they are eking out a miserable existence just to keep body and soul together. Two priests who work in resettlement areas told me of one family who, wanting to ensure that their last bit of mielie meal would last longer, added sand to it. This is a country that has boasted of feeding starving Zambia.

South Africa: The Cordoned Heart contains one hundred and thirty-six photographs that were used to bring home to people the harsh realities of South Africa revealed by the Second Carnegie Inquiry into Poverty and Development. The photographers must be commended for their close cooperation with academics and others in this venture. Their pictures show all the contradictions of the society; "commuters" asleep on their buses because apartheid has forced people to live four or five hours' bus journey from their place of work,

* Kekaza Transit Camp.

the ravages of the forced population removal policies, an emasculated father, thoroughly powerless, surrounded by hungry children whom he cannot feed because there is no food in the house and there is no food in the house because he is not working. And he is not working because apartheid decrees that this must be so. We must thank these photographers for putting a face to all these facets of poverty. We are not dealing with sets of statistics. We are talking about people of flesh and blood, who laugh and cry, who love and hate, who enjoy being cuddled. We are talking about men who want to be with their families, husbands who just want to work to be able to feed their children. This Carnegie Inquiry is about such ordinary people, and the pictures bring them very much to life. I commend *South Africa: The Cordoned Heart* very warmly.

Desmond Tutu
Anglican Bishop of Johannesburg

PREFACE

The photographic essays in this book were selected from approximately one thousand photographs submitted by twenty South African photographers to the Second Carnegie Inquiry into Poverty and Development in Southern Africa. This work was first shown at the Carnegie conference, which was held at the University of Cape Town in April 1984 and comprised over four hundred photographs.

Also shown at the conference was the work of a number of artists and children from various community arts projects around the country, as well as several films and videos made specifically for the Inquiry. The collaboration, in the work of the Inquiry, between some of South Africa's most talented artists, photographers, and filmmakers with academics and labour and community leaders escaped the attention of most commentators. This is not surprising when one considers the overwhelming amount of material about poverty contained in the three hundred papers that were presented during the six day conference.

It is important for us to examine briefly how and why the photographers, whose work is represented in this book, became involved in the Carnegie Inquiry and to understand the realities of contemporary South Africa that have led to their break with traditional notions of the journalist's "neutrality" and the South African artist's distance from the cut and thrust of politics.

Apartheid is violence. Violence is used to subjugate and to deny basic democratic rights to black people. But no matter how the policy of apartheid has been applied over the years, both black and white democrats have actively opposed it. It is in the struggle for justice that the gulf between artists, writers, and photographers and the people has been narrowed. Since the days after the Sharpeville massacre and the turbulent times following the Soweto uprisings, a new generation recognised that no change would be possible unless they reached out and organised side by side with their parents. By the late seventies many black and some white artists and intellectuals had become involved in grassroots work in their communities. It was from the ranks of such photographers—particularly from the members of the Afrapix photographers' collective—that the initiative to work on the Inquiry emanated. We approached Francis Wilson with the view to involving the country's documentary photographers in the work of the Inquiry. We felt that a number of photographers were already involved in documenting their communities and that the Inquiry would help pool resources to establish a comprehensive collection of photographs that would be valuable not only for research but for serving the needs of numerous community-based projects and campaigns.

Within a few months, the photographic project of the Inquiry got underway. I was given the task of integrating the work of the photographers into the overall programme. Many of the essays contained in this book and the associated travelling exhibition were submitted by photographers from already completed essays or from work in progress, which was subsequently supported by the Inquiry. In other cases the photographers were commissioned to work with academics in the field. In many ways, this effort marked an important milestone in the development of documentary photography in southern Africa. It is noteworthy that all the photographers involved in the Inquiry have agreed to donate any royalties from this book to the creation of a Centre for Documentary Photography at the University of Cape Town, which we are in the process of establishing.

The practice of the documentary genre is relatively recent in southern Africa. It was only in the fifties that the first photojournalism magazine was established. *Drum* magazine heralded a cultural revolution in this part of Africa, and within its pages a new literature was born, accompanied by the development of a school of documentary photography. The magazine echoed the influence of *Life* and *Picture Post*. A young German staffer on *Drum*, Jurgen Schadeberg, trained many of our black photographers. Within a few years Peter Magubane, Bob Gosani, Alf Kumalo, and G. R. Naidoo had become household names throughout Africa. Parallel to the growth of *Drum* was that of the newspapers and journals which were the mouthpieces of the Congress movement and which had begun to challenge the Nationalist government's new apartheid policies. It was from within the Congress movement that a number of photographers emerged to document the Defiance Campaigns and broader resistance to apartheid laws. Foremost amongst them was Eli Weinberg, a trade unionist and Congress activist. When the government banned him from working in the trade union movement, he turned to photography to eke out a living. After serving a long

prison sentence in the mid-1960s, Weinberg fled into exile and took with him one of the most comprehensive photographic records of the Congress movement prior to its banning in 1960. A collection of his photographs, published just before his death, is banned in South Africa. In 1967, another South African photographer went into exile, smuggling out with him one of the the most remarkable photographic documents to come out of South Africa. Ernest Cole's book, *The House of Bondage*, is banned in this country, but its influence on young photographers who have had access to it has been immense.

The two photographers who have most influenced the post-1976 generation are Peter Magubane and David Goldblatt. Goldblatt's influence is felt not only through his books but also through his continued involvement in workshops and exhibitions.

Since August 1985 thousands of people have been imprisoned under the state of emergency that was declared over most of the country. The government's response to the world outcry against the actions of its army and police in the townships has been to impose a strict censorship on the gathering and dissemination of news. To photograph or sketch in the so-called "unrest areas" without a police-issued press card and without the permission of a police officer is now a criminal act. The penalty for breaking the censorship edicts is ten years' imprisonment and/or a fine of twenty thousand rands.

These events have once again brought home to us all, artists, photographers, executives, or workers, that we cannot escape the heavy burden of history and that no one can remain neutral. The tear gas and the ring of armour around our townships have smashed all the barriers that many of us have so painstakingly built between ourselves and our public responsibilities.

None of us knows who will survive the coming days, who will succumb and leave the country, who will disappear mysteriously into the night, or who will lose heart in the face of the government's onslaught against its opponents. But I am sure that no amount of repression will stifle the voice of ordinary people for peace and democracy. Through the years of resistance, people have lost their fear of prison doors closing behind them without losing their sensitivity to the plight of their fellow human beings, no matter where they come from or what the colour of their skin.

Omar Badsha

INTRODUCTION

Nearly sixty years ago, before the time of the Great Depression, the rulers of South Africa were troubled by a huge migration of whites into the cities. These were farmers, uprooted from the land during the previous generation by war, drought, pestilence, population growth, and the capitalisation of agriculture. Ill-equipped for modern industrial society, they lived in dire poverty. Faced with this problem but unwilling to consider the wider ramifications of poverty in the whole society or the no-less-dire straits of the black population, a team of university and church people set up the Carnegie Commission on the Poor White Problem in South Africa with help from Carnegie Corporation of New York. Within the limits of its terms of reference, the Commission performed its task well. At the end of several years, the Commission produced reports that spelled out the dimensions of poverty among white South Africans, drew attention to "the process of impoverishment," and made recommendations for action. The failure of the Commission was that, in limiting its concern to whites, its findings were used to promote strategies for improving the position of poor whites that were often at the expense of blacks.

These findings were eventually incorporated into the thinking of Afrikaner nationalism working through the National Party in its drive for power and in the implementation of some of its subsequent policies. It is, for this reason that, when the idea for the Second Carnegie Inquiry into Poverty and Development in Southern Africa was debated in 1980 and 1981, great care was taken to ensure that *all* those impoverished in the South African economy would be included in the terms of reference of the study. This meant looking into the conditions not only of the poor (almost, but not quite, all of them black) in both rural and urban areas of the country (including the reserves) but also of those in neighbouring countries, such as Lesotho, whose poverty is directly linked (see p. 11) to the wealth of South Africa.

The first Carnegie Commission had relied on the participation of a few experts. The second study was designed as a much more open-ended inquiry to draw in the work of large numbers of people, many of them from outside the academic world and from a wide political spectrum. The Inquiry was conceived in South Africa and run by South Africans. Its name, like that of the first Commission, came from Carnegie Corporation of New York, a philanthropic foundation, which provided the funding with no strings attached. Based at the University of Cape Town, the Inquiry was designed as a scientific study. During the preliminary phase, various people moved around the country asking people's advice about whether or not the Inquiry should be set up and about how it should be shaped. Almost immediately a striking contrast in views became apparent. White South Africans were generally enthusiastic about the need for research to gather facts on poverty. Black South Africans were unimpressed by data-gathering. "Why spend money on finding out what we already know?" they asked. "What we need is action against poverty."

This second view was crucial in shaping the subsequent process of the Carnegie Inquiry. Both the search for data and the analyses of causes of poverty were seen by participants not as ends in themselves but rather as foundations on which to build solid strategies for action in both the short and the long run.

Academics from almost all of the two dozen universities in southern Africa were drawn in to contribute papers to the Inquiry. At the same time, working groups were set up with people from outside the universities – people with special knowledge and skills to contribute. These included lawyers, teachers, doctors, farmers, pastors, community leaders, and others. The mandate for the working groups was to think through strategies for action in such diverse fields as law, food and nutrition policy, education, public allocation of resources, and other areas.

The work was not confined to written papers, more than three hundred of which were presented at a conference held, as part of the Inquiry, at the University of Cape Town in April 1984. Other material presented at the conference included video tapes that were commissioned. Children's artwork, reflecting perceptions of poverty and development, was collected from both urban and rural schools. Drama groups and dancers also made their contribution. Ideas about poverty and development around the world were brought in through the medium of film in a festival, *Signs of Hope*, which showed successful development projects ranging from a poor peoples' cooperative bank set up by the Self Employed Women's Association in India, through a rural health centre in Nigeria, to an adult literacy programme in Chile; from bio-gas digesters that provide fuel for cooking in a million Chinese homes to the job-generating public works programme that produced the hydro-electric energy in America's Tennessee Valley Author-

ity scheme after the Great Depression in the 1930s.

One of the most illuminating contributions to the work of the Inquiry came from a set of photographic essays put together by twenty South African photographers. These men and women, from differing backgrounds and regions of the country, sought to document as truthfully as they could the conditions of poverty and the people who endure it in the South African economy. This documentary work was also shown in an exhibition at the 1984 conference which provided the focus for gathering all the material at the end of the first stage of the Inquiry.

Since that time, the task has been to consolidate the work by encouraging as much public criticism and debate as possible, revising the preliminary findings, clarifying ideas about strategies for action, and disseminating all this as widely as possible. The Inquiry has been designed to stimulate a process that it is hoped will continue after the Inquiry draws to a close early in 1987: a process of thinking through, preparing, and (where possible) trying to implement, strategies that will deal effectively with the scourge of poverty in southern Africa.

One part of this ongoing process has been to produce a number of books for publication. This book is the first in the series. Another book, a major synopsis that draws together in one volume the facts, analysis, and strategies that have emerged from all the work of the Inquiry, will follow. At the same time a number of more specialised books, or monographs, are being prepared, drawing together the material on particular places and themes such as metropolitan areas, the platteland, law, and education.

South Africa: The Cordoned Heart has been produced to provide readers with greater insight into what it means to be poor in South Africa and to increase their understanding about why such poverty should exist alongside so much wealth. The text in the book draws primarily from the research papers prepared during the course of the Inquiry. The photographs themselves demand thoughtful attention because the photographers have tried to go beyond headlines. The reader is invited to look through the eyes of documentary photographers and study their work as carefully as any text.

Francis Wilson
Director, Second Carnegie Inquiry
into Poverty and Development
in Southern Africa

SOUTH AFRICA
THE CORDONED HEART

The child who was shot dead by soldiers at Nyanga

The child is not dead
the child lifts his fists against his mother
who shouts Afrika! shouts the breath
of freedom and the veld
in the locations of the cordoned heart

The child lifts his fists against his father
in the march of the generations
who shout Afrika! shout the breath
of righteousness and blood
in the streets of his embattled pride

The child is not dead
not at Langa nor at Nyanga
not at Orlando nor at Sharpeville
nor at the police station at Phillippi
where he lies with a bullet through his brain

The child is the dark shadow of the soldiers
on guard with rifles, saracens and batons
the child is present at all assemblies and law-givings
the child peers through the windows of houses
 and into the hearts of mothers
this child who just wanted to play in the sun at Nyanga
 is everywhere
the child grown to a man treks through all Africa
the child grown into a giant journeys through the whole world

Without a pass

Ingrid Jonker

A SPECIAL CASE

Those who do not know South African poetry might assume that Ingrid Jonker's poem on the child who was shot dead by soldiers at Nyanga had been written in direct response to the events of 1985 when hundreds of children raised their fists and were shot dead in the "locations of the cordoned heart." But these words of struggle were written twenty-five years ago and thus serve to remind us that the agony of 1985 is not new. The march of the generations in the streets of embattled pride is a long one that goes back through three centuries of conquest.

The harshness of the actions by soldiers and police occupying black townships in 1985, combined with the power of television (until crippled by state censorship), has taken the debate about South Africa's future into homes around the world. But this debate, like the circumstances that fuel it, is not new. The child has been present at all "assemblies and law-givings" in the country's history. South Africa herself is the cordoned heart, and her people, oppressed and oppressors together, are imprisoned by the fetters with which one group seeks to bind the other. The debate about how to break free continues to rage — with a heightened sense of urgency.

The Many Dimensions of Poverty

Not very far from the city of East London stands a village called Tsaba. The nearest water source is forty minutes' walk, more than one mile away. Water for the household has to be fetched three times a day in a bucket or plastic drum that, when full, weighs between forty and fifty pounds. Tsaba is one of nineteen villages in the Chalumna area of the Ciskei where altogether some twenty-five thousand people live. A scientific study of rural water supply in the area showed that the energy required to carry the water home is, on average, roughly equal to that used by a miner wielding a pick. It is perhaps not surprising that people there use an average of only nine litres of water per person each day (less than three gallons) — one-twentieth as much as the two hundred litres considered as a reasonable norm in the urban middle-class homes of South Africa. It was also found that nine out of every ten households in Chalumna draw their supplies from unprotected surface sources that are shared directly with cattle and other stock (148:6).* Further north in the Transkei the average household in three villages was found to spend more than three hours every day fetching water (261:13). In a drought year, cases were recorded of women walking more than seven miles to draw water (149:11). In some other parts of the country, the time collecting water is spent mainly waiting in queues. I walked past one borehole in the eastern Transvaal in the winter of 1983 where some villagers had to queue at two in the morning in order to ensure that they got water. Further east in the Mhala district of Gazankulu it was estimated that an average of 760 people had to share each water tap (192:2). In some districts of the same reserve, water was found to cost fifty cents for a twenty-five litre drum (67:8). This works out to be sixty-seven times as much as the cost of clean drinking water drawn from middle-class taps in the suburbs of Cape Town. Poverty can be highly expensive (33:3).

It may seem odd to start an essay on the most industrialised country in Africa by describing problems of obtaining clean drinking water in remote corners of the country. Yet these apparently isolated difficulties serve to highlight two important truths about the incidence and nature of poverty in southern Africa. First, what is true for Chalumna or Mhala holds true for much of rural South Africa, particularly in the reserves—variously called bantustans, homelands, or black national states—where over half the African population of the country has been crowded by government decree into 13 percent of the land (see p. 9 and 14). Second, the difficulties facing the poor in obtaining so basic a human need as clean drinking water serve as a sharp reminder that poverty has many dimensions. It is tempting, and sometimes useful, to reduce the measure of poverty to a single number such as the average income per person. But scientists are increasingly aware of how misleading such a process can be.**

It is not enough to measure illness simply by taking the temperature of the patient. If a cure is to be effected, it is important also to diagnose the nature of the disease. Poverty is like illness: it is complex; its different forms need to be described and understood.

* Numbers in parentheses refer to the relevant Carnegie Inquiry conference papers listed at the back of the book (see p.179-185). In this case, Andrew Stone, "A case study of water sources and water quality of the Chalumna/Hamburg area of Ciskei," page 6. ** Stephen Jay Gould, *The Mismeasure of Man*, New York, Norton, 1981.

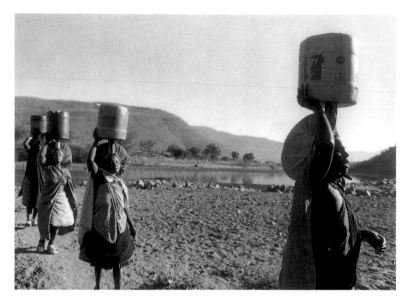

Msinga *Paul Weinberg*

One of the most striking images of poverty in South Africa is that of an elderly person walking home bent under the weight of a ninety-pound bundle of firewood. She is passing underneath one of the huge cables that carry electricity across the length and breadth of the country linking cities, small towns, and farms. South Africa produces 60 percent of the electricity generated in Africa as a whole. But for hundreds of households, and not only those compelled to be in the reserves, electricity is not supplied, and the lack of fuel for cooking, heating, and lighting is an increasingly acute problem for at least half the black families in the country.

In one of the reserves, for example, women spend anywhere from 2.5 to 4.5 hours collecting each load of firewood. In one extreme case a group of women was found to walk twelve miles, spending 9.5 hours, collecting each headload. And most households require between two and three ninety-pound loads of firewood per week. "If wood gathering is counted as part of food preparation, more effort is put into the preparation of food than the growing of it" (156:5).

Throughout the country, including the cities and the small towns of the platteland, there is evidence of a fuel crisis facing the poor. For example, in the little town of Hanover in the Karoo, "Wood is so scarce that people chop out the wooden window frames and doors of old deserted houses in the white dorp for firewood.... A few years ago, people could go into the veld to collect what wood there was; now farmers have fenced their properties making access difficult" (34:19).

Lack of fuel also has serious consequences for all the inhabi-

tants of southern Africa. Increased population density in the reserves, caused primarily by government policy (see p.14 below), has forced people in recent years to cut down live trees for fuel, as no more dead wood is available. This transition has contributed to the destruction of whole forests. In KwaZulu, in the short space of fifty years, forestland has been reduced to one-fifth of what it was shortly before the Second World War (156:11). Several hundred miles away, in the eastern Transvaal, the slopes of the Leolo mountains twenty years ago were completely covered by trees. Today, as I was shown by a local pastor, masses of rock are becoming visible as trees are cut down by people coming up from the plain to collect fuel. Only scattered bush is left.

When the trees go, the springs of water tend to dry up. The so-called sponge effect of forests enables them to act as regulators of our water supply (156:12). Thus the disappearance of trees, caused in no small measure by this relentless search for fuel, is an important factor in the loss of clean drinking water from much of southern Africa. Bad farming, including overgrazing and deforestation, has also contributed to the accelerated encroachment of the desert as the Karoo shrub advances from the southwest toward the heart of the country at a rate of perhaps more than a mile every two years, turning sweet grassveld into semidesert. Disruption of the ecological balance in a fragile environment makes life precarious for everybody.

Almost as invisible to wealthy urban eyes as the ravaged land are ravages of the human body. Some years ago the country's leading business journal, *Financial Mail*, published on its front cover a photograph (taken in a KwaZulu hospital) of an emaciated baby suffering from kwashiorkor, a disease caused by acute protein deficiency. The editor was summoned to Pretoria by an angry cabinet minister who accused him of using a picture that must have been taken further north in Africa to embarrass the government and besmirch the country's image. The people of South Africa, it is widely believed, may suffer from various problems but starvation is not one of them. In fact, acute malnutrition manifests itself in many places and hunger stalks the land. Less than two hundred miles from the richest city in Africa is a large rural hospital. When I first visited it in June 1983 at the height of a very bad drought, the forty cots in the children's ward were filled with sixty babies, many showing signs of starvation. I saw most of them: emaciated, some on intravenous drips, many with gastroenteritis, suffering from kwashiorkor, marasmus, or pellagra. Visiting again in August 1985, I found the numbers were not as great but the ward still contained children suffering from lack of food. There are many hospitals in the rural areas of South Africa each with its kwa-

chiorkor or gastro wards rescuing children teetering on the "edge of survival" (205:7).

Nor is that the only evidence of hunger. A remarkable survey on the extent and impact of resettlement in South Africa, the Surplus People Project, interviewed, in a number of different places, those who had been compelled to move. People complained again and again of hunger. They told of being dumped by the government's department, which called itself "Cooperation and Development," in dry barren areas of the country with little of what they needed to survive.* A later study found that over half the respondents in three Transkei villages never consumed milk, eggs, fish, meat, or vegetables. One-third of the families had diets that were deficient in calories, certain minerals and vitamins, and quality protein (261:10). In a different part of the country, a survey of twenty-five hundred schoolchildren in the introductory (Sub-A and Sub-B) classes found that two out of every five of these children came to school each day without breakfast. And many of them had to walk considerable distances to do so (192:3).

How many children die from hunger? South Africa collects no statistics on death from starvation alone, but some estimates have been made of infant mortality due to malnutrition and related diseases. One of the country's leading paediatricians, Dr. John Hansen, has estimated that the number of African children who died from those causes in one year (1970) was no fewer than fifty thousand (205:2). Statistics are patchy, particularly in the rural areas, but there is enough information available to know that the probability of a child's dying before its first birthday varies dramatically according to whether it is black or white or is from the country or the town. In the metropolitan areas the infant mortality rate is far lower than in any of the rural areas measured – and it has fallen sharply in recent years. In the Johannesburg municipal area, including Soweto, the infant mortality rate (per thousand live births) for blacks fell between 1950 and 1979 from 232 to 35. In the rural Transkei, on the other hand, infant mortality in 1983 was nearly four times as high – 130 per thousand.** Moreover, even in the relatively better-off environment of Johannesburg, black babies were twice as likely as white babies to die before their first birthday. The risks of black children dying so young or growing up undernourished and stunted are far greater in other parts of the country than they are in metropolitan areas like Johannesburg.

It is not only young children who are at risk. Older people, too, suffer disproportionately from the ravages of poverty. In South Africa there is no viable "safety net" for the elderly. The pensions paid to women over age sixty and to men over age sixty-five are very low. The size of the state pension depends

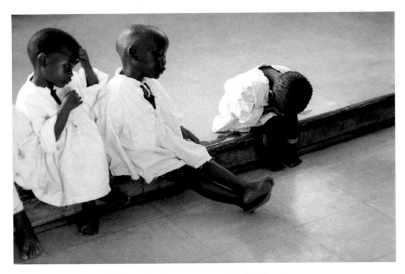

Malnutrition ward, Bophuthatswana *Paul Alberts*

primarily on the race classification of the recipient. The pension for whites is small, but for Africans it is below the poverty line. In 1985 the maximum monthly state pension was R180 for whites, R117 for those classified as "coloured" or Asian, and R79 for Africans. But there were many blacks who did not get even this pitiful amount. In neighbouring countries such as Botswana or Lesotho there is no state pension at all for most old people. Moreover, within South Africa itself, many qualify for pensions who simply do not receive them. Bureaucratic inefficiency and corruption are two reasons why. But the most important is that the South African government does not provide sufficient funds for the administrations in the reserves to meet their commitments. Thus in KwaZulu, for example, there has been a huge pension crisis. Officials there estimate that one hundred thousand old people owed pensions were not receiving them because of insufficient funds (143:2).

Further south, in the Ciskei, one of the doctors working in the state health department in the area described the plight of elderly people who do not have enough money to live on. "These old people are past fending and fighting for their rights. They may be found in dark rooms, on ragged beds. Mostly hungry, often filthy. Their hunger makes them confused and even less able to manage and if you visit their homes you may find – an emaciated old woman, dignified and uncomplaining, until she becomes confused from her hunger and cries out again and again 'I am hungry, I am hungry.' A thorough search of the

* Surplus People Project, *Forced Removals in South Africa,* 5 volumes, Cape Town, SPP, 1983. ** L.M. Irwig and R.F. Ingle, "Childhood mortality rates, infant feeding, and use of health services in rural Transkei," *South African Medical Journal,* vol. 66, no. 16, 20 October, 1984.

room and cupboards reveals only some salt, and her primus and pot are shining bright as if waiting for food to cook.
– or a paralysed old woman, persistently scraping the bottom of an empty pot and putting her claw-like hand to her mouth in a despairing imitation of eating ."*

For many older people the time of greatest vulnerability is the five or six years before they reach pensionable age. In those years many people who have worked as labourers all their lives find it impossible to get work, and they often have virtually no source of income on which to rely. This problem is found elsewhere in the world, but it is a burden that falls particularly harshly on many blacks in southern Africa for whom there are no forms of effective social security, such as food stamps, and who have no access to land or even freedom of movement to search for work (53a:48).

Is Poverty Increasing ?

How many people are poor in South Africa? Is poverty increasing or decreasing? Are things getting better or worse? These are simple questions but attempts to answer them have generated much debate. Even so, some tentative conclusions are possible.

In South Africa as a whole, including the reserves, the proportion of the population living below subsistence is roughly 50 percent (1980). Few white people are this poor. For Africans alone the proportion is of the order of 60 to 65 percent.** Even among blacks poverty is unevenly distributed. Four-fifths of it is estimated to be concentrated in the reserves – those rural areas of South Africa whose main function is to provide labour for the cities; 14 percent is in commercial, white-owned, farms; and only 7 percent is in the urban areas (234:18). In the reserves no fewer than 81 percent of the households in 1980 were living in acute poverty.**

Unfortunately, these figures are imprecise and incomplete. In particular, they do not cover those countries bordering South Africa, such as Lesotho or Mozambique, that have developed as part of the single economy united by the growth of the gold-mining industry (as is shown below on p.11). Neither do they allow us to examine trends in the pattern of poverty in the whole region. Thus it is virtually impossible to obtain adequate data to make meaningful comparisons over time. Over the past two decades, some evidence has emerged to show that the proportion of households living in poverty has fallen – from 75 percent in 1960 to 50 percent in 1980. Within the reserves, where poverty is most heavily concentrated, estimates are that the proportion of South African households living in poverty has fallen from 99

percent to 81 percent.** Although the trend is encouraging, the absolute numbers remain daunting. More and more people are living in the reserves, in part because of natural increase, but even more because of the government policy of relocation. Thus the absolute number of people living below the minimum level in the reserves has increased substantially – from nearly five million people in 1960 to approximately nine million in 1980. And the number of households that are utterly destitute, with no land, no cattle, no remittances from family members working elsewhere, and no transfer payments such as pensions, has risen even more sharply during those two decades – from 250,000 to nearly 1.5 million, a more than five-fold increase. In the country as a whole the number of people living below the poverty line seems to have risen from 13 million in 1960 to 15 million in 1980.**

It appears that, while real wages for everybody employed in South Africa rose between 1970 and 1980, poverty remains acute and widespread, and the number of households that have to endure it seems to have increased. This conclusion is certainly strengthened when one considers conditions in Mozambique, Lesotho, Namibia, Swaziland, and Botswana, where not only are there no state pensions for the vast majority but access to jobs in the industrial heart of the economy is made more and more difficult by the South African government.

Looking ahead, there seems little likelihood that enough new jobs will be created in agriculture, mining, manufacturing, and other sectors to provide work for all those coming on to the labour market. The rate at which South Africa is creating new jobs is lower than the country's rate of population growth. The level of unemployment is high and going higher. Estimates are that one-fifth of the economically active African population was unemployed in 1980. Since then, the twin scourges of recession and inflation have gnawed away at the wage gains of the previous decade, reducing not only the number of jobs but also the buying power of workers' earnings in many sectors. The spectre of more unemployment and more poverty looms.

Why South African Poverty is Different

What is special about South Africa? There are many other countries in the world where millions of families live in dire poverty, where women toil daily, hewing wood and drawing

* Trudi Thomas, *Malnutrition in the Ciskei*, July 1980, quoted in 138:75.
** Charles Simkins "Some aspects of the Carnegie Conference," *Development Southern Africa*, vol. 1, no. 2, August 1984 p.181.
See also 7:2 and 311:5.

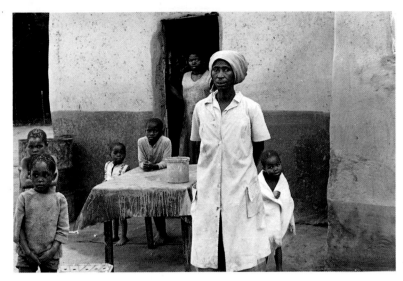

Farm labourer and her children, Piet Retief district *Lesley Lawson*

water while their children die before their first birthdays, and where the population explosion threatens to overwhelm available resources. In the rest of Africa and in Latin America the number of families living below the poverty level is constantly increasing.* Even the fact that South Africa exports food while thousands of her children suffer acute malnutrition is not unique. South Africa, some argue, is just one more Third World country.

In his attack in 1984 on the Second Carnegie Inquiry into Poverty and Development in Southern Africa, the South African prime minister P. W. Botha (now president) implicitly supported this view when he said he found it remarkable that such an investigation should be carried out in his country "when the great continent of Africa is dying of hunger, when people are wasting away in their millions and starving little children lack the basic food needed to keep body and soul together."**

Not for a moment should one minimise the horror of such poverty elsewhere in Africa or in the rest of the world. Its existence the world over warns against any simplistic proposals for sweeping away all poverty in the land of apartheid. Yet it is important to recognise that South Africa *is* a special case. She is not simply "one more Third World country." The poverty that ravages her people is unique.

There are three reasons that, taken together, justify this assertion. First is the degree of economic inequality in South Africa. That such grinding poverty exists alongside massive wealth is remarkable. The statistics, rough as they are, show the width of the gulf between the well-off and the poor. In 1970, the richest 20 percent of the population in South Africa owned 75 percent of the wealth, compared with 62 percent in Brazil and 39 percent in the United States.*** Despite the substantial rise in black earnings that took place during the 1970s, reducing the richest 20 percent's share of income from 75 percent to 61 percent, the degree of inequality has remained acute. In 1980 the poorest 40 percent of the population earned less than 8 percent of the total income.****

The second reason is that much of the poverty in South Africa is a consequence of deliberate policy. For example, the Land Act passed in 1913 prohibited Africans from buying land in most of South Africa. Those parts of the country (adding up eventually to 13 percent of the total) that Africans had not lost by conquest were "reserved" for them, while they were prohibited from buying land anywhere else, including the cities and the commercial farming areas. Since then, the reserves have come to function as dumping grounds for what government spokesmen have called "surplus people"—the shadow side of a gleaming economy. The racist legislation not only prevents Africans from buying land but from moving freely around the country so they can work where they choose. "Many third world countries," writes Joseph Lelyveld, "have irresponsible oligarchies that have as little conscience about their landless and unemployed as South Africa's white elites; sometimes, in truth, much less. But none of them, while preaching reform, creates refugee camps in the midst of prosperity as a matter of state policy."*****

The third, overriding, reason why poverty in South Africa is in a class of its own lies in the fact that there is more to poverty than material deprivation. As David A. Hamburg, president of Carnegie Corporation of New York, argued at the University of Cape Town in 1984, "Poverty is partly a matter of income and partly a matter of human dignity. It is one thing to have a very low income but to be treated with respect by your compatriots; it is quite another matter to have a very low income and to be harshly depreciated by more powerful compatriots. Let us speak then of human impoverishment: low income plus harsh disrespect ... To speak of impoverishment in this sense is to speak of human degradation so profound as to undermine any reasonable and decent standard of human life...." (309:7).

* Julio de Santa Ana, ed., *Towards a Church of the Poor*, Geneva, World Council of Churches, 1979. ** House of Assembly Debates, Hansard No. 12, April 1984. Cols 5353-5354. *** S. F. Archer, "The winter of our discontent," *South African Outlook*, December 1978. **** Stephen Devereux, *South African Income Distribution 1900-1980*, Saldru Working Paper no. 51, Cape Town, 1983. ***** Joseph Lelyveld, *Move Your Shadow*, Times Books, New York, 1985.

into the country's history and examine some unique features of the political economy of the region.

Migrant Labour System

Down the years a large proportion of African workers in South Africa have been prevented from settling with their wives and children near their place of work. They have had to leave their families behind in some rural area while remaining at the job site for periods ranging from a few months to as many as two years. These men have been compelled to stay in single-sex compounds, or hostels, many of them housing eight thousand men or more. For their entire working lives, they may have had to spend up to eleven months at a time in such huge, soulless compounds, without any privacy. They may have seen their families for as little as two or three weeks in the year when, during annual holidays, they have had to return to their rural homes to renew their labour contract. It is possible for a married man to have spent thirty years working to provide for his wife and children, yet to have been unable to live with them for more than two of those years.

The origins of this system of migrant labour lie in the web of laws restricting movement of people and the occupation or ownership of land that was gradually imposed on black South Africans over a period of some three centuries of conquest. With the discovery of diamonds and gold, sparking the country's industrial revolution in the latter part of the nineteenth century, these restrictions led to the emergence of a labour system that has had a profound effect on the shape of economic development over a wide area of the subcontinent.

The men in the gold mines have long been drawn from all over southern Africa. Four generations ago, in 1896, well over half of the black labour force in the gold mines came from Mozambique. In 1906, no less than three-quarters of the black labour force employed by the Chamber of Mines was drawn from beyond the political boundaries of the four provinces that in 1910 were to be forged into the Union of South Africa. The proportion from beyond the Union borders fell in later years when the mines expanded and drew in more workers from the Ciskei and Transkei areas of the Cape province. From the time of the Second World War, however, more and more miners were drawn from beyond the Union boundaries until, by 1973, no fewer than 80 percent of the black workers on the gold mines came from Mozambique, Malawi, Lesotho, Botswana, Swaziland, and other countries in southern Africa.

The migrant system is not confined to the mines. One of the most notable features of the major urban centres of South

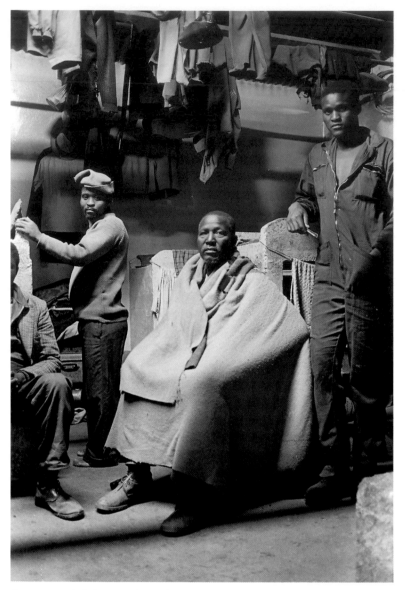

Compound, Johannesburg *Lesley Lawson*

In South Africa racial disrespect is embedded in the very structure of society. Political and economic power is concentrated in the hands of an easily identifiable minority of whites who have, over the years, created a series of comforting myths and ideologies to justify their determination to retain control. Many of South Africa's racist policies have roots deep in the history of the country's political economy. Others are of more recent origin. All engender a harsh disrespect for the poor.

Several features of South African society epitomise that disrespect. These features not only reveal some of the many faces of poverty, they are themselves causes of further impoverishment. To understand this circle of causation, let us delve briefly

Africa during the past twenty-five years has been the building of single-sex barracks to house up to twelve thousand black workers at a time. As recently as June 1985, the government announced plans to build more such compounds, making it plain it has no intention of phasing out the system.*

It is estimated that, at present, over 2 million of the 5 million black workers in the South African economy are migrants. (The other 3 million live, with their families, in the urban townships or on the white-owned farms of the country.) Approximately one-quarter of the migrants work in the mines. The vast majority of them – over 1.5 million (mid-1984) – come from reserves within the country, while some 350,000 (17 percent) come from outside South Africa. Although migrant workers are found in other parts of the world, not least in the United States as seasonal, agricultural workers and in western Europe as *gastarbeiters*, no other country has trapped so large a proportion of its labour force in a structure that is so dehumanising, for so long, or on such a scale. The system is monstrous yet all too easy to ignore when one does not have to endure it. One must listen to the voices of those who live in the compounds to understand the grief it causes.

Fathers talk of the pain of seeing their children growing up as strangers. Sons tell of their shock upon going to town: "We find our fathers with concubines yet our mothers are starving. Besides, the sweethearts are as young as father's children. We get fed up and cannot communicate with our fathers" (5:21). And wives point out that, "For our husbands we are just their old-age home or their hospitals. They really come back to us when they are too old to work or when they are sick" (66:5). And the men themselves lament, "We stay a full year without our wives. That makes us go beyond the bounds of the law and become adulterers." The conclusion, as one of them expressed it, "is that in the towns we are spilt just like water on the ground" (5:22).

What have been the broader consequences of this pattern of oscillating migration? How has it affected the rural areas that have for so long sent a large proportion of their economically active males to work in the mines and factories of the South African economy?

The answer is not as simple as it first appears. According to conventional economic analysis, the matter is relatively straightforward. Men choose to go to the mines because they can earn more money there than they would in whatever alternative work they find at home. Both the sending community and the receiving area benefit. If not, the trade would not take place, the migrant would not be hired, and he would not choose to come.

In the longer run, however, the picture becomes more complicated. One has to look not only at the immediate benefit of profits and wages but also at the whole process of capital accumulation and the pattern of development in the wider society. As workers are drawn to an area by the jobs offered, money is spent there by workers, by management, and by the various authorities. Gradually, as demand for goods and services increases, whether for clothes, wheelbarrows, or lawyers, capital is invested, factories are built, people are trained, organisations are put together. Above the hidden minerals on the bare veld penetrated by the mineshafts, a city grows, with the capacity to generate large numbers of jobs at a wide range of wage levels.

All this is made possible by the work of those who have laboured together, whether as migrant workers two miles below the surface, or as hairdressers – or indeed as such captains of industry as Cecil John Rhodes or Sir Ernest Oppenheimer.

Meanwhile, what of the rural community that has sent most of its able-bodied men away to the cities to work for up to two years at a stretch? As the years have passed, the various sending areas have gradually shifted from producing food within the geographic areas to producing gold and other industrial products elsewhere. As a consequence, local food production has fallen. Until the end of World War 1, Lesotho, for example, exported maize to the mines. During the 1920s, the country remained more or less self-sufficient. However, from the time of the great drought at the beginning of the 1930s, Lesotho became a net importer of maize.

There is, of course, nothing intrinsically wrong with a society that imports food. Many economies have developed by producing cloth or steel or computers to trade for food. The people of Lesotho did likewise: they produced gold. But the gold they dug was on the Witwatersrand of the southern Transvaal or beneath the maize fields of the Orange Free State. And their work contributed to the transformation of sparsely populated land into job-creating, income-generating cities that were not within the geographic boundaries of the area from which they came. While the miners were paid wages for their work, and they sent or took remittances back to their families, the people bought goods that increasingly were produced in the very cities from which the migrants were sending those remittances.

In other societies, such as those in western Europe, the people who started as migrant workers, or their children, moved permanently to the cities taking their families with them. The rural areas became depopulated until there was some balance between what was produced there and the number of

* *Cape Times*, 26 June 1985.

people needed to produce it. But in southern Africa, viewed as a single economy that stretches as far as the recruiting arms of the Chamber of Mines, a bias was built into the pattern of development.

Many of the rural areas of the region contained far more people than the level of production warranted because the law prevented them from moving elsewhere. Most of the economic activity was in the cities; some was on the platteland, in the small towns, and on white-owned farms; virtually none was in the reserves or in border lands. One important consequence of a century of industrial revolution in southern Africa, combined with the system of migrant labour described above, is that the black rural areas, i.e., the reserves and the neighbouring states (particularly Mozambique and Lesotho), have become less able to provide a means of livelihood for their inhabitants in 1986 than they were when gold was discovered in 1886.

The New Political Policy

Against this background one can view a striking change that has taken place in South Africa's political policy since the Second World War. Though there was a shift to the right after the 1948 election as the Afrikaner nationalist movement took over from General Jan Smuts, the radical change in direction came a decade later, when the National Party government guided by Hendrik Verwoerd renounced a policy that had long been a fundamental plank in the platform of all white political parties.

Ever since the South Africa Act of 1909, which created the new Union, left a door open for other territories to join what became the four provinces of the Cape, Natal, Orange Free State, and Transvaal, the policy of successive governments had been to "incorporate" various parts of southern Africa into the Union. South West Africa was brought under South African jurisdiction as a mandated territory under terms of the Treaty of Versailles in 1920, and the white settlers of Rhodesia foreclosed their option by voting in 1922 against joining the Union. South Africa then set its sights on incorporating the three (British) High Commission Territories of Basutoland, Bechuanaland, and Swaziland. Tshekedi Khama, Regent of the BamaNgwato people of the Bechuanaland Protectorate, spent much of his political life during the 1930s and 1940s seeking to prevent incorporation. In the next decade, Prime Minister J. G. Strydom tried hard to persuade the British to hand over the territories. As minister of foreign affairs, Eric Louw, and other South African spokesmen were fond of pointing out, once this incorporation had happened, then half the land in the enlarged South Africa would be in black hands and apartheid would be seen by all to be a fair policy!

In the mid-1950s, however, the emergence of Ghana as an independent state was the first gust in the winds of change that blew through Africa during the next three decades as one country after another was freed from political, although not economic, control by one or another of the European colonial powers. There followed the representation in the United Nations of a significant number of highly articulate new governments, each with a vote at the General Assembly. As a result, it was no longer conceivable that Britain would one day allow the incorporation of the High Commission Territories into an enlarged, white-dominated, Union. Verwoerd, who had come to power in South Africa within a few months of Kwame Nkrumah's assumption of power in Ghana, recognised the realities, although he still tried to persuade the territories to accept incorporation. Faced with their refusal, he then countered with a stroke that transformed an apparent defeat into the springboard of a new strategy for the retention of power by whites throughout the subcontinent.

Because of the territories' total economic dependence upon South Africa flowing from the system of migratory labour and the pattern of capital accumulation in South Africa's cities, it was possible for Verwoerd to sell to his white electorate the idea that the emergence to independence of the High Commission Territories was a good development. Far from being a threat to white security or white power, the political independence of areas, that had long since been fused into the single wider economy controlled from the Vaal triangle (centred on Johannesburg), carried with it all sorts of gains for the white republic. After all, what nation-state can be held responsible for the educational expenditure or the unemployment, old-age, and other welfare benefits needed in another sovereign land? And if that sovereign land should ever try to pursue too independent a political line, then a threatened closure of a border post, a refusal to allow migrant workers to come in (as President P. W. Botha threatened in August 1985), or the squeezing of some other less visible economic artery should persuade that government to rethink its stand.

From there it was but a short step to the revolutionary new policy adopted by the National Party government, led by Verwoerd. If Basutoland could become Lesotho and if the Bechuanaland Protectorate could become Botswana, then surely the reserves, too, could become independent.

Economically speaking there was little difference between the histories of neighbouring countries like Lesotho and the land reserved for Africans under the 1913 Land Act. Both had become

recruiting grounds for the mining industry. If the Transkei could be pushed into independence in 1976 then why not other parts of the archipelago of labour reserves? Thus the various bits and pieces of Tswana-speaking reserves scattered across three provinces were declared the independent nation of Bophuthatswana in 1977. Venda, a reserve in the northern Transvaal, acquired its first president in 1979. Ciskei, in the eastern Cape, became the fourth "black national state" in 1981. There were still six more to go. Some like KwaZulu and Lebowa resisted strongly. Others like KwaNdebele, a fragment of land situated about eighty miles northeast of Pretoria in the Transvaal, and Qwa Qwa, a remote patch in a corner of the Orange Free State, were busy preparing in 1985 to become separate "national states."

Ridiculous as these boundaries might appear to outside observers, their consequences are anything but amusing for all the people whom these apartheid borders exclude from the industrial economy, where the jobs and the wealth of the country are generated.

Prevention of Black Urbanisation

For years one of the central thrusts of government policy in South Africa has been to prevent the movement of Africans to the urban areas. As far back as 1922, an official commission argued bluntly that "the native should only be allowed to enter the urban areas which are essentially the white man's creation when he is willing to enter and to minister to the needs of the white man and should depart therefrom when he ceases so to minister."* From the 1950s on the stated goal of the antiurbanisation policy was to slow down the flow of Africans to the cities, to halt it, and then (by 1978, it was hoped) to reverse it.

As the pressures for urbanisation mounted, the contradictions within the apartheid policy became more and more difficult to contain. On the one hand, the state was pursuing economic growth that led, inevitably, to further urbanisation. On the other hand, it pursued with no less vigour the policy of "separate development," whose ideological cornerstone from the end of the 1950s on was to establish "national states," or "homelands." Africans gained citizenship of the appropriate ethnic state as it acquired "independence" and their South African citizenship was revoked.

This dual policy had the peculiar distinction of requiring African men to be in two places at once: in the cities as "labour units" to keep the wheels of mining and manufacturing turning, and in the rural labour reserves as husbands, fathers, and citizens. The contradictions of apartheid could *only* be resolved by

a system that kept the workers moving like shuttles across the looms of the South African economy. But as that economy continued to grow, more and more workers and their wives wished to settle permanently near their place of work in the cities. This was, however, directly contrary to state policy, and so further steps were taken to prevent it from happening.

Of the array of techniques adopted by the state to prevent black urbanisation, there were essentially three kinds: pass laws; the limitations on housing construction; and the outright destruction of black communities. Each of these tactics cruelly disrupted the lives of black South Africans and directly contributed to the process of impoverishment. Under the pass laws, established in the nineteenth century as instruments for the control of Africans after the abolition of slavery, a staggering number of people have been arrested. During the 1950s the average number of convictions under the pass laws was 319,000 every year. During the 1960s the number of prosecutions rose to 469,000 annually. And in the first half of the 1970s the annual average was 542,000, more than one person every minute of the day and night throughout the year. The constant fear of police raids coupled with the indignity of arrest, often from one's bed in the early hours of the morning, characterise one of the faces of poverty that is distinctly South African. Over the past seventy years more than 17 million Africans have been prosecuted under the pass laws, which continue to exert a vicious toll and have, in recent years, been complemented by other measures to control the movement of blacks.

From about the middle of the 1960s on, the state as a matter of deliberate policy slowed down, and in some cases actually stopped, the building of new houses for Africans in the cities and towns of South Africa. The central government refused to make money available for housing, except in the "homelands," and in other ways exerted pressure on local authorities not to build such housing. Though it seems incredible, officials in 1971 told me that the state was seriously considering moving the whole of Soweto, the sprawling black township on the edge of Johannesburg, several hundred miles to the KwaZulu reserve in Natal. Workers could then commute, "like the Japanese," on a monorail system that would whisk them hundreds of miles to work and back every day. (This mad idea was never implemented.)

The consequence of this antiurbanisation policy, far from achieving its purpose, was extreme overcrowding in the black townships. A doctor who worked in Soweto for several years

* Transvaal Province, *Report of the Local Government Commission* (Stallard), T.P.1, Pretoria, 1922, para. 267.

estimated that, by the beginning of the 1980s, approximately twenty people were living in each four-roomed house, "and stories of thirty people living in a four-roomed house are not uncommon" (170:2). During the 1970s, only five hundred new houses in Soweto were built each year, enough to accommodate just thirty-five hundred extra people at the official rate of seven persons to a house. Yet during this same period the natural population growth annually was of the order of twenty-five thousand. There were at least twenty thousand extra people each year for whom no houses were built. This figure takes no account of the housing needs of people moving to Johannesburg from rural areas.

Even though the law prohibits it, one way of creating more space is to build for oneself. In Soweto and in many other townships throughout South Africa large numbers of "backyard shacks" or "garden huts" have appeared. Most of them are said to be occupied by legal residents who simply cannot fit into the houses any longer (170:3). "In Soweto as a whole, and in Alexandra Township, many houses have more than one family living in them. In Alexandra, in particular, the position is particularly bad, with large families cramped into very small single rooms. This situation forces people to build shacks as a relief from overcrowding. If found, the shacks are demolished instantly and all the material taken by the WRAB [West Rand Administration Board]" (2:8).

In Cape Town all house building for Africans was halted in 1966 in an attempt by the state to reduce the number of Africans in the western Cape by 5 percent a year. Even though the city was expanding and more workers were being drawn into it, with the exception of huge barracks for single men no more housing was built. No allowance was made for natural population increase. There was no shelter for the wives and children of migrant workers who crept unauthorised into the city to join their men. Squatter shacks mushroomed, not only in backyards but also in vacant lots; one along Modderdam Road, another close to it at a place called Unibel, and yet another, now very well-known, at Crossroads.

Neither the absence of housing nor the pass laws were a sufficient deterrent to the flow of Africans into the cities. More force was necessary if the state's policy was to be executed, and so bulldozers were called in to carry out mass demolitions. In the cold, wet winter of 1977, the ten thousand inhabitants of Modderdam Road watched as their shelters were razed to the ground. Six months later, Unibel, home of another fifteen thousand people, was obliterated. Crossroads, declared the officials, was next on the list to be destroyed. But the people there resisted. And the spotlight of the national and international press

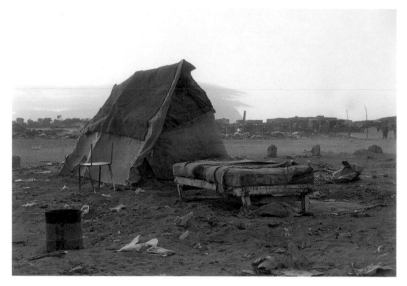

Crossroads *Chris Ledechowski*

fell upon them, strengthening their cause.

In the long struggle at Crossroads, bulldozers have been used, batons have been wielded, and, in 1985, bullets were fired (twenty-two persons were killed). For now, the people seem to have won the battle: Crossroads is to remain. A new township called Khayelitsha is being built nearby, and plans to subject three other black townships to forced removals under the Group Areas Act have been shelved. The policy of clearing all Africans from the western Cape at the bottom tip of Africa seems finally to have been abandoned. But the cost has been enormous.

Cape Town, like other urban areas of South Africa, still faces a policy that is fundamentally hostile to the process of African urbanisation. Arrest for contravening the pass laws, intolerable overcrowding, and fear of the destruction of family shelter are in 1986 ever present realities for the urban poor in South Africa.

Overcrowded Reserves

One of the most devastating consequences of the antiurbanisation policy has been its impact on people who once dwelt on the white-owned farms, which constitute about 80 percent of the area of South Africa, and where, thirty years ago, one-third of black South Africans lived. Changing techniques of agricultural production, particularly the increased use of tractors, combine-harvesters, and chemicals, made it possible for more food to be produced by fewer workers. At first the number of new jobs created each year in agriculture lagged behind the population growth rate. Then, by the end of the 1960s, the absolute number of jobs in agriculture started to fall. More and more

people were pushed off the land.

There is nothing unusual about the displacement of agricultural workers through mechanisation; countries elsewhere have experienced it. What was unique about South Africa was the response of the state to these changes. Those caught in the mincing machine of structural economic change and evicted from the farms were not allowed to move to the cities in search of new jobs. They had to go to the "homelands" – to the already overcrowded labour reserves.

In the Qwa Qwa reserve, an area designated as the homeland for black South Africans whose mother tongue is Southern Sotho, there is hardly any arable land, no mining, and very little manufacturing. During the First World War a government commission reported that the reserve was already overcrowded with five thousand inhabitants (286:3). By 1970 the number had risen to twenty-four thousand, with most households relying for their survival on remittances from migrants or on pension and other transfer payments. In recent years conditions have worsened considerably. Through a combination of agricultural mechanisation and the application of an ideological policy to reduce the number of blacks on white-owned farms, hundreds of thousands of people have had to move to Qwa Qwa, whose population has risen to half a million by 1985. The extent of impoverishment resulting from this process is illustrated by the story of a family whose neighbours were "appalled and ashamed" by the sight of a household literally starving to death in front of them while they could do little to help (52:24).

Mr. Serote with his wife and seven children arrived in Qwa Qwa from a Free State farm in 1974. Since then he has worked intermittently as a migrant labourer. In 1981 he secured a labour contract at the state oil-from-coal plant, Sasol II. Like many others in Qwa Qwa, he did not realise that this contract was not renewable. He also became ill at this time, which made it difficult to find another job. Nevertheless, in mid-1982, he secured work in the not-too-distant town of Bethlehem, but after four months he was so ill that he had to return home. Diagnosed as having tuberculosis, he has not worked since then.

During 1982, Mr. Serote's eldest son secured a contract some distance away in the gold-mining town of Welkom. Subsequently the young man fell sick but clung to his job because it was the family's only source of income. The second son was removed from school halfway through the year in 1982 when his fees could not be paid. He was still too young to be issued a reference book and so could not apply for a contract job as a migrant. He was also unable to find a job within Qwa Qwa. By 1983, the family was in deep crisis. Mrs. Serote and her eldest daughter were both diagnosed as suffering from pellagra, an acute form of malnutrition, and the older woman had suspected T.B. as well. Then a younger child was sent home from school because she was fainting from hunger in class.

A combination of drought, illness, and hunger in the Serote family meant that even the small vegetable garden beside the house was no longer tilled. Mr. and Mrs. Serote said they had exhausted the possibilities of begging or borrowing in the neighbourhood. Owing to the vagaries of relocation, neither of them had any relatives in Qwa Qwa. They talked of their anxiety for, and guilt about, their children and said repeatedly that they had failed as parents. "I cannot sleep at night any longer," said Mrs. Serote, "because my son was so ill when he last came home [at Easter], but I sent him back to work [in Welkom] because his is the only income we have. I am forced to kill one child in order to feed the others" (52: 15 and 24).

It is estimated that between 1950 and 1980 some 1.5 million people were squeezed off the commercial farms in South Africa. Of these, 1.4 million ended up in the reserves.* Small wonder that in areas like Qwa Qwa, or in the other reserves, people feel trapped: imprisoned by laws that bind them to a place where there is no work, no land, and no hope of making a living.

If their families are not to starve, most workseekers living in such reserves must either get contracts as migrant labourers or else become "pendelaars." This Afrikaans word was created in the 1970s from the Dutch word for a shuttle service. It is translated in government documents as "commuters" and is used to describe those who live in parts of reserves that are just close enough to urban areas for them to travel to work on a daily basis. Some may genuinely be called commuters in that the area where they live, such as Umlazi outside Durban or Mdantsane outside East London, is close enough to the workplace for a daily bus or train journey to be feasible, although expensive. But for many pendelaars the daily journey to work and back is a nightmare.**

Starting with a forty-minute walk to the bus stop at 2:00 a.m., some workers then spend three hours on overcrowded buses before changing once or twice to reach their destination in time to start work at 7:00 a.m. A recent study *** in KwaNdebele, a small reserve whose inhabitants live between seventy and ninety-five miles northeast of Pretoria, found that many of those travelling to work spend more than sixteen hours away from home five or six days every week (see p.34).

* Charles Simkins, *Four Essays on the Past, Present and Possible Future of the Distribution of the Black Population of South Africa*, Cape Town, Saldru, 1983. ** For a vivid description of such a journey, see Joseph Lelyveld, *Move Your Shadow*. Times Books, New York, 1985, chapter five. ***J.H. Ehlers, *Pendelaars in KwaNdebele*, Pretoria, R.G.N., 1982.

The "commuter solution" is one fruit of the grand design of apartheid whereby Africans born in South Africa are being turned into citizens of the emerging "black national states." An African family head looking for a house in Soweto but overwhelmed by the housing shortage (see p.50) can "choose" to move to a reserve like Bophuthatswana or KwaNdebele, build a house "in his own country," become a pendelaar – and thereby forfeit his or her right to live in Johannesburg. This leads in turn to the loss of South African citizenship. The logic of the policy is inexorable. As a senior government minister once explained in parliament, its consequence is that, in due course, "there will be no black [African] South Africans." A major step in this direction was taken in 1984 when a new constitution was introduced for the Republic of South Africa that made provision only for those classified "coloured," "Indian," or "white." The majority of people were constitutionally excluded from the country of their birth.

Milan Kundera, the Czech writer living in exile, has described how he, like everybody else, has at some stage of his life confronted the reality of death. But when he was growing up he never dreamed that his country was anything but immortal. Since 1968, however, and the brutal suppression of the Prague Spring, he, like other Czechs, has had to consider the possibility that his country will vanish forever under the might of Soviet domination. Most black South Africans have been faced, over much the same period, with a variation of the same awful realisation. Not that their country has disappeared; rather *they* have.

Forced Removals

Over and above those black people pushed off the commercial white-owned farms by economic pressures and compelled, by government policy, to settle in the rural reserves, there are hundreds of thousands of others whose removal from the land has been caused solely by the ideological imperatives of the government's grand apartheid plan of segregated cities and ethnic states. Both in rural areas and in the towns, people have been uprooted. Stable communities have been ripped apart for no other reason than that the inhabitants were of the wrong colour – deemed, in an Orwellian euphemism, to be "inappropriately situated." It is estimated that some 3.5 million people have been subject to forced removals in South Africa over the past twenty-five years.*

The striking feature of this resettlement policy has been its cruelty. In 1983, in a village called Mogopa, in the western Transvaal, I saw solidly built churches and schools lying in heaps of rubble. The village had been bulldozed by the government as a prelude to moving the people from land they had been able to buy before the Land Act of 1913 prohibited them, as Africans, from buying land in most of the country. It was lovely land, well watered, and stocked with cattle. The people were to be moved to a place called Pachsdraai in the independent "homeland" of Bophuthatswana. I saw the stone houses that the people had painstakingly built up over the years. I met the village elders gathered anxiously to discuss how best to prevent the great evil that was looming over them – the destruction of their homes and their community. I heard about the water pumps that had been removed and about the buses that were no longer coming. Aninka Claasens of the anti-apartheid organisation, Black Sash, explains what happened next: "What does the state do once [it has] smashed the schools, stopped the transport, cut off the water, threatened force – and people still refuse to move? It waits. There is a limit to how long people can live without schools, without pensions, without migrant labour contracts, and with daily uncertainty about their future. If it is a matter of who can sit it out, the state is the more likely winner" (74:15).

Still the people refused to move. After the first demolitions they regrouped and set about the reconstruction of Mogopa. They rebuilt the school from rubble. Then, in the early hours of 14 February 1984, Mogopa was surrounded by armed government police. At 4:00 a.m., the people were informed through loud hailers that they must load their possessions into trucks and go to Pachsdraai. The residents were not allowed to leave their houses. The government-appointed chief, Jacob More, took the police and the officials to the houses of the leaders first, who were handcuffed and put into police vans. Their families refused to pack their possessions – a task left to government labourers. Women were carried into the lorries and buses. Children were loaded with the furniture and dispatched to Pachsdraai. All of this happened in the presence of scores of armed policemen with dogs at their disposal. People caught standing together outside their houses were beaten with batons. Parents became desperate to find their children and got onto buses to Pachsdraai to go to look for them there. No outsiders were allowed into Mogopa, excepting the police, of course, and the white farmers who had free access in and out to buy the people's livestock at a tenth of its value (74:15).

Equally alarming stories are told by people who have already been moved to one of the government resettlement camps set up in the so-called "homelands." One thousand miles southeast of Mogopa is the resettlement camp of Glenmore on the banks of

* Surplus People Project, *Forced Removals in South Africa*, 5 volumes, Cape Town. SPP, 1983.

the Fish River, which marks the old eastern Cape frontier and the boundary of the Ciskei. Here lives Mr. Mapapu, who was a farm labourer for many years. But in 1979 he was compelled by government officials to demolish his house and to move to the resettlement camp some sixty miles away from where he had been working as a casual labourer on chicory farms in the Alexandria district.

Before the move to Glenmore, the Mapapus' two small daughters, eighteen-month-old Nominiki and five-year-old Ntombiyakhe, had been active, spirited youngsters. Afterwards, Mr. Mapapu began to notice a difference in their appearance and behaviour. "They were not as active as they had been. They had sunken faces, they got pale, and their bodies were thin. Most of the time they were just lying on the ground, in the daytime too. I was worried about them, more than I can tell. I and my wife talked about them. My wife said if I was a man I would leave this place and go to a farm anywhere and find work. My answer was that . . . I couldn't find work there . . . She wasn't angry with me. She was mostly worried about the children.

"We were hungry, I and my wife . . . there is no way you can describe that hunger."

The children became so ill that eventually the baby, Nominiki, was sent from the local clinic to hospital in Grahamstown suffering from malnutrition, gastroenteritis, and primary tuberculosis. There she gained weight and was eventually discharged. Meanwhile the five-year-old, Ntombiyakhe, became ill with hunger. There was no food in the house and still the promised pension payment did not come. Eventually the shopkeeper would extend credit no longer, and the handouts from equally poor neighbours were not sufficient to help them. The child died (76:10-18).

There was no need to dig a grave, as the authorities had already caused a number to be excavated – adults on the east side of the cemetery and the smaller children's graves on the west. Many of them were already occupied. There was also no need to buy a coffin. "When we arrived at Glenmore, a number of people died, and many people had no money. A number of coffins were sent up to Glenmore from Grahamstown and put in the premises of the superintendent. So when a person or child died you just went to the superintendent and took the size of coffin you wanted, free of charge."

Ntombiyakhe was buried at 10:00 a.m. the next day in the Glenmore graveyard, a patch of level ground surrounded by thorn trees that lies beyond the furthest houses of the township. The service was conducted by a lay preacher and was a subdued affair. "There were not many people present," says Mr. Mapapu (76:18).

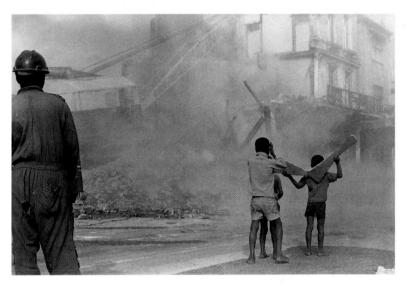

Demolition, District Six *Paul Alberts*

Perhaps the most notorious of all the government removals in the urban areas was the destruction of District Six, home of thirty thousand people classed as "coloured" in the heart of Cape Town. District Six was a diverse society established over a period of two hundred years. Its inhabitants prayed in mosques and churches and synogogues. It housed tailors and fishmongers, musicians and dressmakers, cabinetmakers, schoolteachers, principals, city councillors. On its streets, snoek, sosaties, koeksusters, and roti were sold. There were sounds of fruit vendors, homemade banjocs, muezzin calling the faithful to prayer, the laughter of children. Hindu funerals and Moslem weddings filled the streets at weekends. Although overcrowded, District Six was within walking distance of work. It was a cultural centre. At one time or another it had been home to musicians like Abdullah Ebrahim (Dollar Brand), writers like Richard Rive, political leaders like Cissie Gool. It was above all a vibrant community where, despite the gangs, people were not afraid to walk about at night or leave their children playing outside.

In 1966, the district was proclaimed white. The order setting in motion the process of removal of the citizens there and of the destruction of their homes was signed by the then minister of the Department of Community Development, P. W. Botha, later to become first executive president of South Africa. Virtually every building was broken up by bulldozers. Hundreds of strong brick houses, some of them over a century old, were reduced to rubble. The vibrant world of District Six became an empty wasteland. It was as if there had been war.

The people who were moved from District Six were dispersed into small, cheap, matchbox-like houses throughout the Cape Flats. In Lavender Hill, a bleak new township in Cape Town's "coloured" ghetto, one of the community leaders explained what it meant to be moved by "the Group" (the government authorities responsible for administering the Group Areas Act) from areas such as District Six and Harfield Village where she once lived. "We had houses there; we were happy; we were poor; but there was community. We were picked up from District Six and we were scattered like sand around the Cape Flats. We had nothing. There was no community left; we could not rebuild" (311:25).

By the middle of 1985, the government was coming under increased criticism internally and internationally for its removals policy. Some communities, such as those living in Driefontein in the eastern Transvaal and Huhudi in the northern Cape, which had fought hard and at great cost against removal, were reprieved – at least temporarily. But there are still in South Africa two million people whom the Surplus People Project estimates are under threat of removal, mainly in terms of proposals for "consolidation" of the bantustans.*

Consequences for Communities

Destruction of the fabric that binds communities together is perhaps the worst evil stemming from the twin policies of forced removals and migratory labour. These policies combined by the 1980s to transform Cape Town into possibly the most violent, certainly by 1985 the angriest, city in the world. In the African and "coloured" townships, the rates for murder, rape, robbery, and assault are generally between two and ten times greater than they are for white suburbs. In some cases they are nearly forty times as great (93:10). Between 1956 and 1976 in Cape Town, the proportion of children born to unmarried mothers nearly doubled. Extended families could not reconstitute themselves in the matchbox houses. "Families were either hopelessly overcrowded or smashed" (258:1).

In the African township of Langa, the policy of migratory labour led to a situation where, by 1970, the male:female ratio was no less than eleven to one. This figure was too high even for the ideologues of apartheid. Some steps were taken to reduce it, but even in 1980 the ratio was no less than three men for every woman in the township. Gugulethu, not far from Langa, also housed huge concentrations of men on a single-sex basis in hostels, some of which were built on land that had orig-

* Laurine Platsky and Cherryl Walker, *The Surplus People: Forced Removals in South Africa*, Johannesburg, Ravan Press, 1985.

inally been zoned either for recreational purposes or as open space. Is it then surprising that rape should be five times more of a threat to women living in that township than to those in middle-class suburbs with adequate housing and no single-sex compounds?

The destructive consequences are not confined to the cities. One of the most striking changes to have taken place in the last decade in the rural areas, particularly in the resettlement camps, has been the increase in crime and the resulting insecurity of life. As Buntu Mfenyana found in remote parts of Kwa-Zulu, "Knifings, rape, abductions, drunkenness, and all the other aberrations which we tend to associate with urban townships like Soweto . . . and many others have become part of the daily life in the so-called 'rural areas'" (78:5).

There are other faces of poverty that are found in South Africa as nowhere else. They include a battery of laws and practices that discriminate against people purely on grounds of their racial classification as defined in the Population Registration Act, under which every South African is categorised as a member of a particular "group." Although there has been much publicised easing of some of these discriminatory statutes and practices in recent years, those that remain in 1986 include prohibitions against Africans owning land throughout most of the country, the requirement of African adults to carry passes at all times, compulsory residential segregation, huge differences in state expenditure per pupil in segregated schools, and exclusion from political power. There remains the regular assault on human dignity wrought by such laws and practices that treat millions of people as less than human. And that, as the president of Carnegie Corporation reminded us, is a fundamental component of impoverishment.

It is time to end this essay and turn to the photographs. George Orwell is right. "Words are such feeble things. What is the use of a brief phrase like . . . 'four beds for eight people'? It is the kind of thing your eye slides over, registering nothing. And yet, what a wealth of misery it can cover"(quoted in 35:1).

On the other hand, it is easy to dwell on the misery of poverty— to wring one's hands at the ruthless attacks on those struggling against it and to wallow at a safe distance in the horror of it all. But this book must not leave readers overwhelmed with feelings of hopelessness or defeat. Strategies that those enduring poverty adopt in order to survive are also acts of resistance, as one can see from the faces of the people in these photographs.

Francis Wilson

THE PHOTOGRAPHS

with text by Francis Wilson

"My children are not living . . . In order for us to live we should eat. But now I am not working — it is just like these hands of mine have been cut off and I am useless. Now life for my children will be difficult. They will scarcely eat. Now that I am not working I do not know what I shall do or what I shall take and put against what" (124:20).

The unemployed young man quoted here is situated at one of the most vulnerable locations within the southern African economy: on its periphery yet unable to escape dependence on it. He embodies most of the paradoxes of this area's conditions. He is one of increasing numbers of Basotho men and women who are unable to find work in their own country, Lesotho. Before the First World War, Lesotho grew enough grain to feed itself and to export as well. Since then, this tiny country has become more and more dependent on her big neighbour, while the tens of thousands of Basotho migrant labourers have helped generate South Africa's wealth by their work on the South African mines and farms. Most of the men go to South Africa as temporary migrants, generally for six months or a year, before returning home for a spell and then going again. They have been prohibited by South African law from migrating permanently and settling in the cities with their families. Thus, since the discovery of gold and the industrial development of South Africa over the past century, Lesotho and her people have become producers of gold rather than of grain or anything else within her political boundaries.

But in the 1980s, the people of Lesotho find themselves not only poor but extremely vulnerable. For years it has been possible for any physically fit young man to sign up at a local recruiting station for a job in the South African mines. Others have been able to walk across the border to look for work in the wider economy. But recently, getting a job on the white farms has become much more difficult. In the mining industry, the proportion of black workers drawn from outside South Africa has fallen dramatically, from 79 percent in 1973 to 43 percent in 1982. While the number of Basotho mineworkers had not yet declined by 1982, there were nevertheless more people in Lesotho each year wanting jobs than jobs were available at the recruiting offices. Moreover, the South African authorities were imposing far more stringent controls at the border posts, making it impossible for unemployed people to come across and look for jobs.

Lesotho is trapped. No longer is there easy access for the Basotho to the wider southern African economy that they helped to create. Those needing work must either find it within the country or wait helplessly at the recruiting offices for a possible contract to South Africa. For women the position is even worse. South Africa will not employ them. Survival depends largely on remittances from those who have been lucky enough to get jobs as migrants. Unemployment means destitution and despair.

Lesotho: Road to the Mines

Photographs by Joseph Alphers

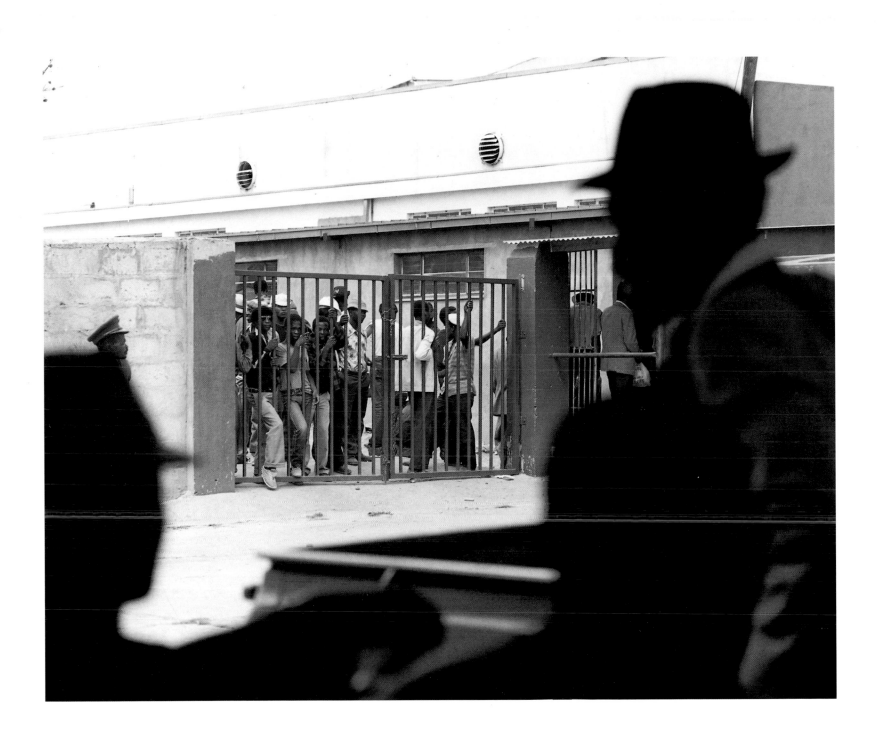

Unsuccessful applicants for contracts to the mines, Employment Bureau of Africa, Maseru 1983 **21**

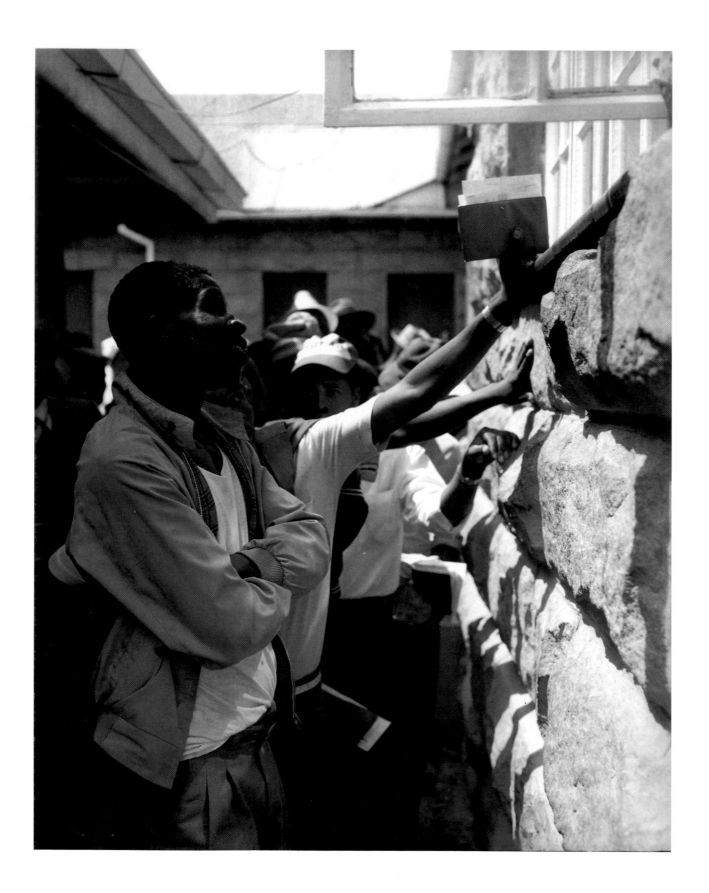

22 Applying for work, Employment Bureau of Africa, Maseru 1983

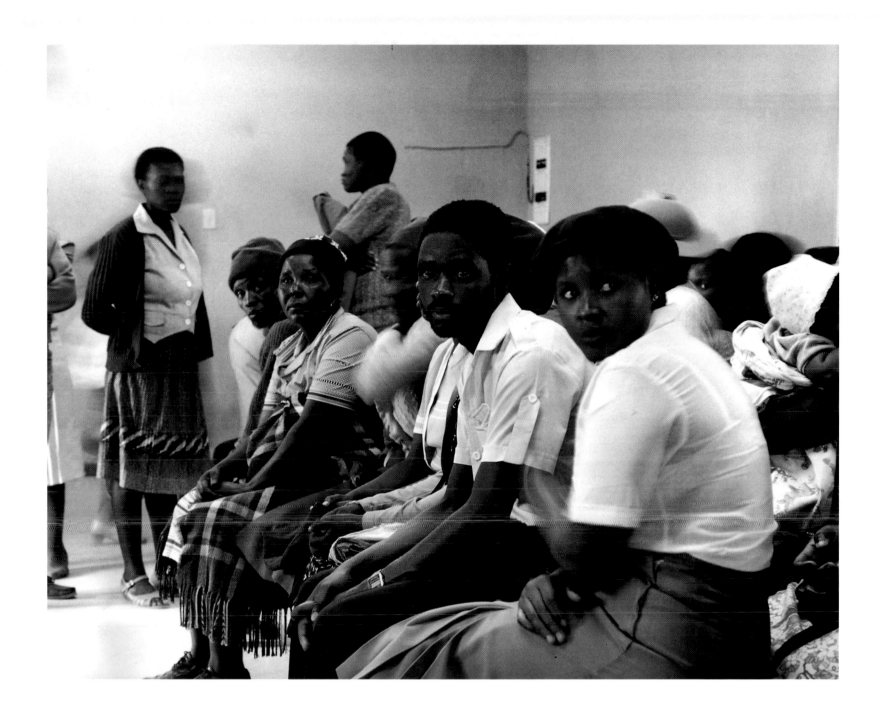

Families collecting remittance payments, Employment Bureau of Africa, Maseru 1983 **23**

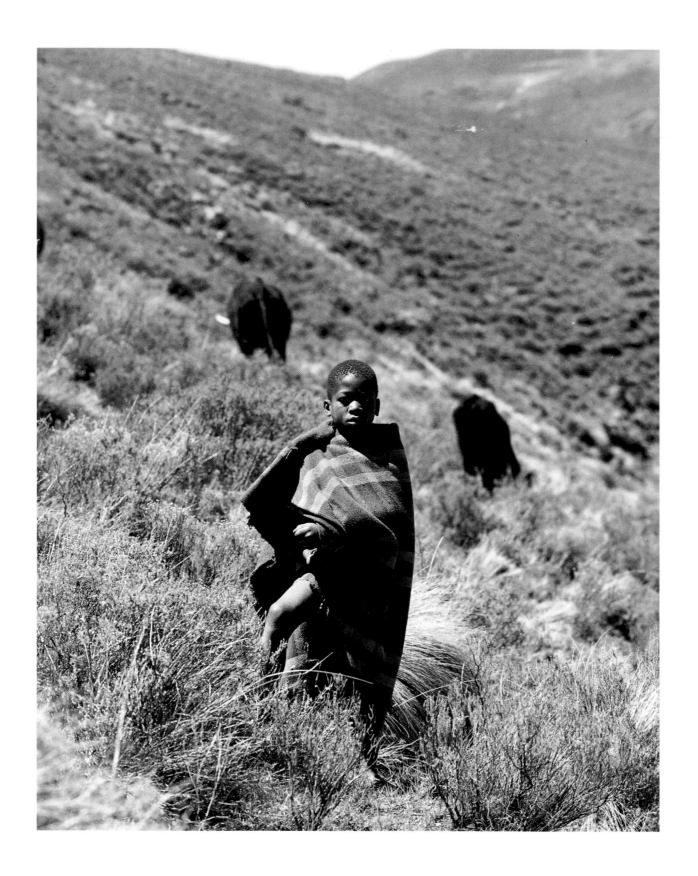

24 Herd boy, Lesotho highlands 1982

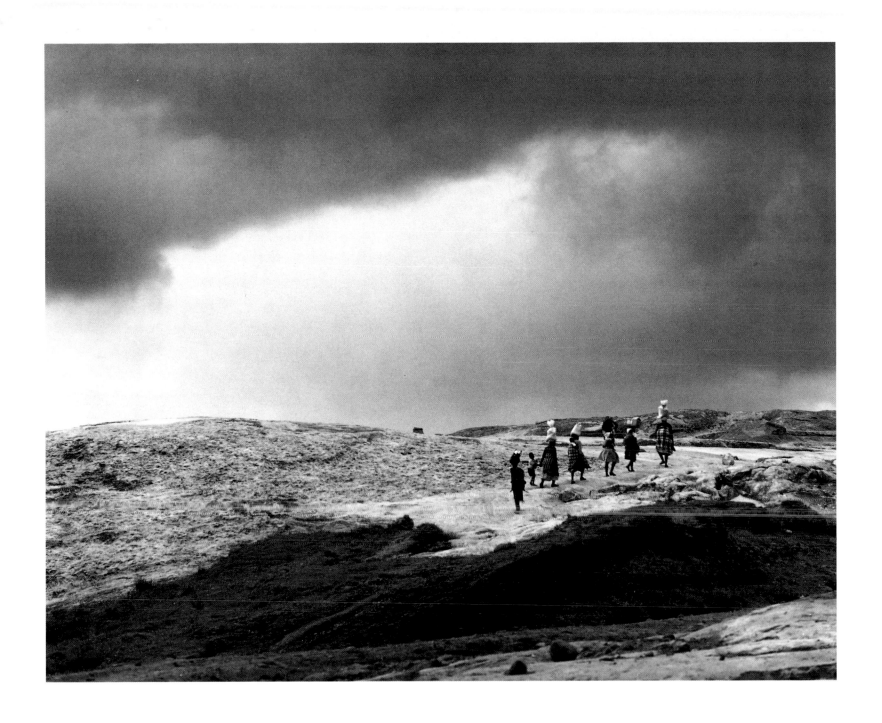

Women returning from a day's journey to the trading store, Lesotho highlands 1982 **25**

Cattle are very important to the people in the rural areas of South Africa. But many families have no cattle at all, and few have an adequate herd for ploughing and milking. For example, in Venda, one of five ethnic "national states" created out of the reserves of the Transvaal, a study found that only one-third of the families in one remote rural district had any cattle at all (63:15).

Petrus Malandzi and his family, who live in Venda, are more fortunate than most people in this new independent "homeland." He has been able to accumulate cattle over the years and, because he is related to the local chief, he has been able to keep them. He remains comparatively well-off after working in Johannesburg for twenty years.

But not everybody is so fortunate. Many people have become poorer as a result of government policies that have compelled large numbers of people to move and be separated ethnically to create these ministates. Mr. Hlengani Mkhabele, a migrant worker from the northern Transvaal, explains:

"In 1936 I was in Johannesburg when things started to happen. The whites started talking about what they called a 'trust land' which was said to be for the black people . . . The 'plantation' near Borota was full of whites – poor whites. They said we were being moved to give way to these poor whites. We were moved in ox wagons . . . By then I had some goats and cattle. When we arrived at our destination, we were all housed on one farmer's property to enable people to start building their homes. Then people's cattle started to die. The cattle died because of a change of drinking water and grazing lands . . . Goats too died. In 1939, the first person died. Following that many people died after drinking water from waterlogged fields. . . . The epidemic lasted a whole year and even an ox could not stand up once it had fallen." Mr. Mkhabele managed to build up his herd again so that by 1947, "I had about sixty-three goats and eighty-nine head of cattle." But the authorities compelled him to cull his stock, and then, in the 1960s, he was forced to move again to a place where the cattle that remained "started to die one after another. I had to sell them fearing that they also would die from the drought in the area. Even then, they were bought very cheaply. Through this and that, I lost all my livestock" (1:14).

The granting of "independence" to Venda in 1979 exacerbated the plight of people in the Transvaal. The South African state began to push all the people not needed on white farms or cities into the new "country." In one mountain community, the number of households nearly trebled over eight years from 1975 to 1983, and the proportion of families with access to land fell from 100 percent to 33 percent (64:14).

Life in the rural areas no longer guaranteed cattle or land or any of the agricultural resources normally associated with life far from urban jobs. Mr. Malandzi, shown here with his cattle, is an exception. It is the landless and cattleless poor who are the rule.

Venda

**Photographs by
Chris Ledechowski**

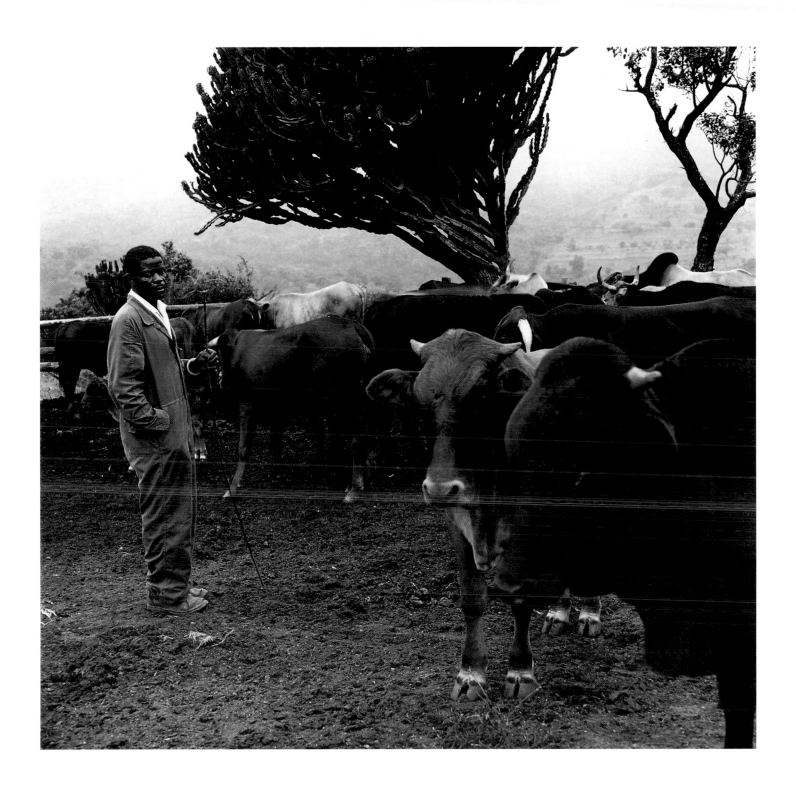

Petrus Malandzi 1982 **27**

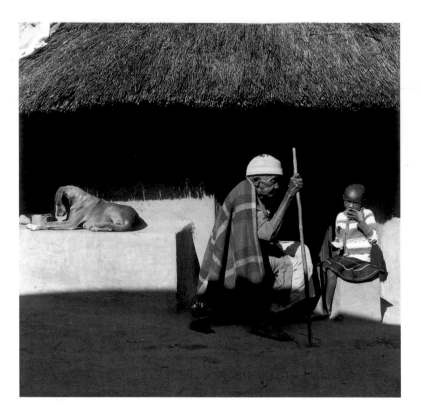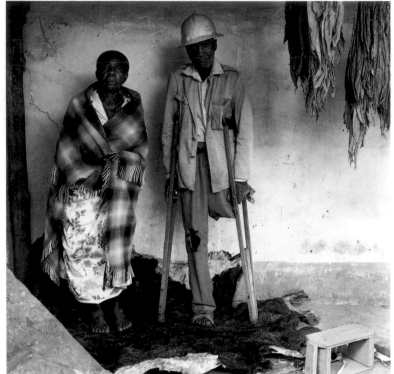

28 *Left,* Eliza and her blind grandmother 1982
 Right, Eliza's uncle and aunt 1982

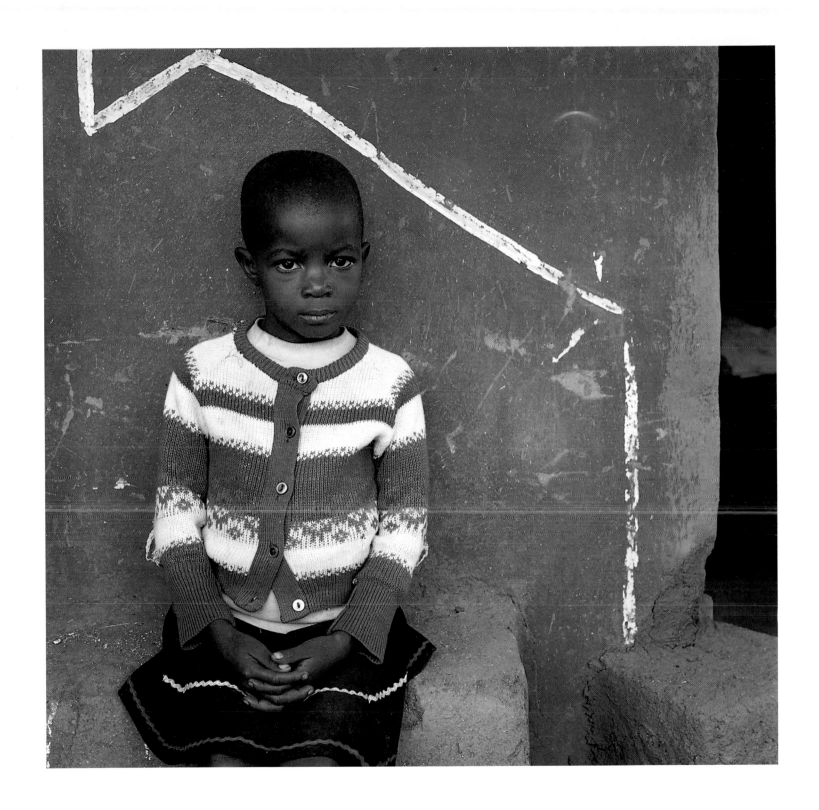

Eliza Malandzi 1982 **29**

Bophuthatswana is best known to the outside world as the home of South Africa's first casino. Here the laws against gambling and against sex between black and white were suspended in the heady days of the gold boom in the second half of the 1970s. Bophuthatswana, which became an independent state in 1977, consists in reality of several fragments of land scattered across the Cape Province, the Orange Free State, and the Transvaal. Despite a flood of wealthy tourists to the casino from Johannesburg and elsewhere, Bophuthatswana, like other reserves, remains an archipelago of poverty for the people who live there. Few can earn their living from the land. In order to get a job, many families move to the parts of Bophuthatswana like Winterveld, just close enough to urban areas for breadwinners to be able to travel daily to work. Other breadwinners go to town as migrants, spending much of their lives in single-sex accommodation. Those who are left behind in remote rural areas face daily the struggle to find water, fuel, and jobs (77:26).

Life is precarious. Kwashiorkor is no longer a notifiable disease, but thousands of children still die from malnutrition and its related diseases. In many though not all of South Africa's cities, the infant mortality rate has improved dramatically over the past twenty years. But in the rural areas, the hospitals all have malnutrition wards full of emaciated children waiting to be fed and treated. But improvement is possible. By training local health workers, one important project in a remote Bophuthatswana hospital cut the infant mortality rate per thousand live births from around one hundred to under twenty over a two-year period at the beginning of the1980s (268:18).

Bophuthatswana: The Casino State

**Photographs by
Paul Alberts**

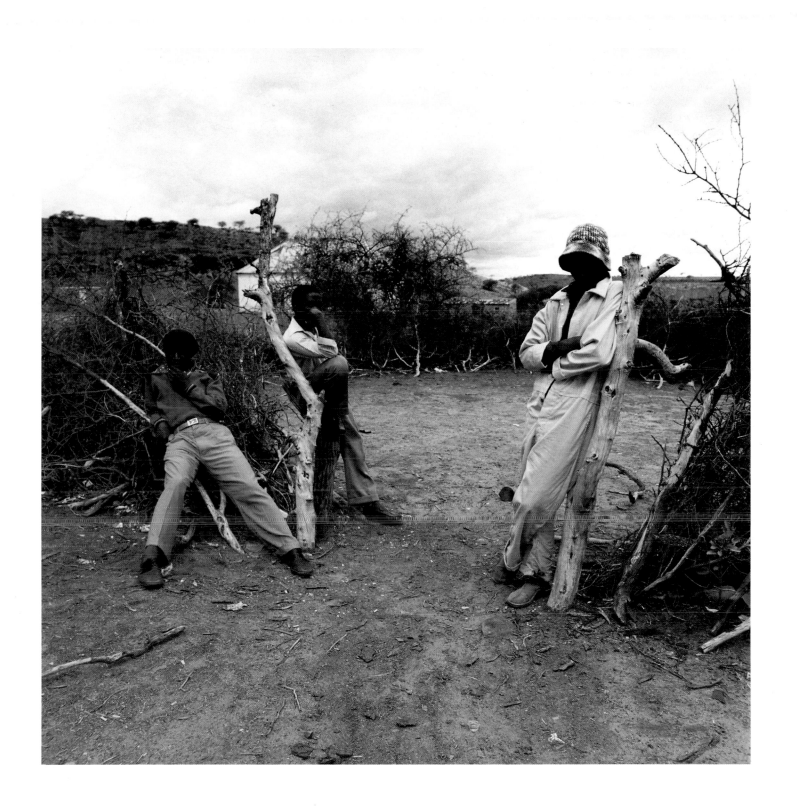

Unemployed men, Taung District 1982 **31**

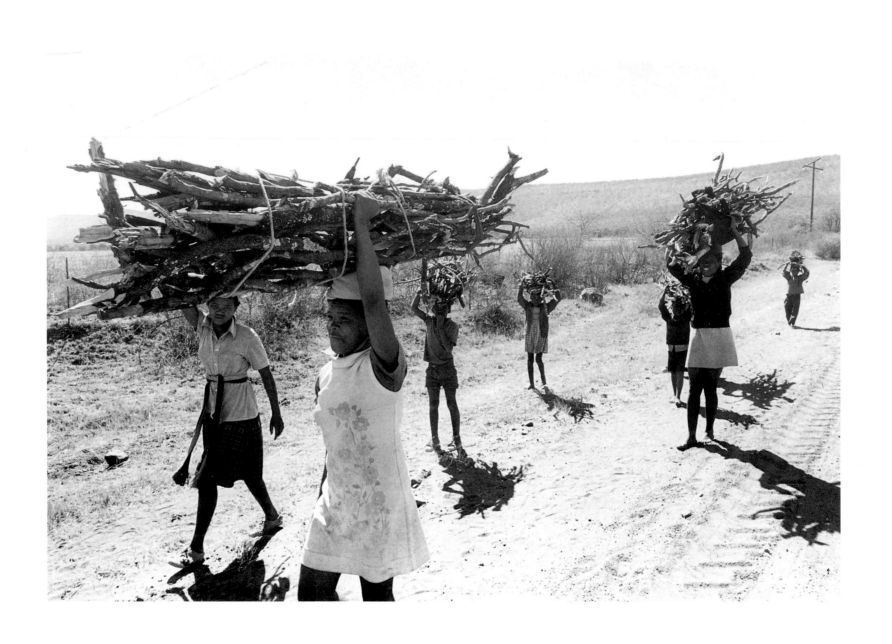

32 Gopane District 1980

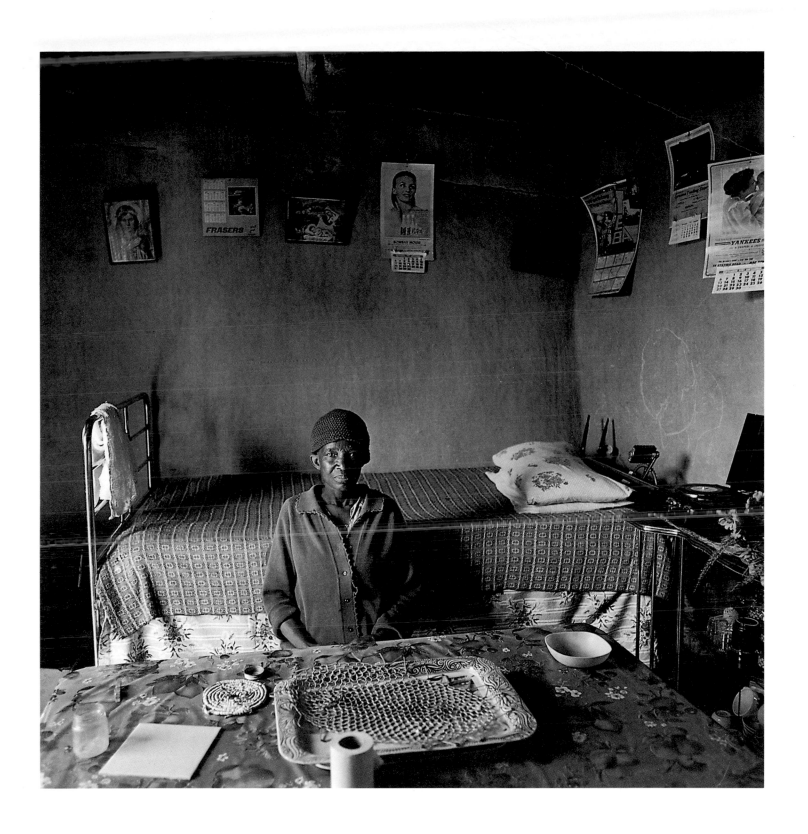

Woman in her single room mud house, Die Stadt District 1984 **33**

KwaNdebele was created as a new reserve in the 1970s as a place for Africans squeezed off commercial farms and other places. Its function was to help stop the normal process of urbanisation to the industrial core of the Witwatersrand and Pretoria. In 1970 the population in the area was approximately thirty-two thousand. By 1984 the number in KwaNdebele had risen to anything between three hundred thousand and half a million people.

According to the director-general of the South African government department responsible the people moved to KwaNdebele because they wanted to. "One day the prime minister asked me: 'What motivates these people to trek here like this?' My answer to him was: 'What motivated the Israelis to go to Israel after the Balfour Declaration?' Idealism gripped them and see what happened to Israel. It is the same thing in KwaNdebele. It is all about the magnetism, the pulling power of a spiritual fatherland. They are streaming in and we just can't keep up with services there. They prefer to live there, in their own community. And what is the result? Buses. That is what it is all about" (83:37).

The director-general's analysis of the causes of the movement of people to KwaNdebele is a supreme example of the self-deception that power can breed; but his assessment of the consequences is entirely accurate. As there are almost no employment opportunities in KwaNdebele, wage earners must move out of the reserve for work.

"In 1979 Putco [a private bus company] started to run two buses a day from Pretoria to the resettlement camps of KwaNdebele. By 1980 there were sixty-six a day, which jumped to one hundred and five in 1981; to one hundred and forty-eight a day in 1982; then two hundred and twenty a day in 1983 and two hundred and sixty-three a day in 1984 . . . " *

By this time the government paid the bus company a subsidy equivalent to more than one thousand dollars a year for each pendelaar or "commuter." "A negative social investment," as Joseph Lelyveld puts it, "that went up in gas fumes when it might just as easily have gone into new housing for the same black workers nearer the industrial centers if that had not violated the apartheid design. . . . The KwaNdebele bus subsidy – the government's largest single expense in the development of this homeland – was higher than the KwaNdebele gross domestic product." *

The shortest bus ride from KwaNdebele to Pretoria takes about one hour and forty-five minutes. The longest journey lasts about three hours. From the terminus at Marabastad, many workers take onward transport (train, bus, or taxi) to get to work. Thus some of those living furthest from Pretoria catch a bus at 2:30 a.m., arrive in Marabastad at 5:30 a.m., and then travel a further hour or more to reach work at 7:00 a.m. The process is reversed in the evening, and they arrive home at between 9:00 and 10:30 p.m. Many of the bus riders of KwaNdebele spend five or six hours a day and some as many as eight hours a day travelling and waiting in queues.

* Joseph Lelyveld, *Move Your Shadow,* Times Books, New York, 1985.

The Night Riders of KwaNdebele

**Photographs by
David Goldblatt**

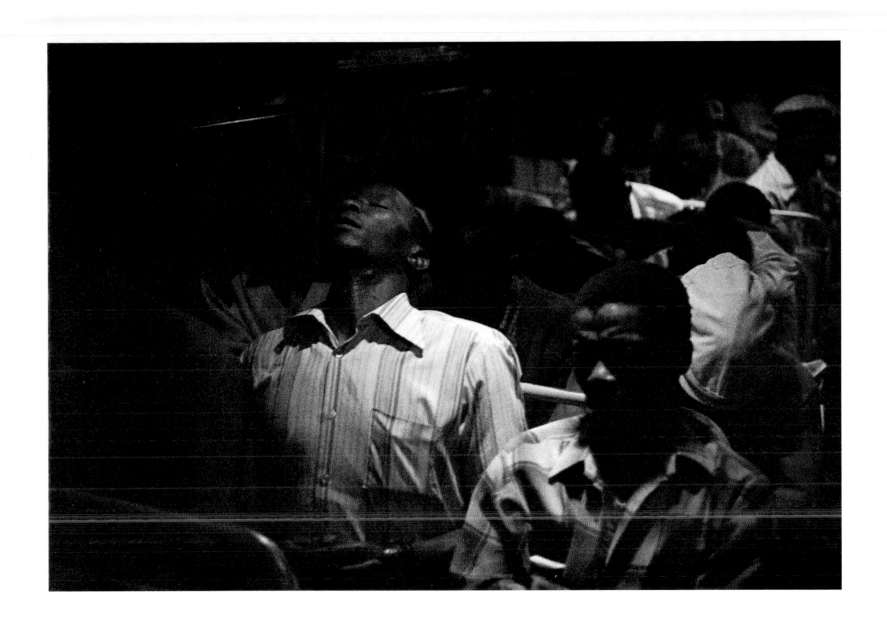

2:30 a.m., bus driver collects tickets from first passengers of the day

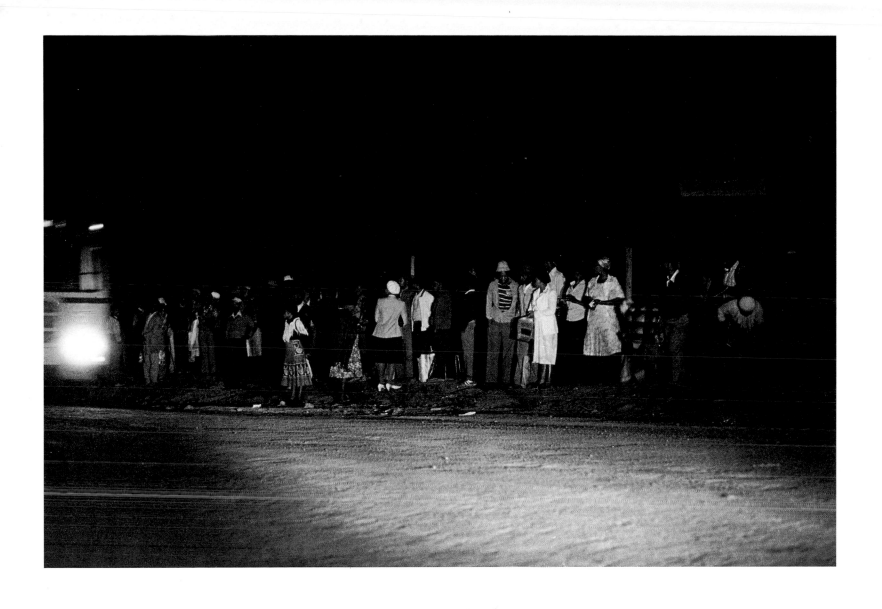

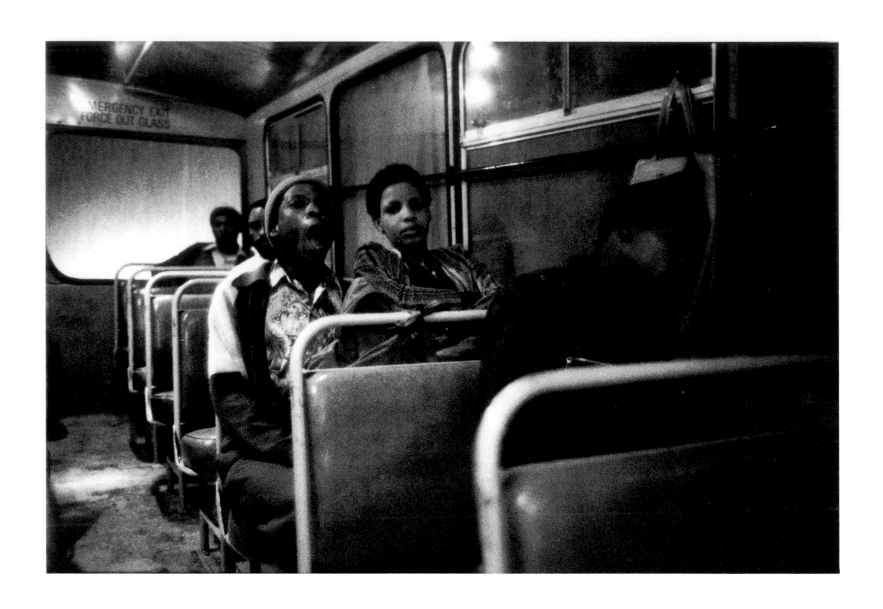

2:30 a.m., three hours still to go, Wolwekraal – Marabastad bus

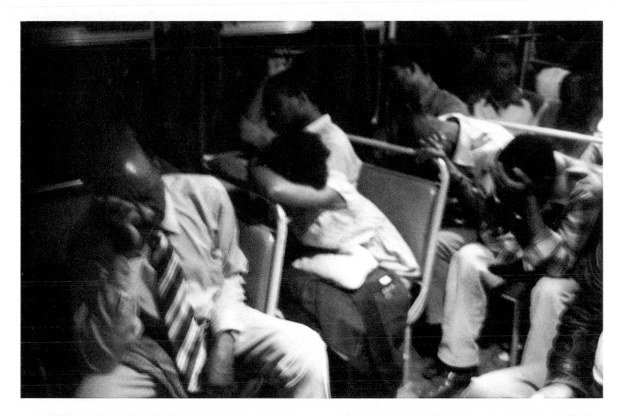

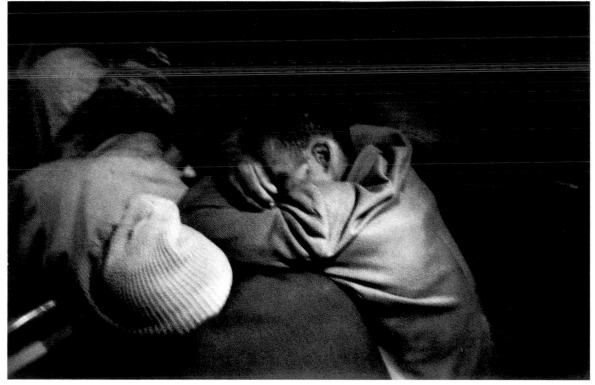

Above, 4 a.m. on the Wolwekraal–Marabastad bus. **39**
Below, Forty-five minutes from terminus.

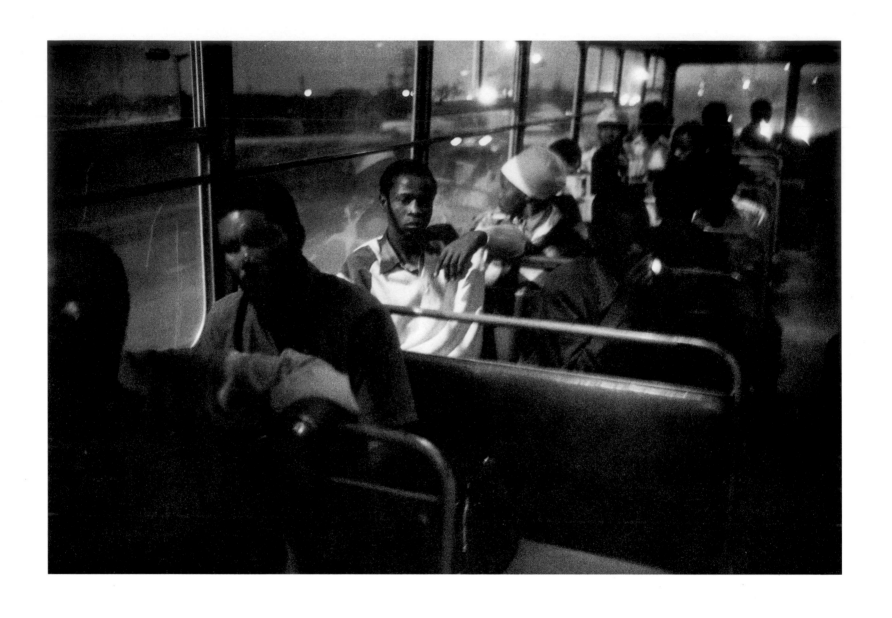

7:15 p.m., pulling out of Pretoria on 7 p.m. Marabastad – Waterval Bus

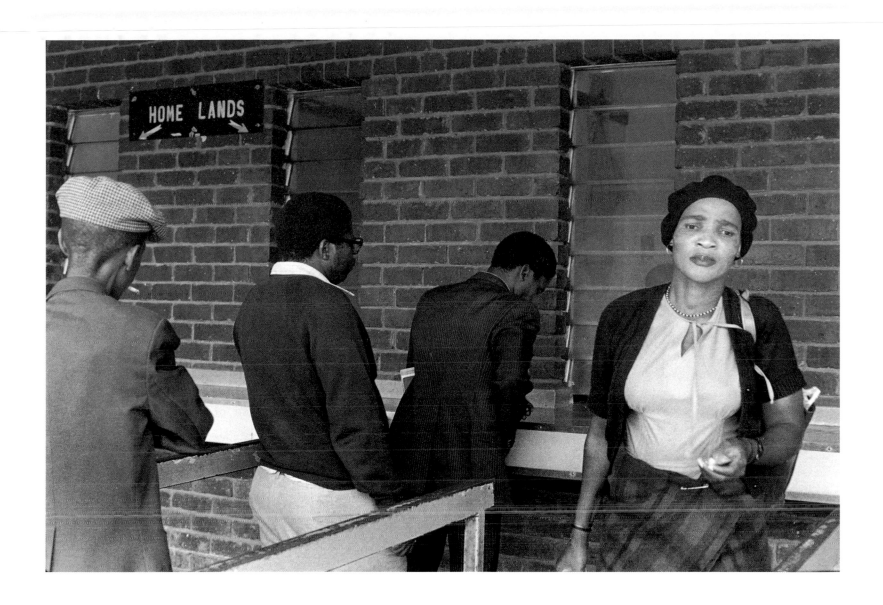

Buying weekly tickets for KwaNdebele – Pretoria bus routes **41**

Consider the words of a black "migrant" worker, living illegally with his family in the Crossroads squatter settlement near Cape Town in 1979. He is talking about his firm, a prominent construction company that decided to build a first-class hostel for its workers:

"This firm is building for single men—'boys,' one should say—knowing full well that it has in its employ both single and married workers. Why has it not occurred to them to build for married men? For its married workers it has milked from the dried-out teat of the cow's udder. Therefore I am not impressed with the mental skill of this firm. Married people are important because they are the pillar of the nation and produce the citizens of the future. It is this family life that the honourable construction company holds in contempt. That is why I am critical of its approach. Because it neglects the very core of nation building."*

It is estimated that two out of every five African men working in the cities of South Africa have to live separated from their families. In the cities and at the mines, most migrants are housed in what can only be described as huge single-sex "labour-batteries," some of which accommodate over ten thousand men.

At the gold mines, which employ over half a million men, more than 97 percent of black workers are prevented by law from living with their families. In other urban sectors of the economy, the pass laws combined with housing policy have prevented large numbers of workers from bringing their wives and children to join them.

The system continues to expand. In mid-1985 the government announced funds for the building of further massive "hostels." According to the cabinet minister responsible, "Although single-sex accommodation is not an ideal type of housing, it is not intended to phase out the system while there is a demand."**

But those who must endure the system do not wish to live like this. At a meeting of migrant workers, held in the same month that the government was announcing plans for further expansion, an organisation was launched to fight for the rights of workers to have their wives and families living with them.***

As one researcher for the Carnegie Inquiry pointed out in her study, "Men without children," "These men are denied the opportunity to share in the shaping of the man or woman their child will be. How often a man said to me, 'I go home and I watch my children and I think, by their behaviour, they are not mine'" (5:28).

* This interview was recorded by Wallace Mgoqi for the documentary film, *Crossroads*, produced by Lindy Wilson, Cape Town and London, 1978.
** *Cape Times*, 26 June 1985. *** *Cape Times*, 1 June 1985.

Compounds

**Photographs by
Paul Konings and Ben Maclennan**

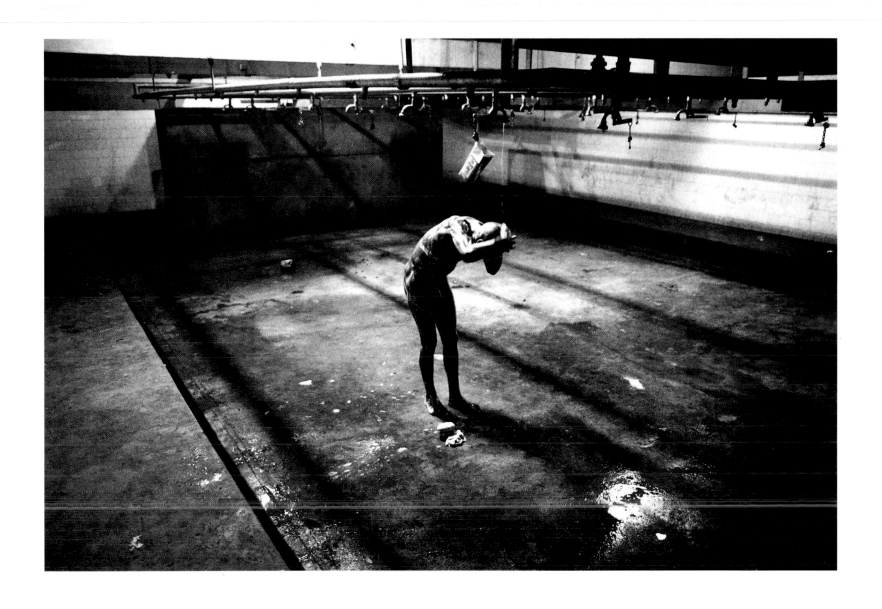

Compound, Johannesburg 1980 *Ben Maclennan* 43

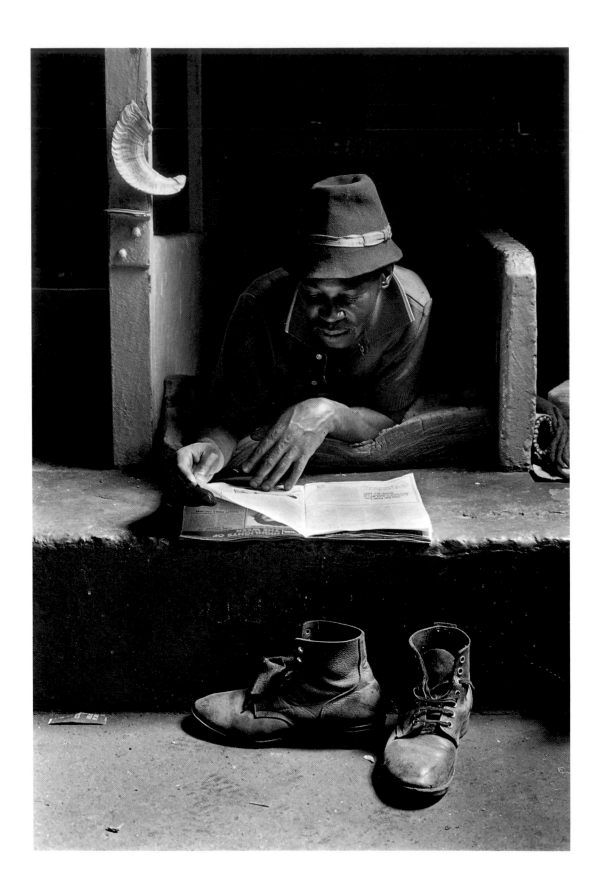

In concrete bunk, compounds, Johannesburg 1980 *Ben Maclennan*

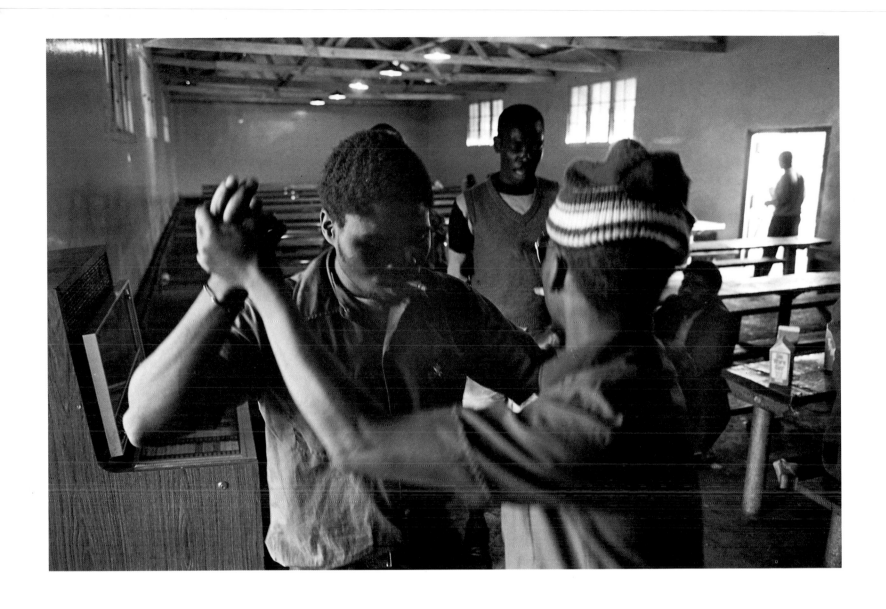

Compound, Johannesburg 1980 *Ben Maclennan* **45**

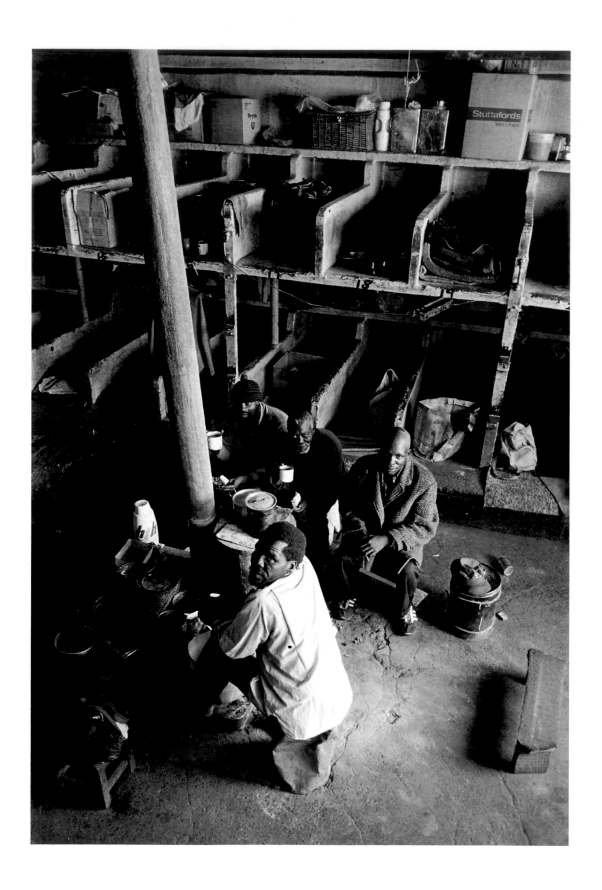

46 Communal stove and concrete beds, compound, Johannesburg
1980 *Ben Maclennan*

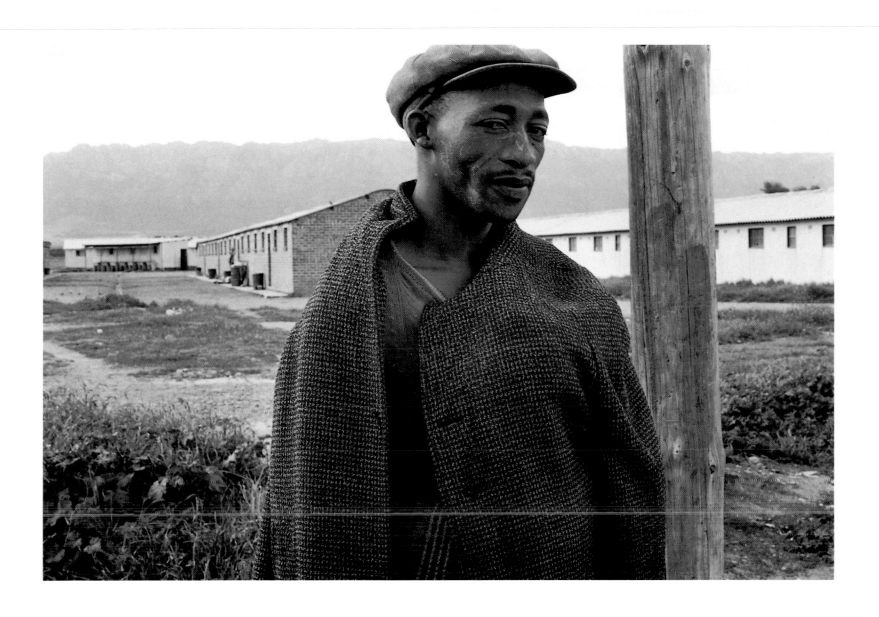

Migrant labour camp, Gordon's Bay 1980 *Paul Konings* **47**

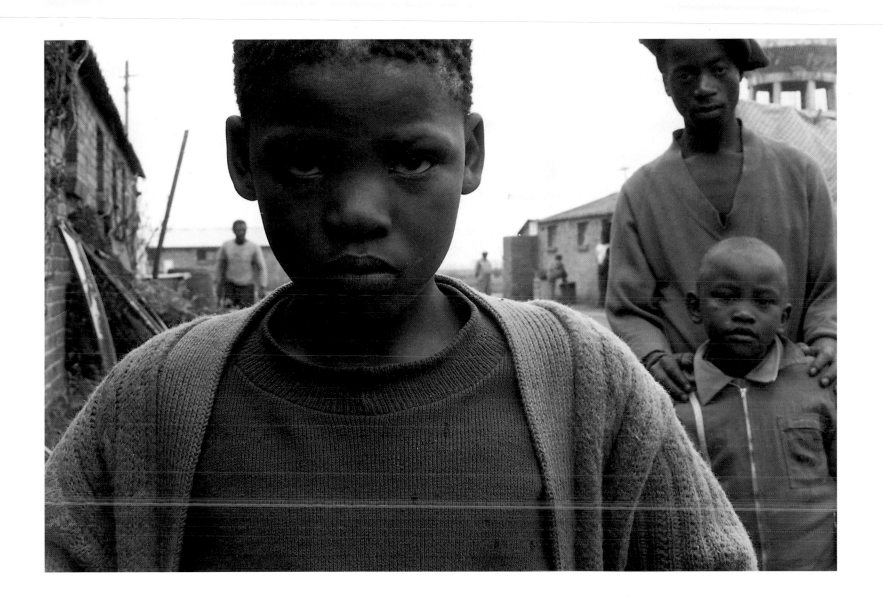

Migrant labour camp, Langa, Cape Town 1980 *Paul Konings* **49**

Even without Johannesburg, Soweto is one of the largest cities in Africa, a cultural centre, a place of reference for the entire continent. Perhaps the most famous image coming out of Soweto is the photograph of the body of the young Hector Petersen carried by a distraught fellow pupil. Petersen was the first child to be shot dead by police in June 1976, when the state cracked down on peaceful demonstrations by black schoolchildren against an oppressive educational system.

What kind of place is Soweto? Through the eyes of a doctor, Soweto is, in appearance, "very similar to many South African black townships, the main difference being that it is bigger. The rows and rows of 'matchbox' houses are drab and uniform, but not squalid. . . . Most sidestreets are unpaved and contain some litter, but main roads are tarred and the ground around most houses is swept and tidy. A program of electrification is in progress but most occupants still use coal stoves for both cooking and heating, with the result that the township is often covered by a pall of smoke, which in winter turns to thick smog. Each house is provided with clean piped water from the Rand Water Board, and each house has a toilet connected to a water-borne sewerage system which feeds into one of the main Johannesburg sewerage disposal works. Blocked toilets, burst water-pipes, and cuts in the supply of water are common and very annoying, but from the public health point of view the water supply and sewerage systems are reasonable, and they are being upgraded. However . . . one of the major problems that does militate against health in Soweto is overcrowding" (170:2).

Almost all (97 percent) of the houses consist of four rooms or less (not counting bathrooms or lavatories). Yet the average number of people living in each house is estimated at almost twenty. Stories of thirty or more people living in a single house are not uncommon.

During the 1960s and 1970s the authorities not only prohibited virtually all private building but deliberately slowed down the rate of construction by the state as part of their policy to discourage further black urbanisation. At a conservative estimate, the number of houses built by the state during the 1970s was insufficient to house more than one-sixth of the natural population growth of Soweto, not even taking into account the housing needs of those moving into the city from rural areas.

Hence, as we have seen (p.13 and 14), there are increasing numbers of people, many of them born in Soweto, for whom there is no space at all. Some live in the large numbers of outside rooms that have been built illegally in the township during the 1980s. Others, though legally permitted to be in the township in that they have either been born there or worked uninterruptedly for one employer for ten years (or for several employers for a total of fifteen years), are driven by desperation to forfeit their urban rights by moving to such places as KwaNdebele to live (see p.16) as long-distance "commuters"; the night riders of the South African economy. Others become squatters in places nearby, like Macdonald's Farm.

Soweto

**Photographs by
Lesley Lawson**

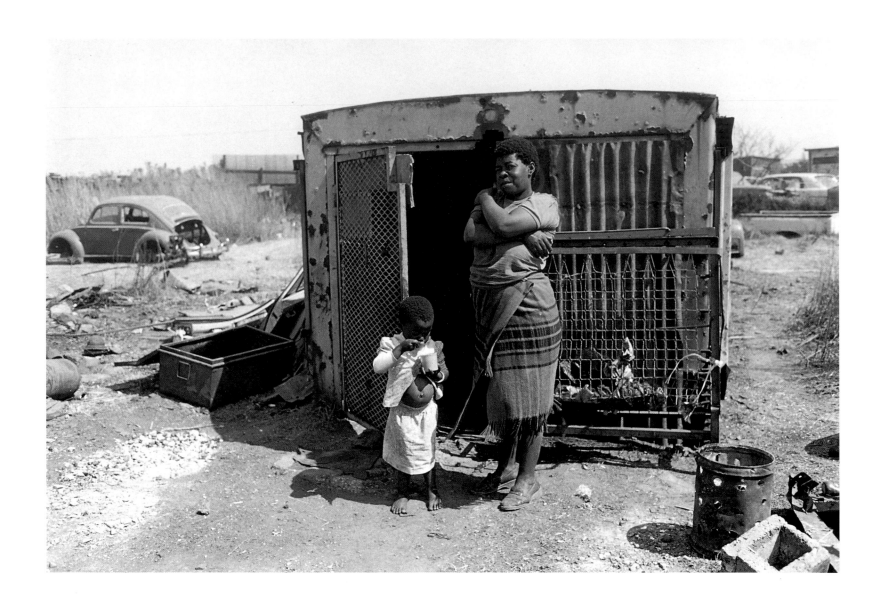

Macdonald's Farm, abandoned car lot, home of squatters, Soweto 1982

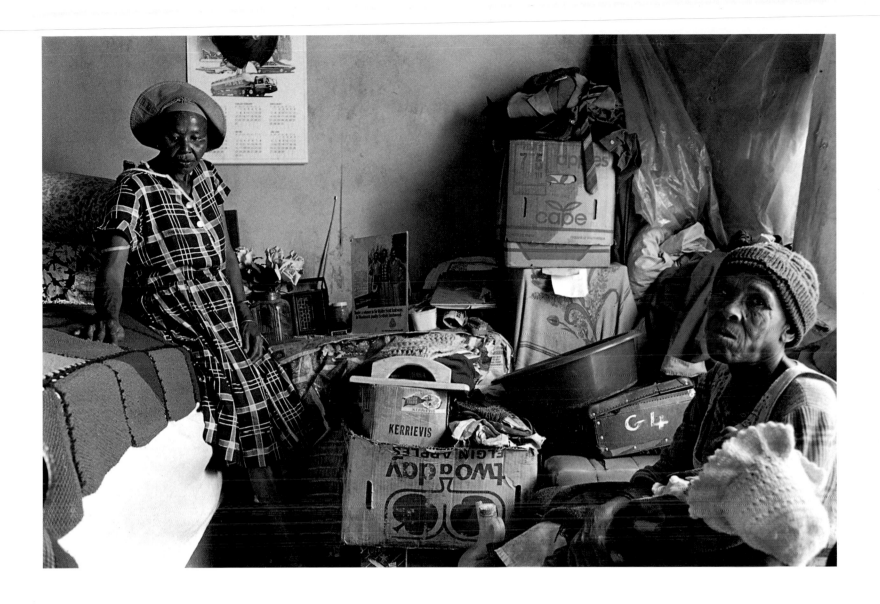

Alexandra township in Johannesburg has a long and turbulent history. "Alex" was one of the few urban areas in South Africa where Africans were able to own land. It was one of the last areas on the Witwatersrand to which Influx Control was applied (November 1956). People who could not go elsewhere thus poured into Alexandra, which by the mid-1950s had a population density four times as large as that of the overpopulated, state-created African township of Orlando. "Alex" was made up of long-established, solid family housing and closely adjacent slum conditions with all their squalor and violence. Thuggery, by such gangs as the Spoilers and Msomis, was probably worse in Alexandra than elsewhere. At the same time, community solidarity was probably stronger, as whites of Johannesburg began to realise in 1957 when the people of Alexandra staged one of the most celebrated bus boycotts of the fifties.

In terms of the government's group areas policy, Alexandra, like Sophiatown, was found to be altogether too close to the white suburbs of northern Johannesburg. And so, over the next five years, twenty-four thousand people were moved out of "Alex" to other townships on the Witwatersrand. The plan first aimed to reduce the population of "Alex" to forty-five thousand, of whom thirty thousand were to stay in family housing, while the remaining fifteen thousand, mainly women, were to be housed in hostels. In 1963, the government announced plans to abolish the freehold rights, going back two generations or more, of two thousand property owners as a prelude to moving all families to other townships and converting Alexandra into single quarters for twenty thousand men and women housed in eight hostels. But over the next decade, despite massive resettlement of families to other parts of the Witwatersrand, the population of Alexandra continued to grow until, by the end of 1971, there were estimated to be between eighty thousand and one hundred thousand people living there.*

At this stage, the government revised its plans and decided to build not eight but fifteen massive single-sex hostels to house a total of sixty thousand men and women. The first two, for 2,642 men and 2,834 women respectively, were opened in 1972. Seven years later, however, plans were changed again when the government announced that Alexandra would be redesigned for family housing. By the mid-1980s, however, little development had taken place and the bitter fruit of years of misgovernment was visible for all to see. Next door to the richest part of the wealthiest city in Africa lay the square mile of Alexandra, overcrowded, shabby, run-down, lacking basic infrastructure. "Drainage is virtually nonexistent and the roads are in an appalling condition after rainy periods. . . . Garbage removal appears to be inefficient with roads often littered for prolonged periods" (19:7). And there is also "a major sanitation problem. The bucket system is used and is totally inadequate, resulting in sewerage flowing in the streets" (2:9). But the people of Alexandra had won. Despite all efforts over several decades, the state had failed to obliterate "Alex" or to reduce it to the dehumanised labour camp dreamed up by the apartheid planners.

* Francis Wilson, *Migrant Labour in South Africa*, Johannesburg, S.A. Council of Churches/SPROCAS, 1972.

"Alex"

**Photographs by
Wendy Schwegmann**

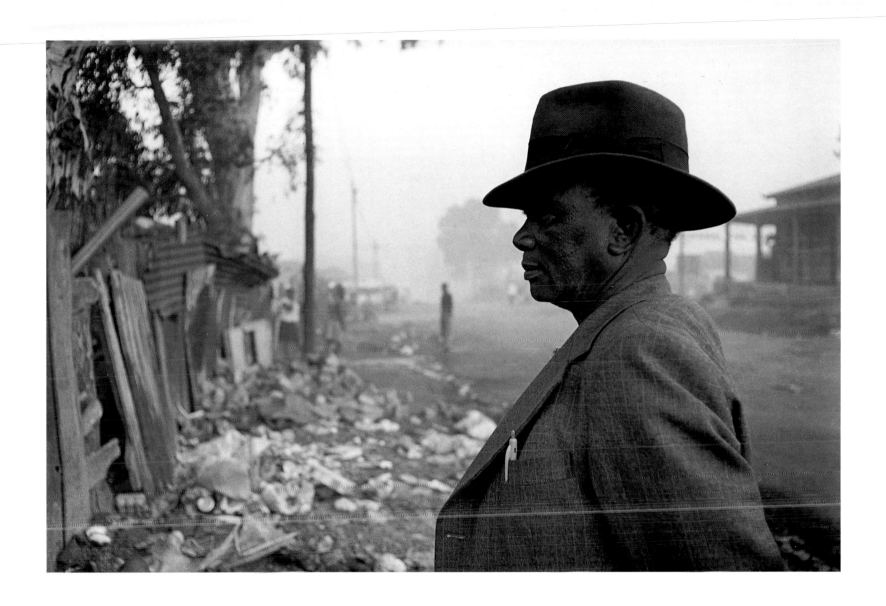

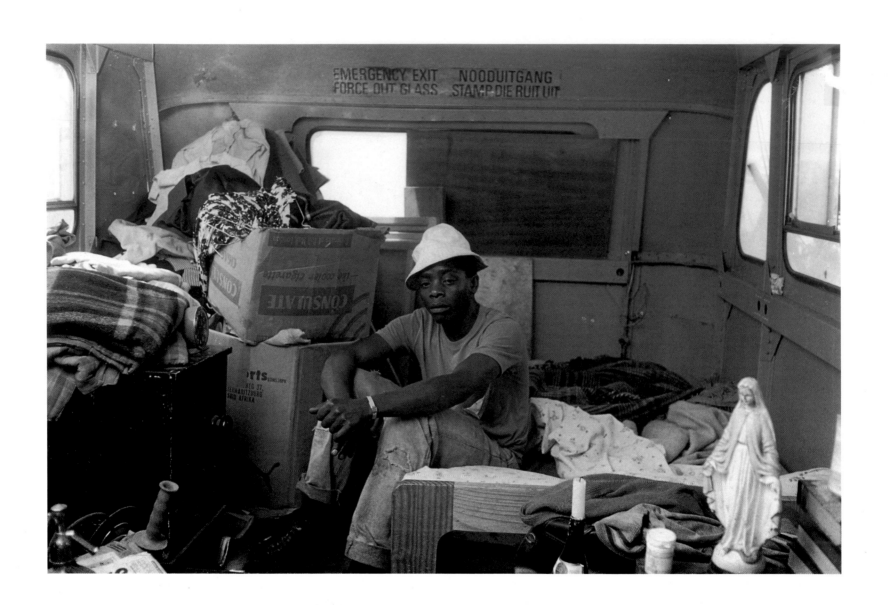

56 Man living in bus, Alexandra Township 1983

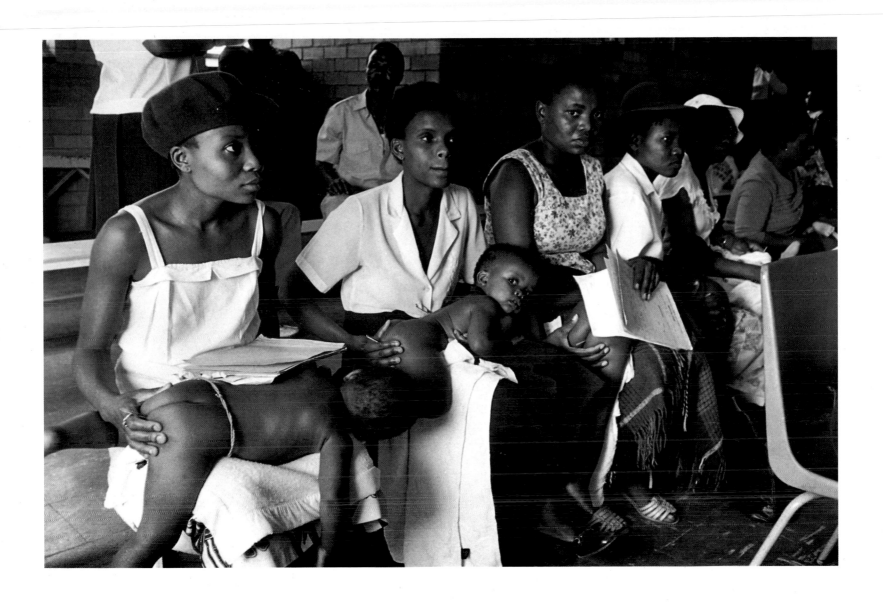

Alexandra Township Clinic 1983 57

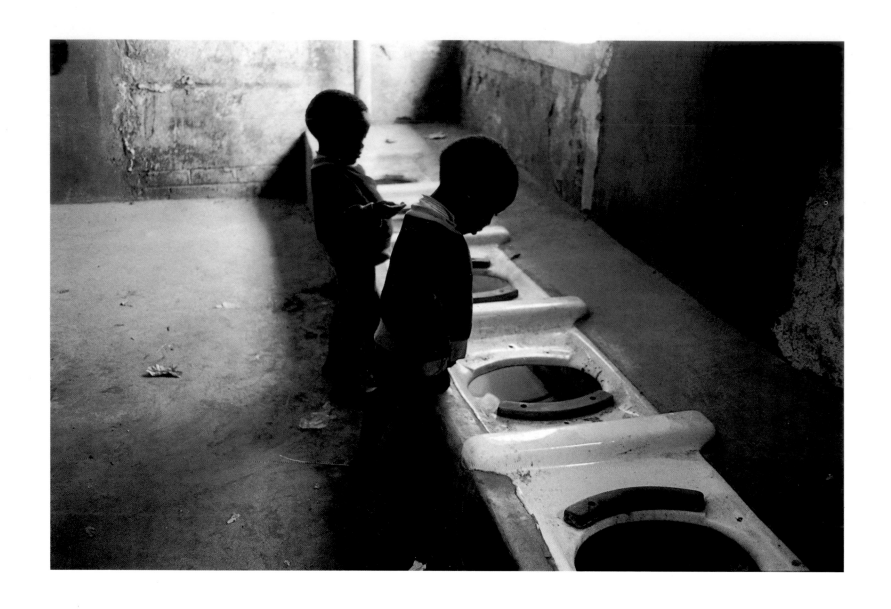

58 Former T.B. Clinic now being used to house displaced people,
 Alexandra Township 1983

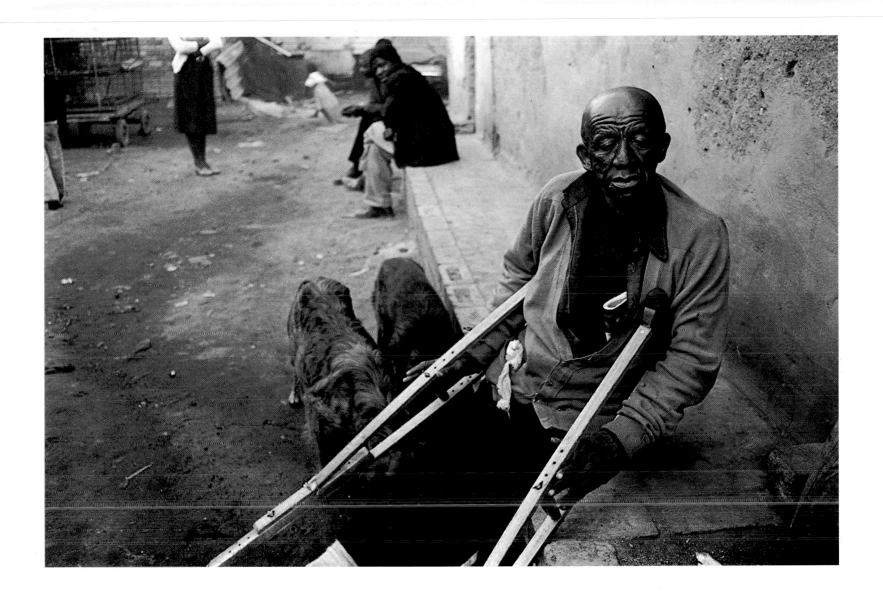

Cisco, former member of the notorious "Russians" gang active in **59**
1950s, Alexandra Township 1983

For most pensioners, whether white or black, life in Johannesburg is tough. State pensions in 1985 for whites were R180 per month. African pensioners get a monthly income of R79 paid in a lump sum of R158 every second month. With these pensions, whites can barely subsist; blacks are living below the poverty line (141:6). Yet blacks in the city are probably more fortunate than those who are aged and live in the rural areas. The urban pensioners are reasonably certain, even if it means queuing all night, of getting their money. In the rural areas this is not so. In KwaZulu, for example, it is estimated that there are perhaps one hundred thousand people of pensionable age who are not receiving the pensions that are due them (143:2), because the South African government does not provide sufficient funds to the KwaZulu authorities who pay out the money.

When pensions do come through, they are critically important. In one detailed study of Nkandla in KwaZulu, it was found that pensioners constituted only 5 percent of the community but contributed 25 percent of the cash income (53a:20). This was found to be true in many other parts of the country, both in the reserves and on the platteland. Everywhere it was found that a reliable source of cash income was more important than access to land or ownership of cattle (286:12-13). After remittances from migrant workers, pensions were the second largest source of cash income in the "homelands" and in many ways the most important because payment was regular and reliable (52:19). In the Ciskei a study of three resettlement camps showed that 49 percent of all income was derived from pensions (189:5), while in the Transkei a study of income distribution showed that for those households (nearly two-thirds of the total) with incomes of less than R1,500 per year, pensions were more important than local wages or home production (149:5).

It is worth noting that in Lesotho, whose economy is essentially no different from, and certainly no richer than, that of the Transkei or the Ciskei, no civil pensions of any sort are paid by the government to the majority of people needing them. The burden of old age has to be borne alone.

Pensioners

**Photographs by
Omar Badsha**

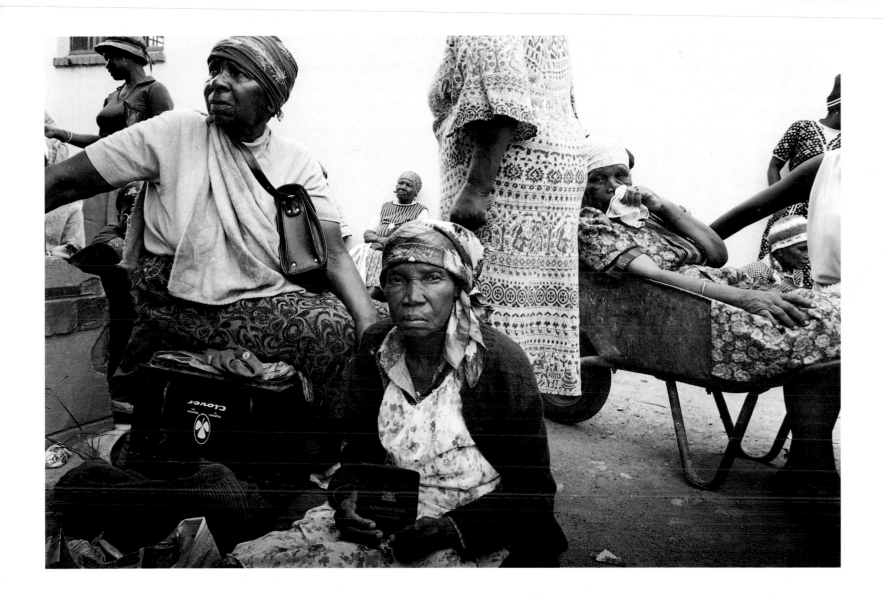

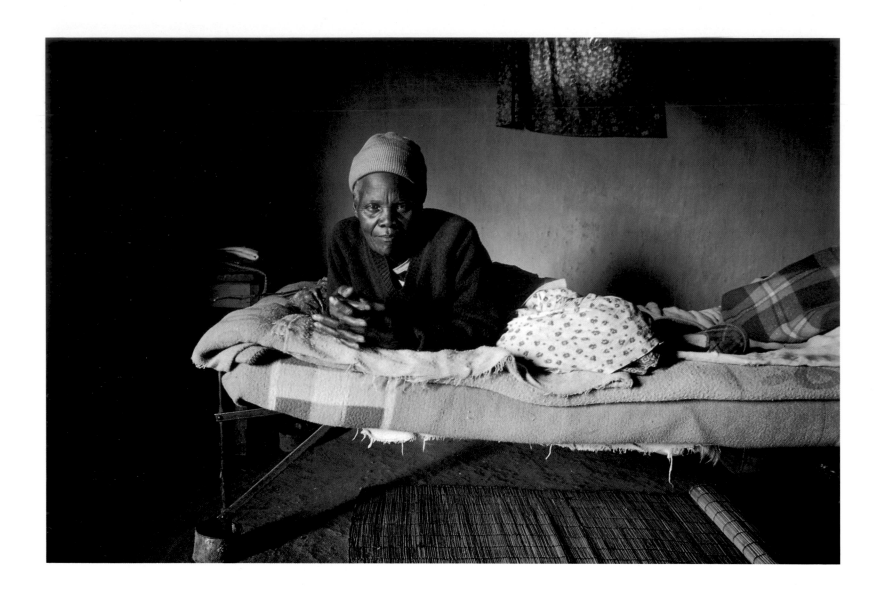

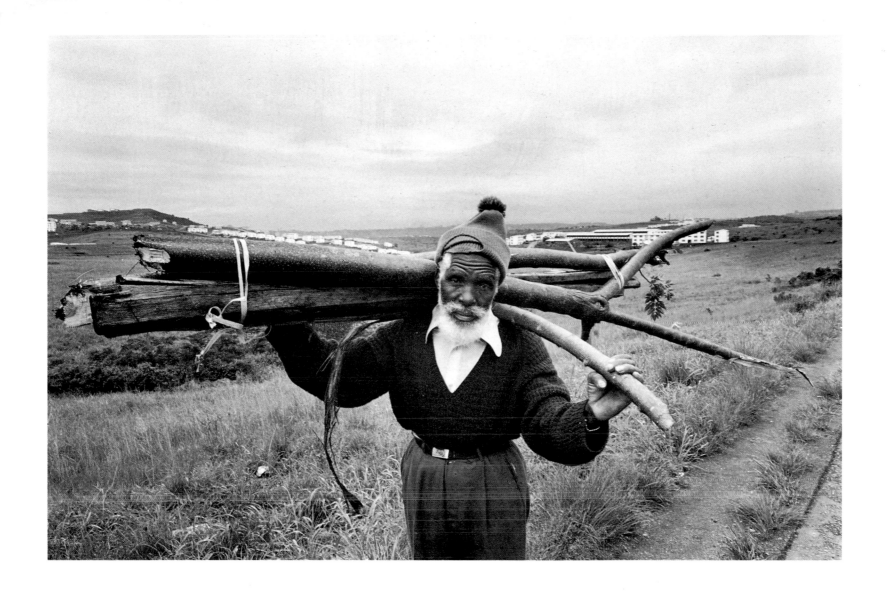

Pensioner in buffer zone between African township of KwaMashu **63**
and "coloured" township of Newlands East, Durban 1983

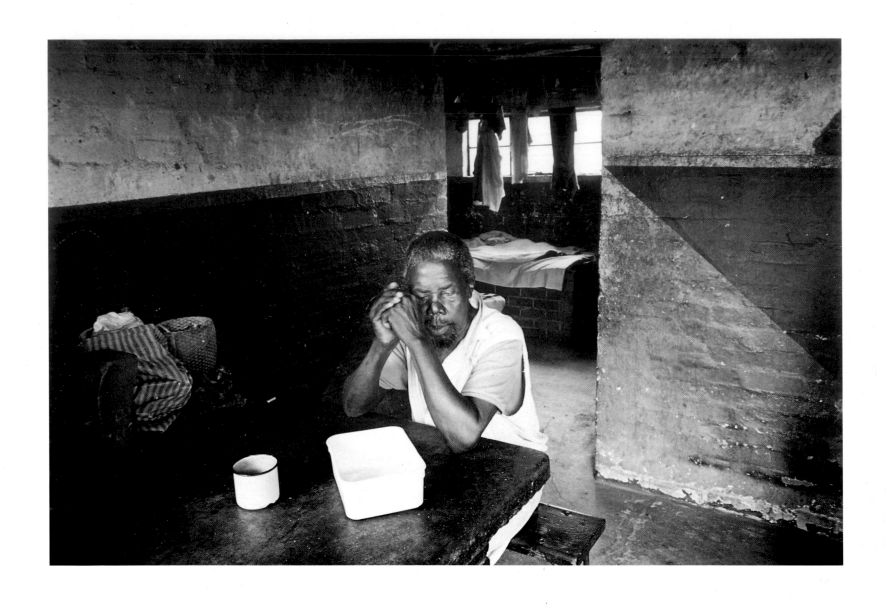

Pensioner who has lived all his life in a compound, KwaMashu 1983

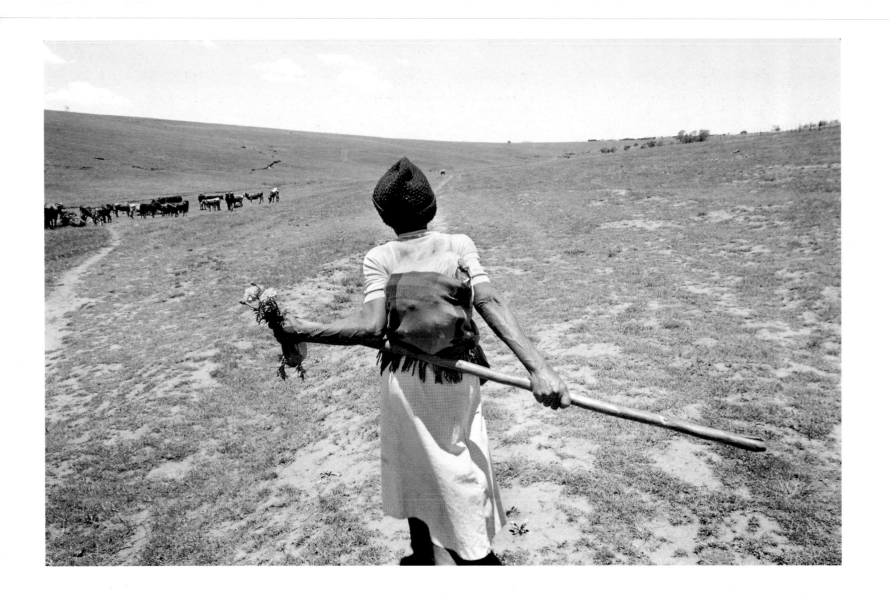

Pensioner walking home after tending her patch in the
community vegetable garden, Transkei 1983

65

Most political and economic analysis in and about South Africa is focused either on what is happening in the towns and cities or on conditions in the reserves or "homelands." Yet one in five black South Africans lives on the white-owned farms that together cover about 80 percent of the country. Approximately 1.3 million persons are employed in commercial agriculture, which, until recently, provided more jobs than any other sector of the economy.

Life on farms varies widely, ranging from conditions considerably better than for labourers living and working in the cities to conditions that are bad indeed, falling sometimes as low as serfdom. In practice, farmers, individually and collectively, have virtually unbridled power over the lives of their labourers. Moreover, the freedom to move for the farmworkers is severely curtailed by poverty, indebtedness, pass laws, and chronic housing shortages in the towns.

In South Africa, there is no statutory protection against the employment of children over the age of seven on farms (84:22), and evidence of the use of child labour is widespread. Where there are farm schools, hours can be adjusted by the farmers to ensure that children are available for work when needed.

Access to education varies widely for farm children. In some areas, most children are able to go to primary (though not secondary) school; in other parts there are hardly any schools at all. It is also true that most farm school education does not provide a sufficient base for people to break out of the spiral of conditions that traps them in poverty.

There are widely different levels of overall income, both in cash and kind, for farm labourers and their families. In some areas there have been substantial increases, sometimes a doubling or more in real terms over fifteen years (27:5), although at the expense of employment. But even where average incomes have risen, there are seasonal fluctuations, because a large proportion of family income is derived from seasonal labour or because a substantial proportion of wages is paid in kind, at harvest time. Households "are haunted by the spectre of starvation" during several months of the year (36:54 and 28:39). On some farms, where cash wages even in the 1980s are as low as R12-R30 per month, the spectre remains throughout the year.

Fear of eviction is a further insecurity felt by farming families. At one rural hospital the paediatrician reported that she was finding it difficult to admit very ill and malnourished children from one particular farming area, because absence from the farm could lead to their family's eviction from their houses (206:1).

During the past two decades large numbers of farmworkers have been pushed off farms. In most parts of the country, under the pressure of mechanisation and other changing techniques of production, farms have been growing steadily in size. And when a farmer buys another farm, he can generally work that land with labourers already in his employ without hiring those living on the newly bought farm. And so, although they may have been on the land for generations, the labourers are told to pack up and go. The only place to which they may legally go is one of the already overcrowded reserves where poverty is even worse.

Farm Labourers

**Photographs by
Paul Weinberg**

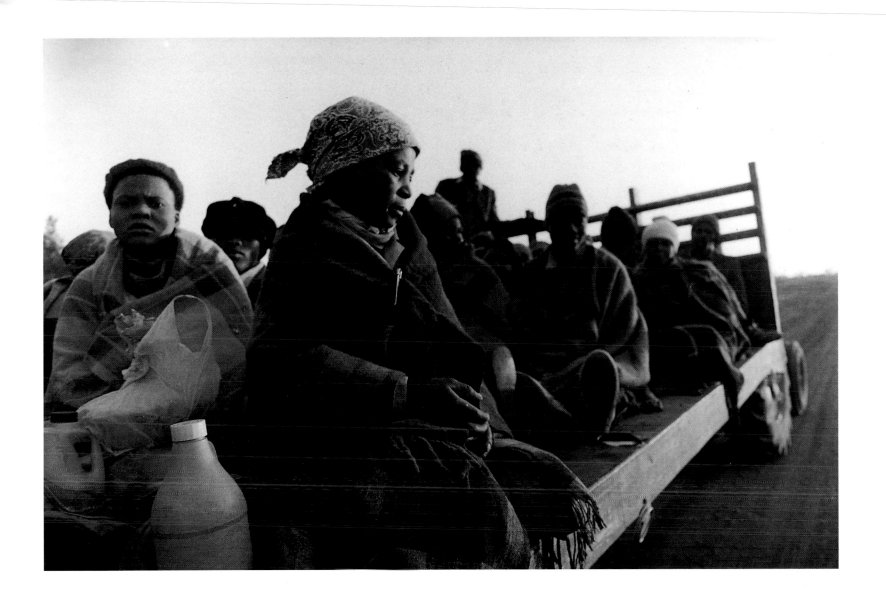

Labourers on the way to the mealie fields, Driefontein 1983 **67**

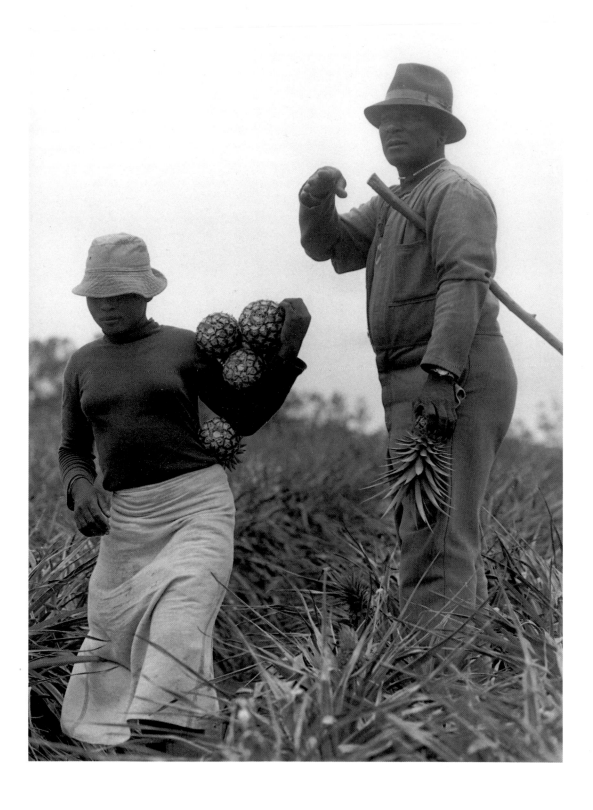

Induna and labourer on pineapple farm, Zululand 1983

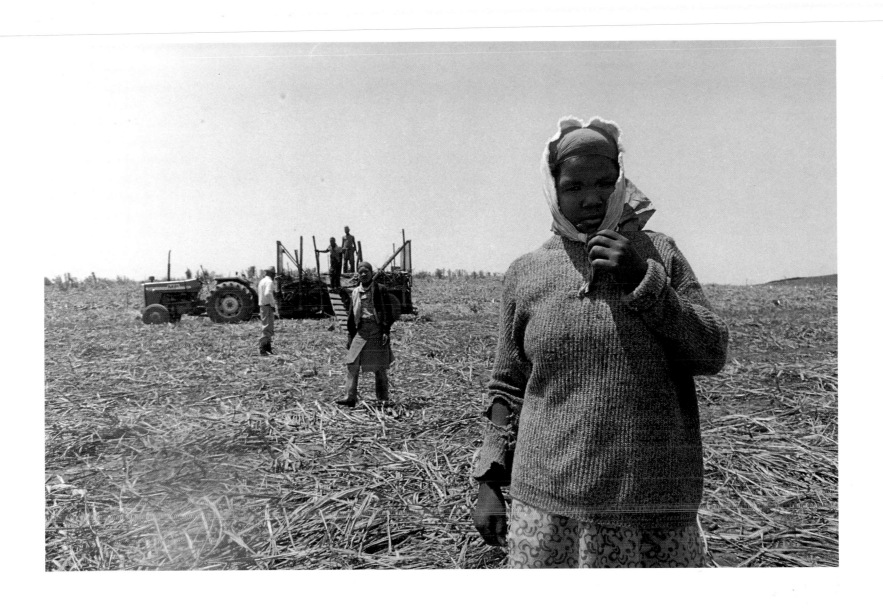

Contract labourer, sugar cane farm, Zululand 1983 **69**

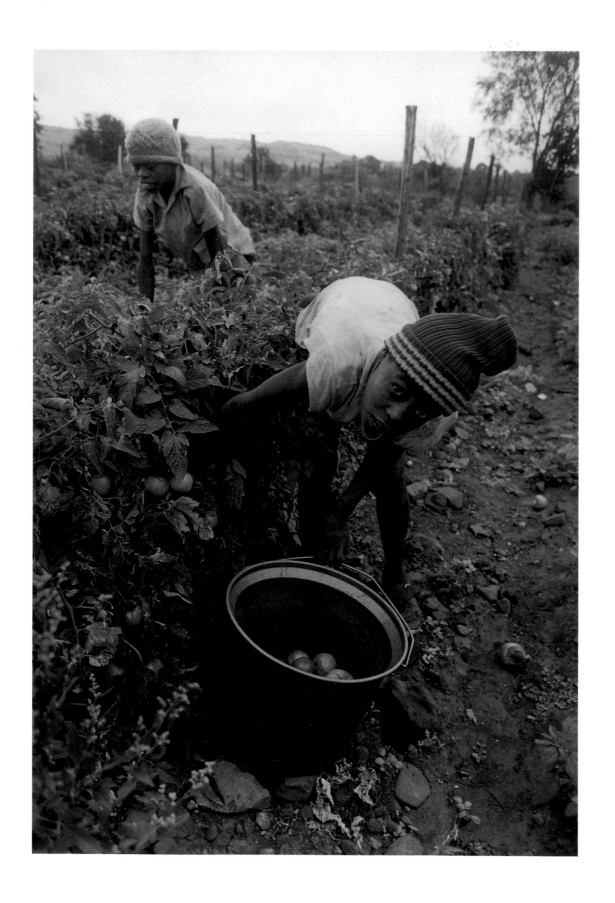

Magaliesberg District, Transvaal 1983

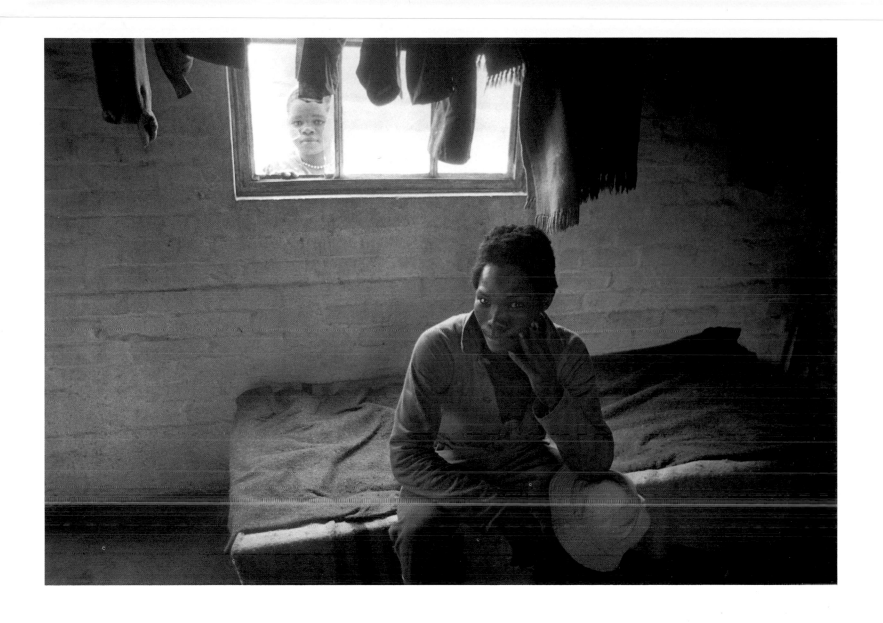

Contract labourer in compound, sugar cane farm, Zululand 1983 **71**

In Natal, especially around the city of Durban, market gardening has long been an important activity. Tremendous energy still goes into these enterprises that allow individual families to eke out a subsistence living on small family plots. But a large number of the market gardens have had to close down. They have been forced out of existence by the Group Areas Act of 1950, which regulated ownership of land according to racial group. Most of the land was reserved for whites and therefore was not accessible to the majority of market gardeners who were South Africans but of Indian origin. They were prohibited by law from owning land in white areas. By restricting the area of land reserved for Indian ownership and occupation, the legislation also has had the effect of driving up the price of land near the city, thus further squeezing the market gardeners.

The diminishing size of the plot has often meant that the young men of the households must seek work elsewhere. Consequently one finds that the only people employed by the gardeners are drawn from the hundreds of African men and women desperate for work and living illegally in the urban areas.

Market Gardeners

**Photographs by
Jeeva Rajgopaul**

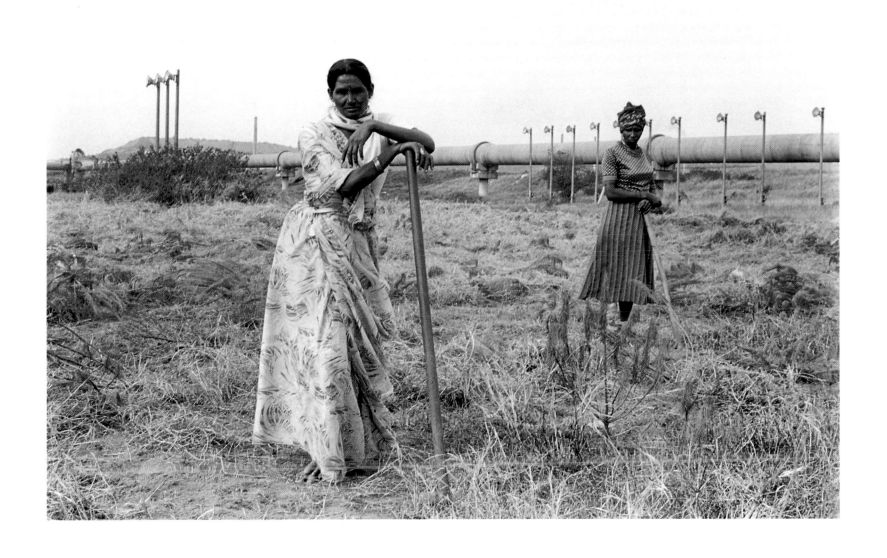

Gardener and her assistant clearing land adjoining Louis Botha Airport, Merebank 1983 **73**

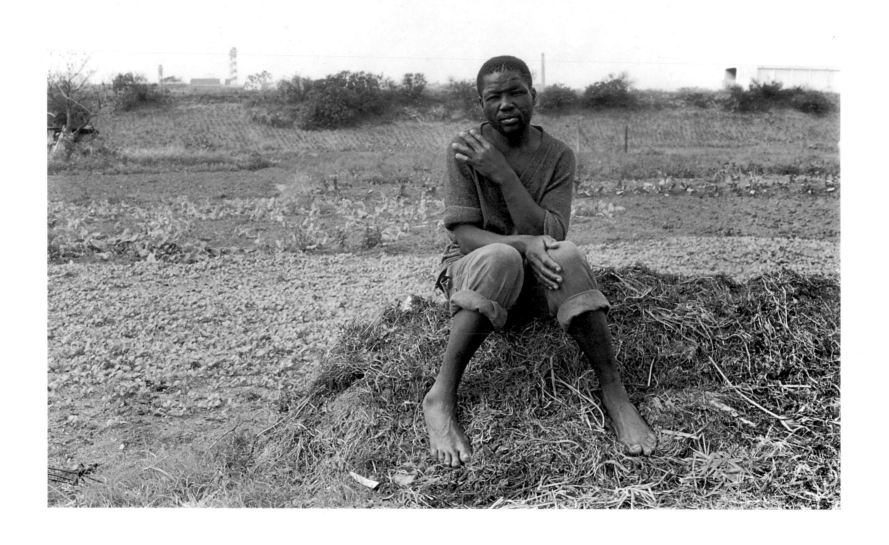

Labourer, Merebank 1983

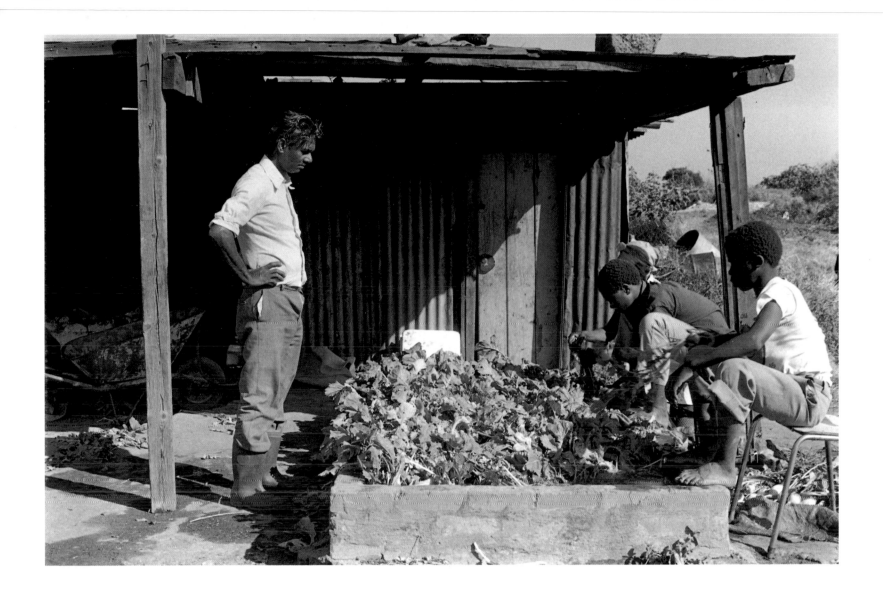

Gardener supervising washing of beetroot, Merebank 1983 **75**

"The informal sector is not always the answer and nor is it a universal panacea to poverty in black rural areas. It is wealth which breeds opportunities and it is low cash flows and restricted demand which inhibit the activities of women in most remote rural areas. Even where outside opportunities exist, they may be seasonal, temporary and highly vulnerable to interference from official sources. . . . Persecutions often occur at pension payments, at busranks and outside beerhalls and factories, where women trade illegally and have no hope of obtaining licences at present. . . . Unfortunately it often seems that it is women who are the losers . . ."(235:41).

In the Transkei, "Women are seen also in the busy roads, at bus stops, at gates of schools or on building contractor sites, trading from Monday to Monday. They deal in small fresh produce, cooked food, and fruit, and crafts, sometimes alcoholic drinks. They sometimes carry small children on their backs. They are at those 'roadside or gate markets' and stalls every day of the week whatever the weather" (239:9).

"The informal sector in rural KwaZulu does provide local women with some money-making opportunities. These are a vital hedge against poverty and the lack of opportunities for women in formal sector employment . . ." (235:41).

The women in the accompanying photographs are from Umbumbulu in KwaZulu. Buying off-cuts from a factory provides them with material for further processing — and the opportunity to make a little money.

Women from Umbumbulu

Photographs by Myron Peters

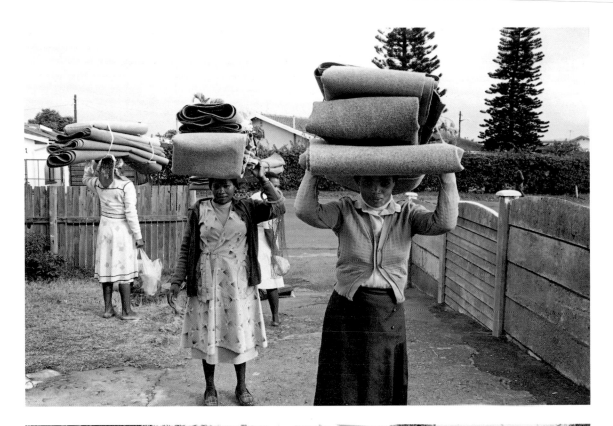

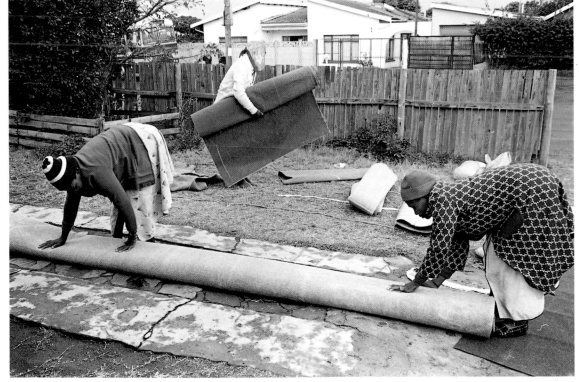

Isithebe was established as a "growth point" some one hundred kilometres north of Durban in KwaZulu, one of the reserves, as part of the government's decentralisation policy to establish jobs away from the main industrial centres. In most societies it is preferable and natural to take jobs to people rather than to make people move somewhere else for jobs. But in the case of South Africa's decentral-isation policy, the costs of establishing jobs where the black popu-lation has been dumped outweigh the gains.

In terms of the policy, the state aims to create as many jobs as possible in the reserves, and so, to attract industry to these areas, it offers employers a range of concessions including tax relief, special railway rates, and cheap labour. Wage determinations do not apply in areas bordering the reserves; in the reserves they have often been replaced by ineffective or unimplemented legislation.

The creation of each decentralised job is extremely expensive for society as a whole. The consensus among economists is that the need for job creation is so great that the country cannot afford such an inefficient and expensive policy. Rather, every incentive is needed to create jobs in the existing urban centres. Moreover, the emphasis on cheap labour to attract industry encourages the "homeland" government to crack down on all forms of labour organisation.

The South African industrial decentralisation policy actively undermines economic development in surrounding countries. In-dustrialists in Lesotho or Swaziland or Botswana can easily find that the incentives offered by the South African government to establish factories in one of the "homelands" make it worthwhile to move their operations. Moreover, foreign investors coming to South Africa may well be influenced by the special incentives to settle in "home-lands" such as the Ciskei or KwaZulu, rather than in bordering coun-tries like Botswana or Swaziland, where the need for job creation is no less acute.

Finally, the way in which the incentives actually work is open to abuse. Thus, for example, hundreds of thousands of people are forced to live in Qwa Qwa, and because of the oversupply of poss-ible labour, wages are abysmally low. The wage subsidy of over one hundred rands per worker each month paid by the state as an incen-tive has been used by some firms to augment white salaries. The black workers, on the other hand, for whom the subsidy was actually intended, are paid at less than half that rate.

Border Industries

**Photographs by
Cedric Nunn**

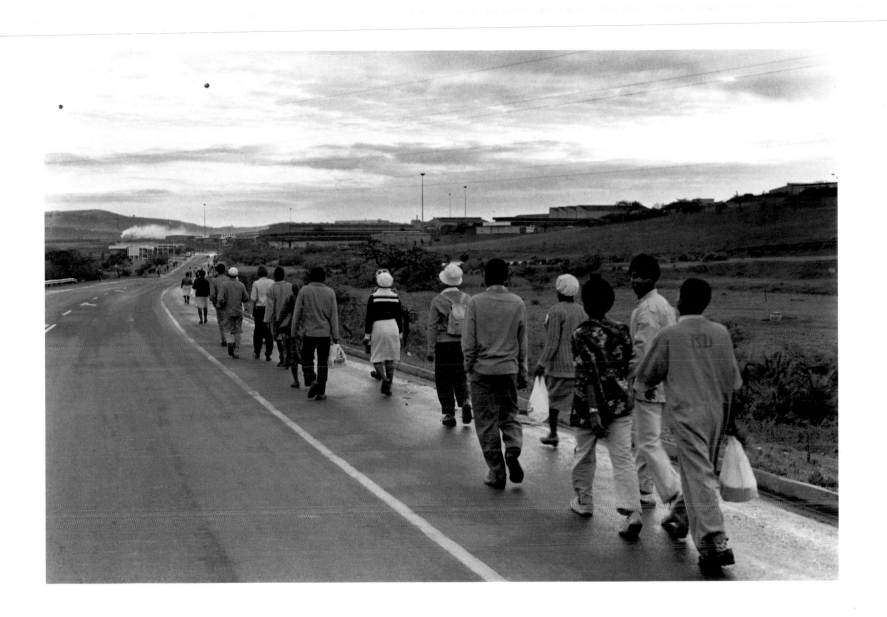

Isithebe Industrial Park 1983　　**79**

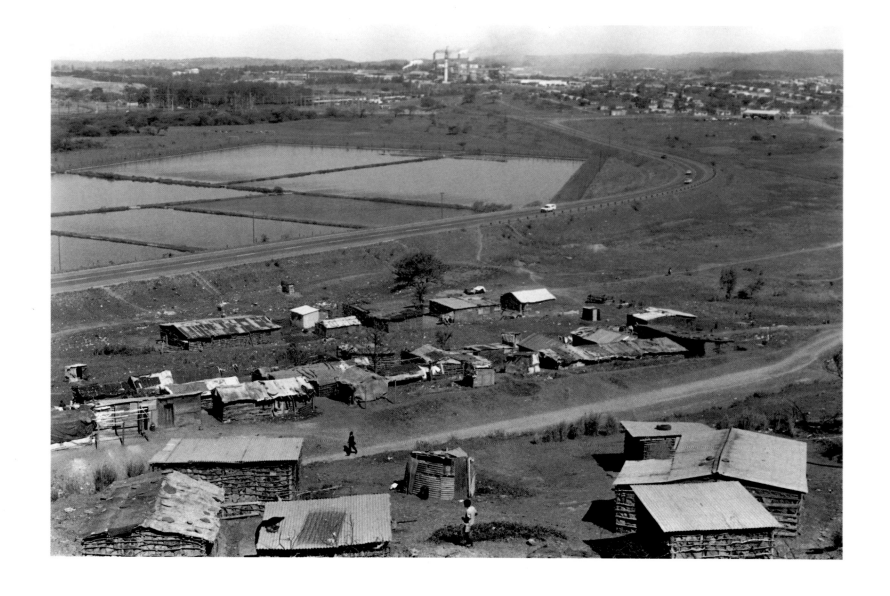

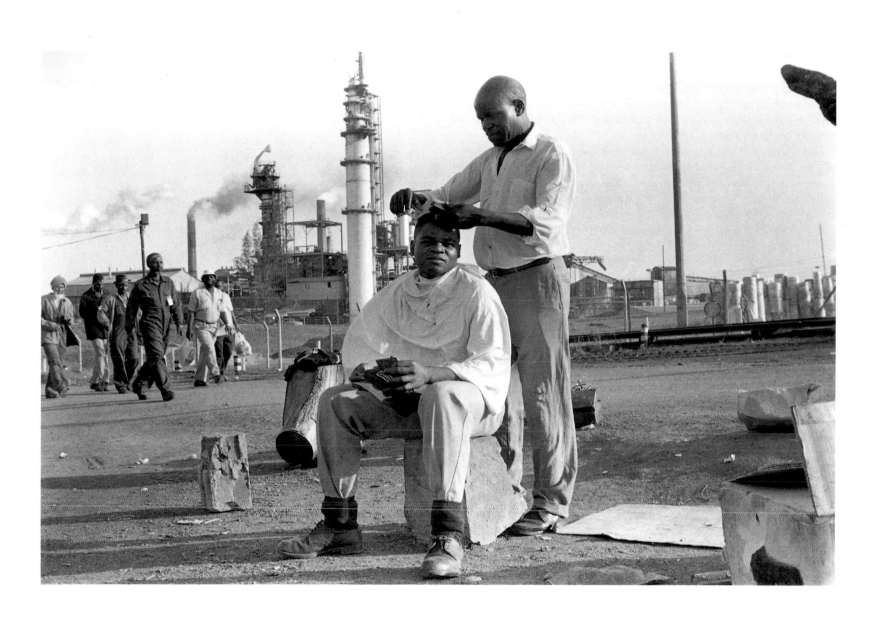

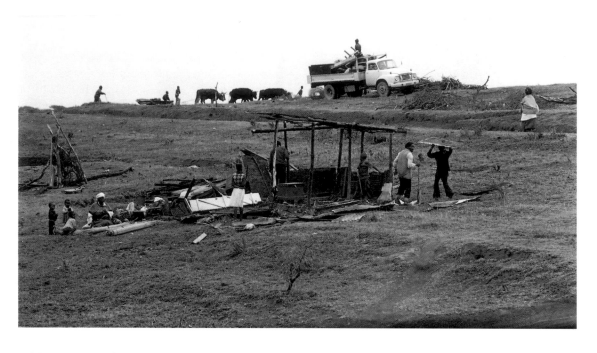

84 *Above,* Dismantling house, Kammaskraal 1982
 Below, Remains of a dismantled house, Kammaskraal 1982

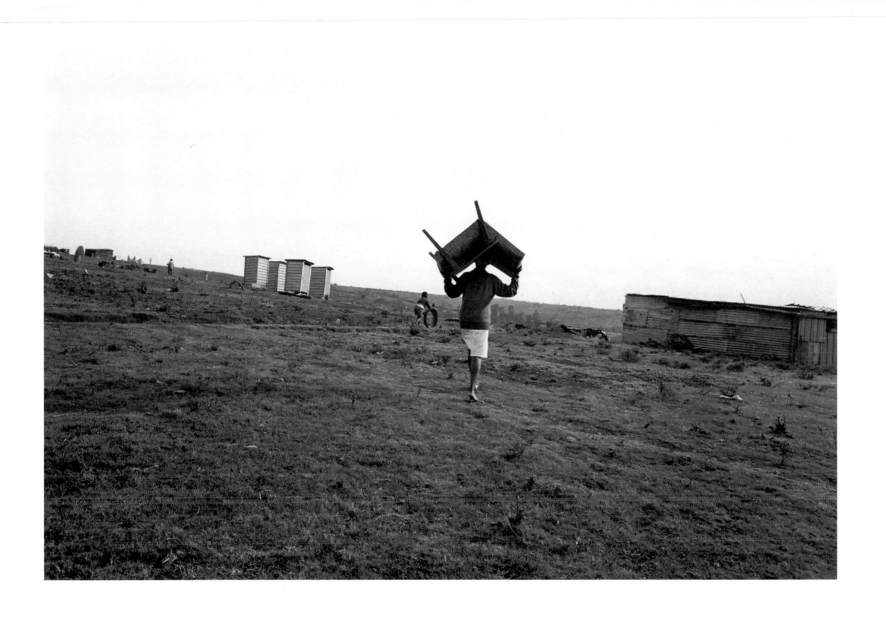

Moving furniture for collection by government trucks, Kammaskraal 1982 **85**

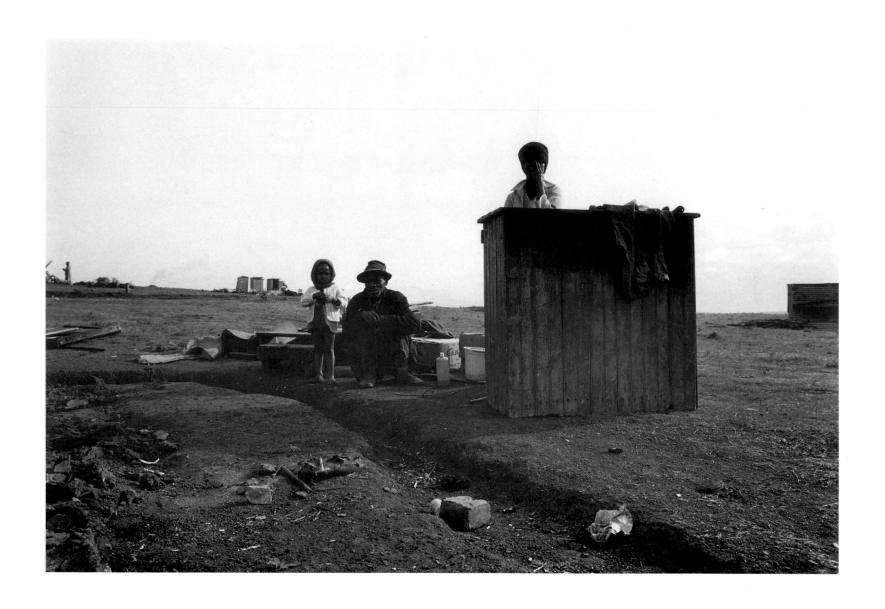

86 Family has dismantled house and is waiting for the
government truck, Kammaskraal 1982

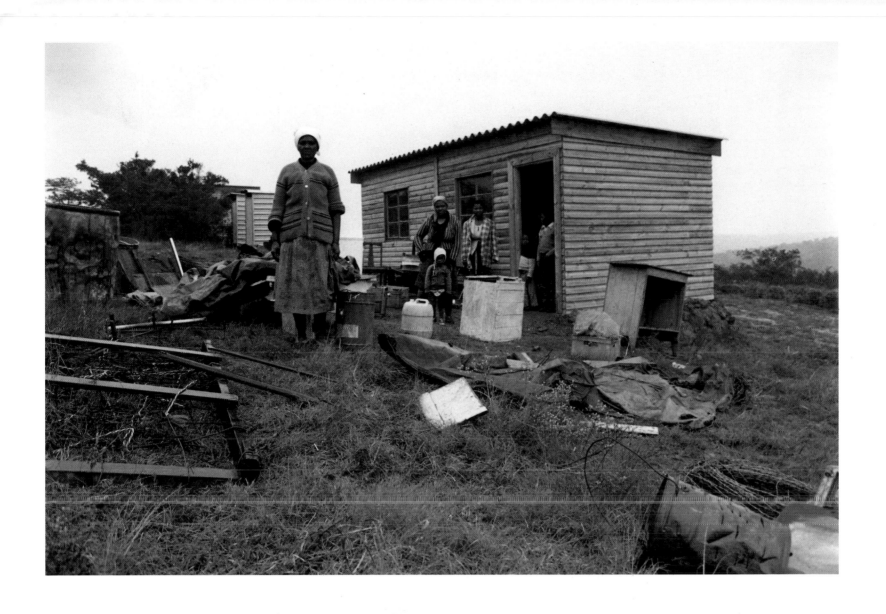

From Machaviestad to Rooigrond, from KwaPitela to Compensation, from Mogopa to Pachsdraai . . . to those who do not know these remote areas of South Africa, the names will not mean much. But for many South Africans these names conjure up the whole hideous process of forced removals, whereby some 3.5 million people have been uprooted from the land – or from places in the cities where they have long been established – and moved to some "homeland" or, if they are "coloured" or Indian, have been relocated from one part of the city to another. Here and there a few whites have had to move; in a few cases people have moved from their own choice. But for the overwhelming majority the process has been involuntary – traumatic, destructive, cruel, and impoverishing.

People were moved to Rooigrond in 1971 after a long battle. They were forced to leave land near Potchefstroom where they were reasonably prosperous small farmers with houses and farm machinery. Neither they nor the authorities see Rooigrond as a permanent home. They still hope to go back to Machaviestad or at least to receive "land, tractors, money to build the same type of houses they had at Machaviestad, and compensation for the years spent at Rooigrond without land or facilities."* The authorities on the other hand wish to move the people on to some other place. The people refuse.

Not far away is Mogopa, where some of the photographs in this essay were taken. A brief account of their story is included elsewhere in this volume (p.16). But the forced removals are not confined to Rooigrond and Mogopa or even to the Transvaal. People have been uprooted in all corners of the land.

Across the country in Natal, the people of KwaPitela, for example, suffered much the same fate as those of Mogopa. They, too, lived in solid houses near well watered fields. Some, including women, had jobs nearby. But KwaPitela was "inappropriately situated," a black spot. For the chess players in Pretoria the matter was simple; the pawns had to move to another square. And so the people were uprooted. "In July 1981, KwaPitela was eliminated. Government officials, eighty trucks, and a crew of workers removed the people of KwaPitela, and what they could salvage of their property, to a resettlement camp cynically called Compensation. . . . Each family was allowed a small site with a tin latrine and a one-room temporary tin hut. Compensation has no infrastructure and is miles from any centre of employment, with no public transport to and from the camp. There are no ploughing or grazing fields available, and the land is dry and dusty. Previous patterns of employment had been dislocated, and yet the people had been thrown out of self-sufficiency into a cash dependent situation. They were paid out in cash on their arrival in Compensation, but the money most households received was totally inadequate" (86:18).

In terms of the law, people owning less than twenty hectares of land are not entitled to any land in return for what has been taken from them. Houses built up over several generations are destroyed. Water, fruit trees, the shape of the hills, familiarity with long-loved places – all these and more are ripped away without a thought.

* Surplus People Project, *Forced Removals in South Africa,* Cape Town, SPP, 1983.

Removals

**Photographs by
Wendy Schwegmann**

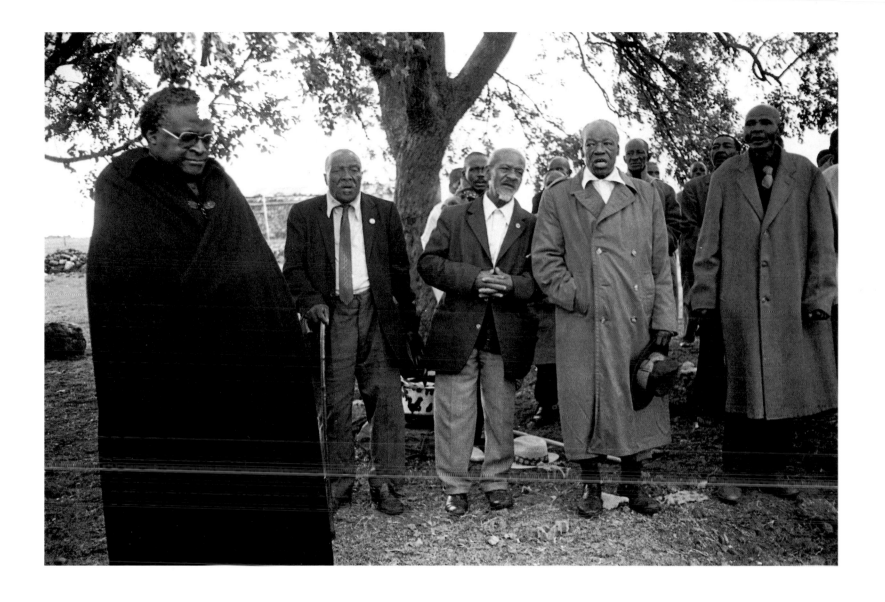

Bishop Desmond Tutu and residents of Mogopa after all **89**
night vigil to protest against removals 1983

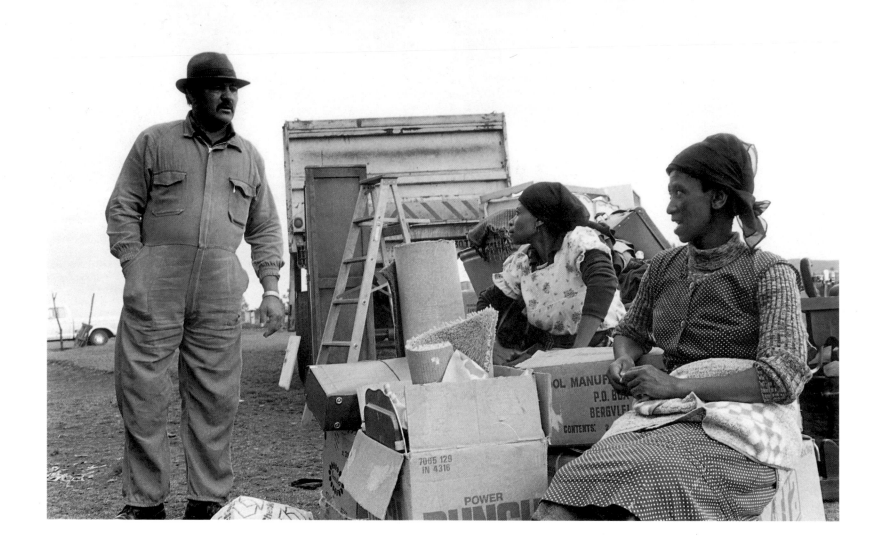

Transport company worker hired by government to move Mogopa residents 1983

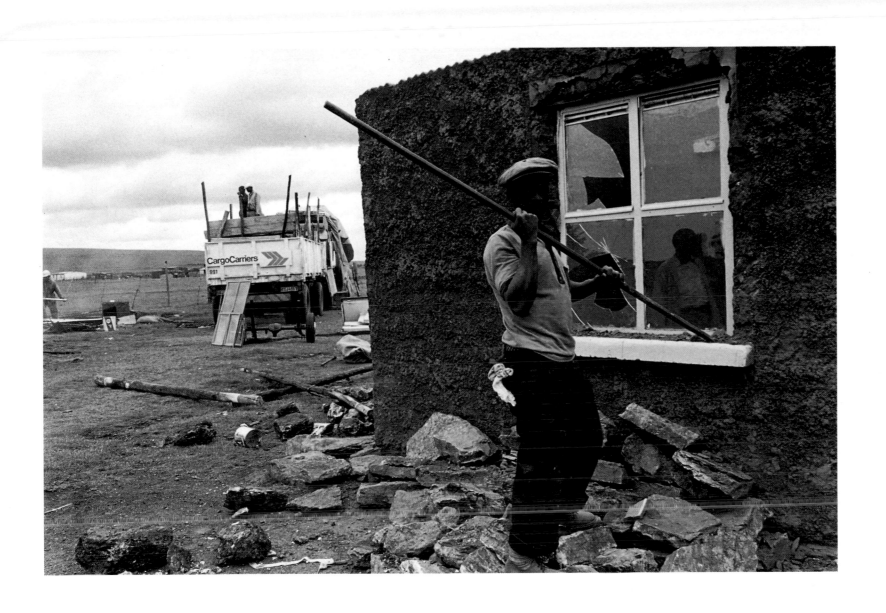

Mogopa resident dismantling his home in preparation for removal 1983 **91**

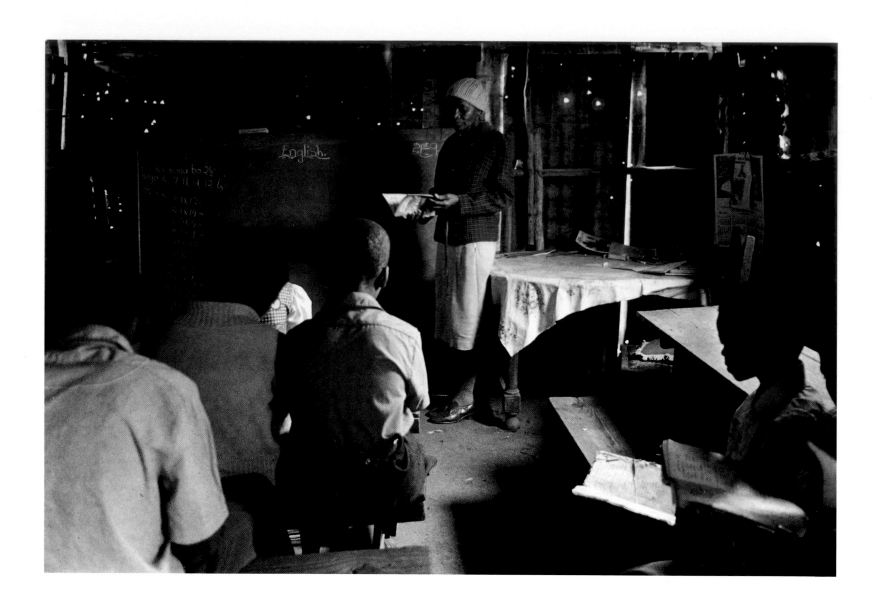

92 Classroom, Rooigrond 1984

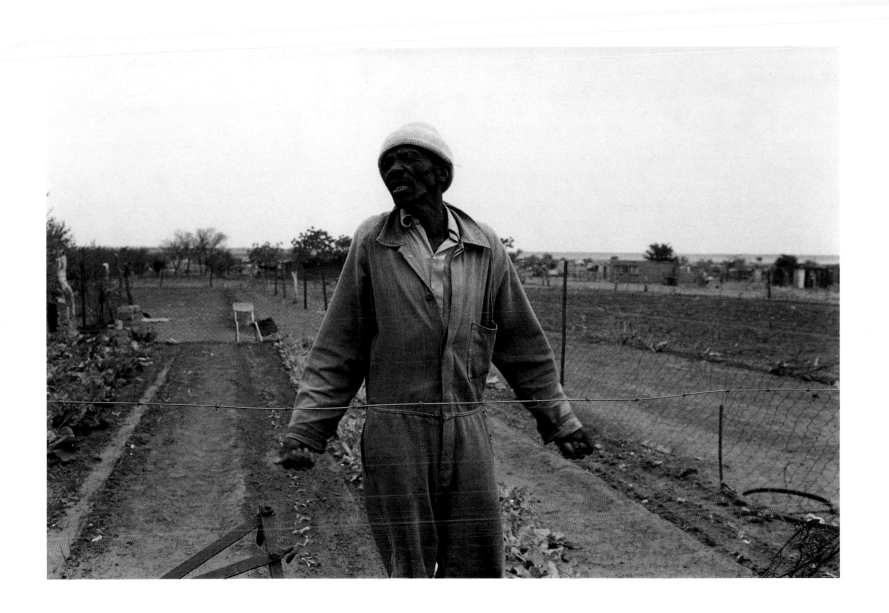

Pensioner in community garden, Rooigrond 1984 **93**

North of Richard's Bay, along the Natal coast, lies an area known as Reserve Four. In terms of the 1913 Land Act it has long been one of the many reserves (in this case part of KwaZulu) that made up the 13 percent of South Africa set aside for African occupation. But Reserve Four is unlike the rest of the reserve areas in that it is not too densely populated and has substantial mineral deposits. The land, moreover, is well watered and fertile.

Mpukonyoni, in Reserve Four, is one of the most fertile areas in the region and well suited to growing cassava. But, as in most of the reserves in South Africa, agricultural development has been stifled down the years. In 1981, however, a project centred at the University of Zululand helped the first sixty cassava growers to each establish a small crop. Early in 1982, the Mpukonyoni Cassava Growers' Association was formed. At the same time the university, through its Centre for Research and Documentation, involved a wide range of people in projects that involved fruit tree distribution, water supplies, and legal aid. Within six months, an umbrella body, the Mpukonyoni Farmers' Union, representing some one thousand households, came into being (227:5).

The hope symbolised in this model rural experiment must be contrasted with the other side of reality in the area. Reserve Four has been found guilty of being "inappropriately situated" and the people condemned, it seems, to a process of resettlement. Although the minerals in the area are already being exploited by a private company that pays no royalty to the people of the Reserve, and although the people are well settled and farming seriously, the powers-that-be want Naboth's vineyard, and they seem determined to take it.*

*Surplus People Project, *Forced Removals in South Africa: Natal,* vol. 4, Cape Town, SPP, 1983.

Mpukonyoni: Reserve Four

**Photographs by
Paul Weinberg**

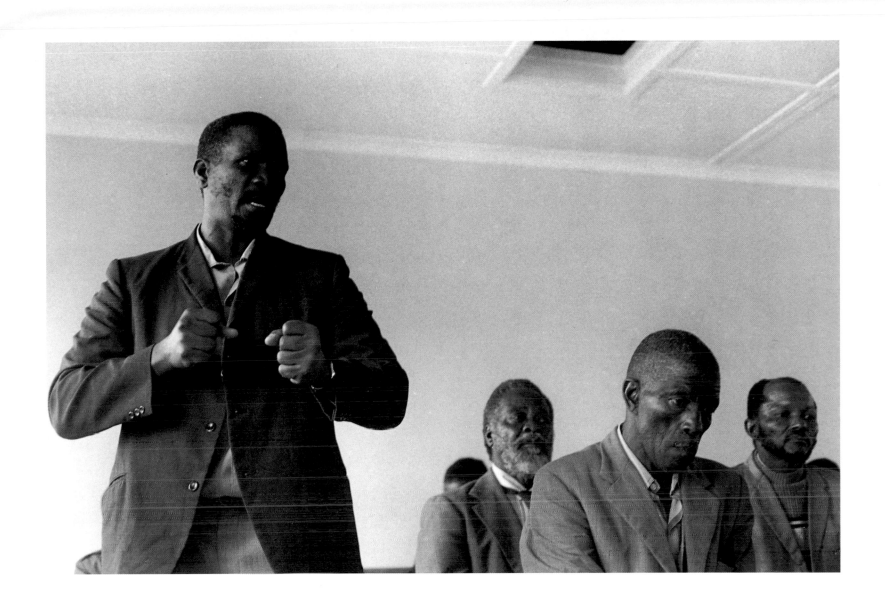

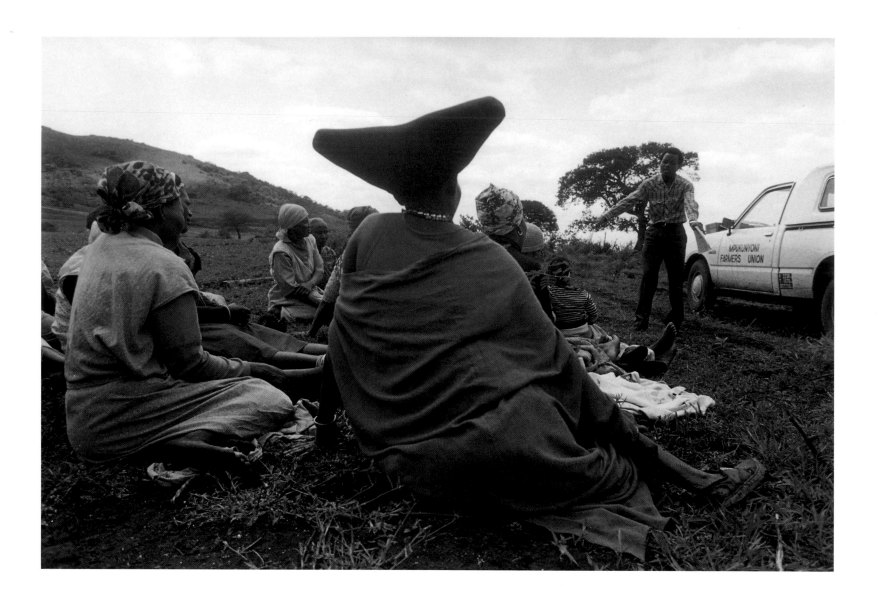

Vegetable garden group 1983

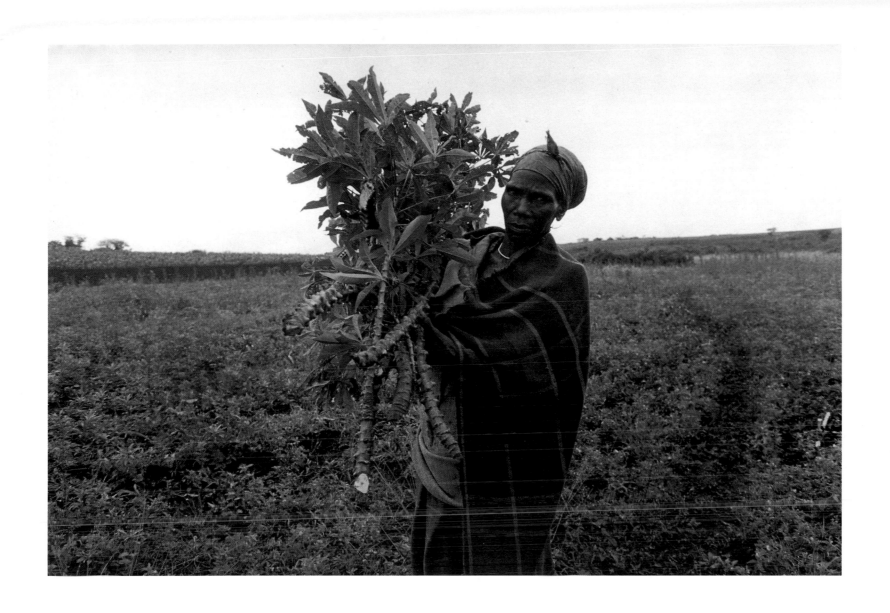

Gathering cassava on a family plot 1983　　**97**

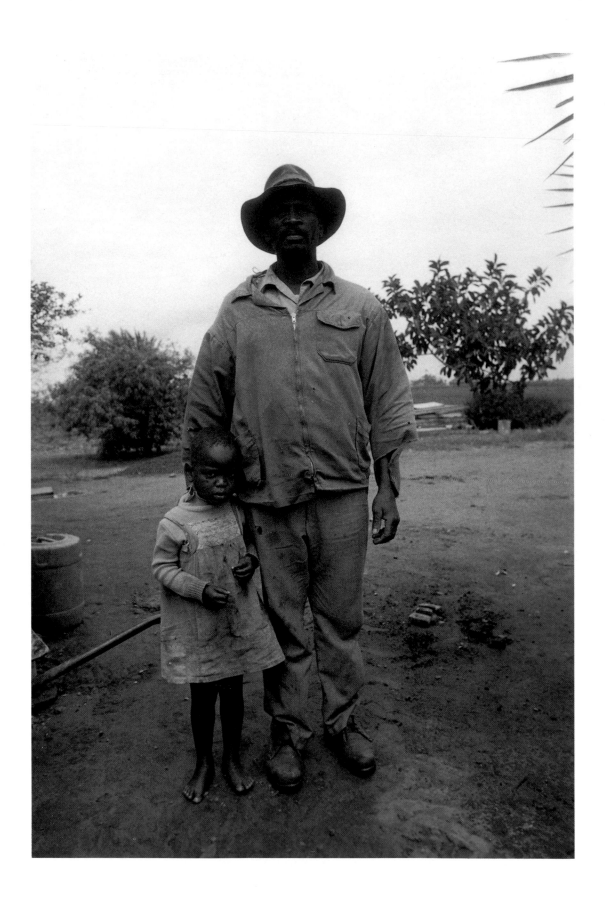

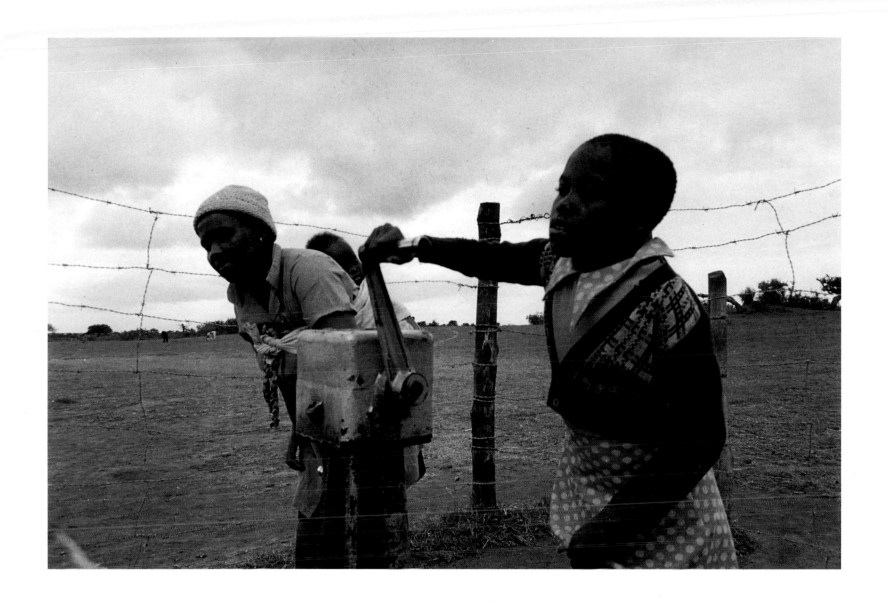

Drawing water from a communal borehole 1983 **99**

"Imijondolo" is a newly coined Zulu word for shacks or shack settlements. Situated some twenty kilometres outside Durban is Inanda, a shack settlement of over three hundred thousand people. It reveals, like Winterveld on the northern outskirts of Pretoria, or Crossroads in Cape Town, the failure of the white state to impose total control over how or where people live.

For thirty years, government policy has been directed specifically at reducing, halting, and ultimately reversing the flow of rural blacks to the white cities. For these same years, rural blacks have flowed into South African cities looking for a way to make a living. One way of resolving these contradictions was opened up for two or three cities that happened to be situated within "reasonable" commuting distance of part of the reserves. The legislation controlling and prohibiting black settlement in urban areas of South Africa did not apply to the "homelands" of Bophuthatswana or KwaZulu, each of which covered patches of land close to Pretoria and Durban respectively.

Thus, as the need to live closer to jobs continued to mount, people began to move. Slowly at first, and then in increasing numbers, people rented a bit of land from whomever had managed to gain ownership or effective control of it. There shacks were built. Unanticipated, unplanned, unwelcome, and unbudgeted for, these huge new suburbs were nevertheless facts of life. In official eyes these shacks should not have existed. But thousands were built, forming a community without any basic infrastructure. No water was laid on; sewerage was in the form of self-dug pits in close proximity to densely packed shacks. Roads were unpaved; rubbish was not collected. The smell was awful, the dangers to health alarming. But people were in striking distance of jobs; money was coming into the households. More and more people kept arriving. Something had to be done.

After major typhoid and cholera epidemics in 1979 and 1980, the state Department of Health persuaded the Department of Cooperation and Development to take responsibility for the area by acting as the local authority in Inanda where, previously, there was no effective local authority as the area was still to be incorporated into KwaZulu. The state put pressure on landlords to evict their tenants and began to demolish squatter shacks. A scheme was organised after some time by the business community through the Urban Foundation. Inanda Newtown was established as a site and service project. This enabled people to build their own homes, starting with very simple structures, in an area where basic infrastructure had already been installed. But only those who already qualified to be in Inanda were eligible for the scheme. Thousands living in the area are still vulnerable. These residents have no legal rights to be there and can be evicted by their landlords, particularly if the latter are under pressure from the health department to provide basic services.

Imijondolo

**Photographs by
Omar Badsha**

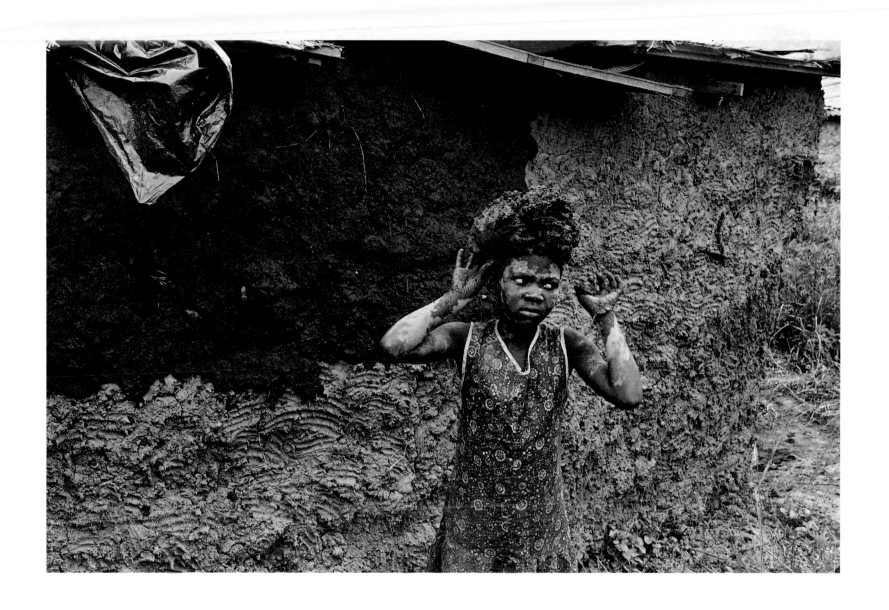

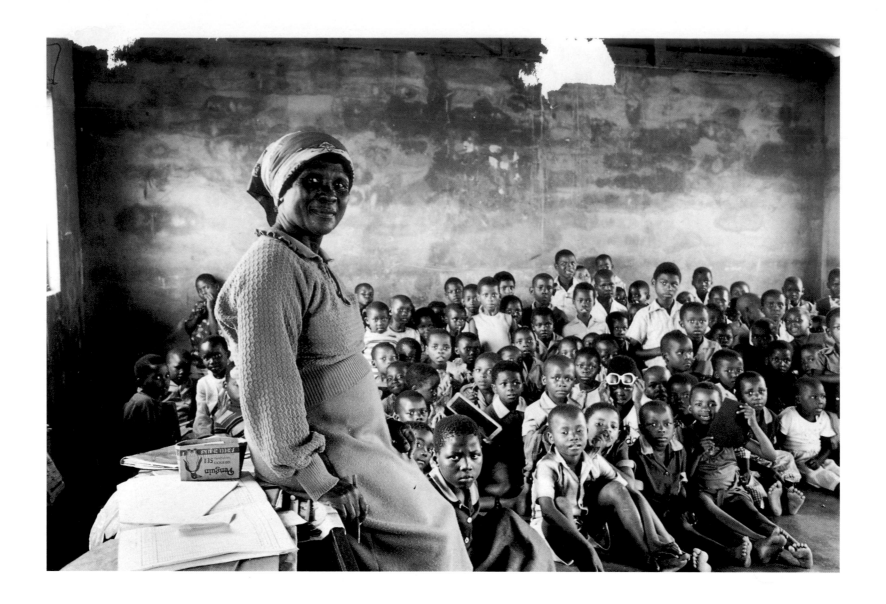

Teacher with class of eighty pupils, Amouti 1982

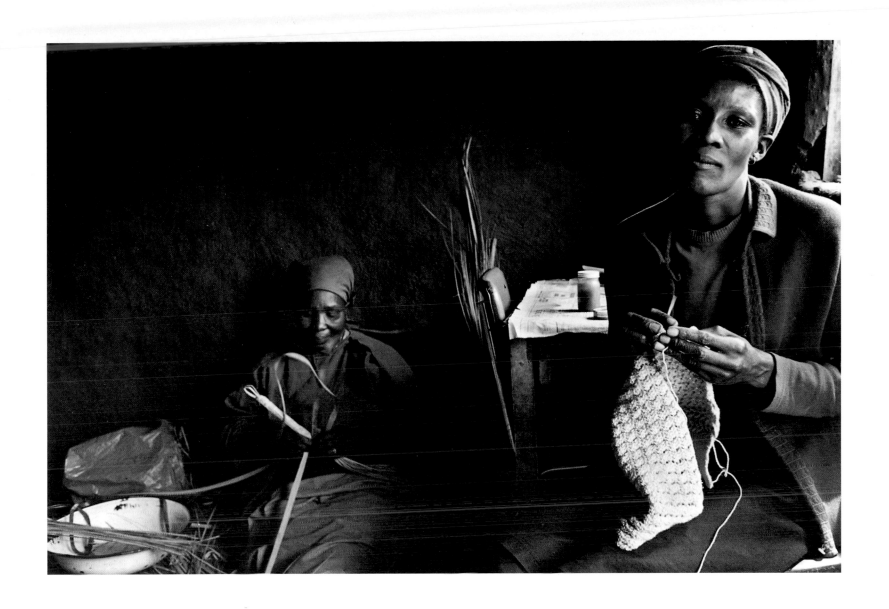

Neighbours in Shembe village, Inanda 1983 **103**

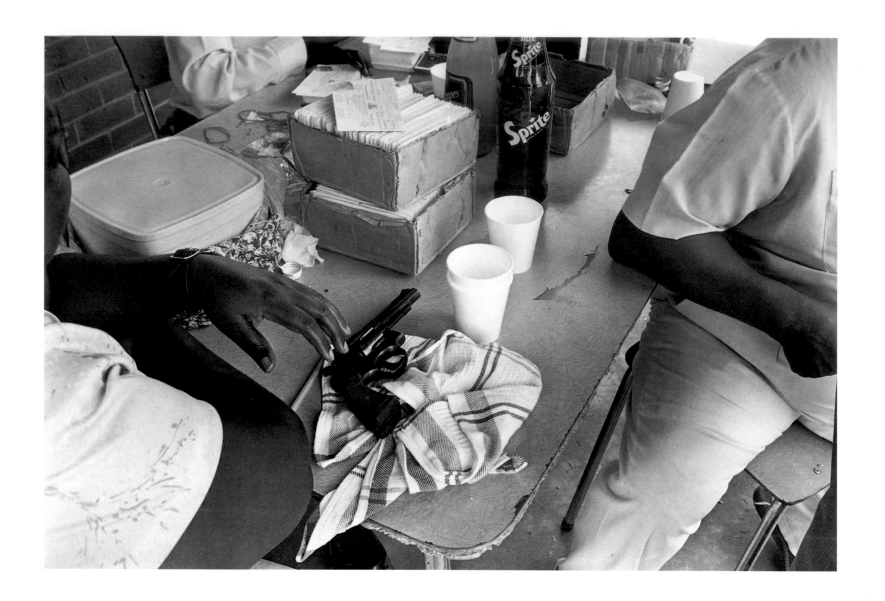

104 Pension pay-out point, Mamba Store, Inanda 1981

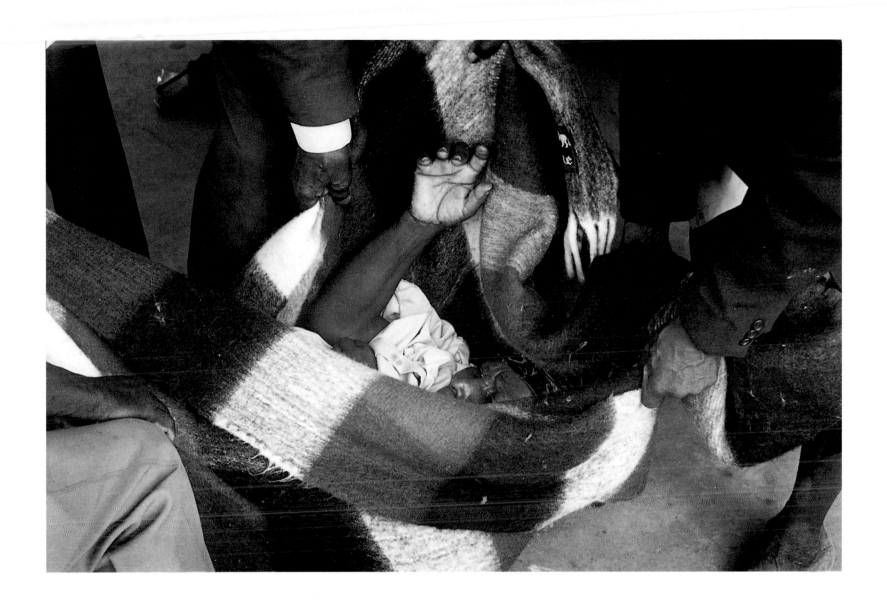

Woman being carried to collect pension, Mamba Store, Inanda 1983 **105**

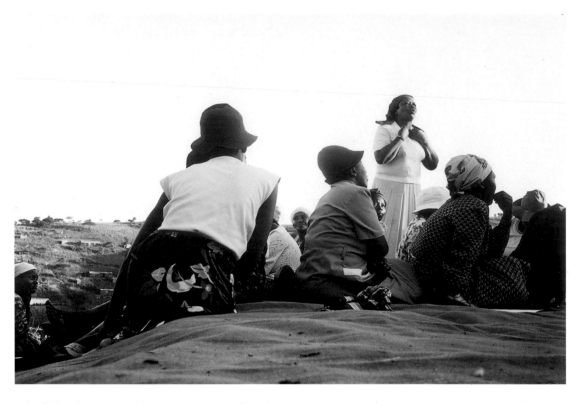

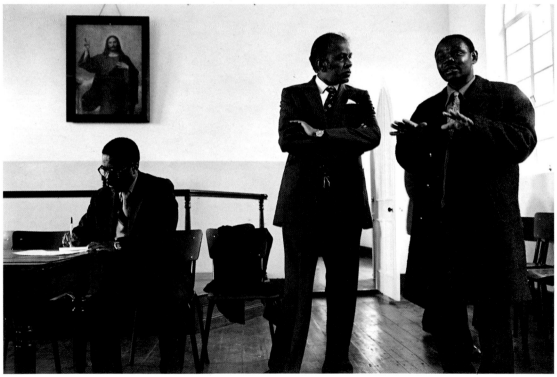

106 *Above,* Protest meeting against removals, Inanda 1983
Below, Attorney representing Inanda squatters addressing meeting of
residents through an interpreter, Verulam 1983

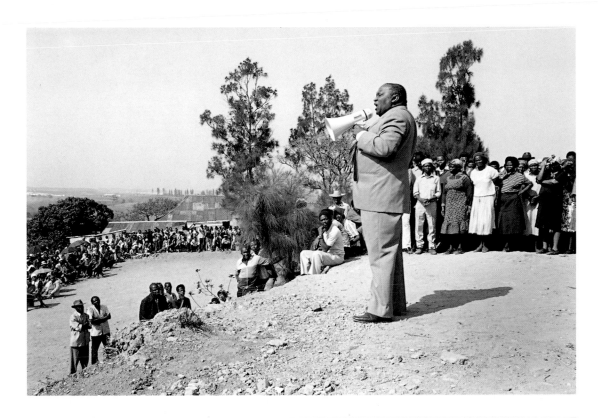

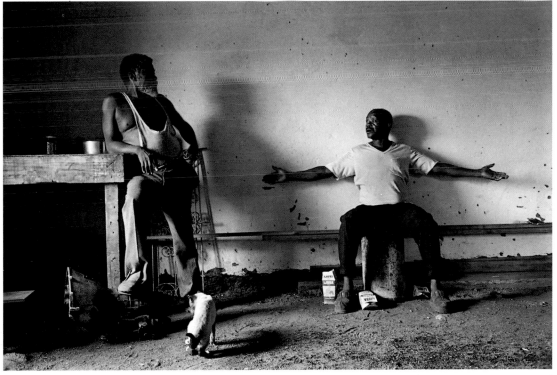

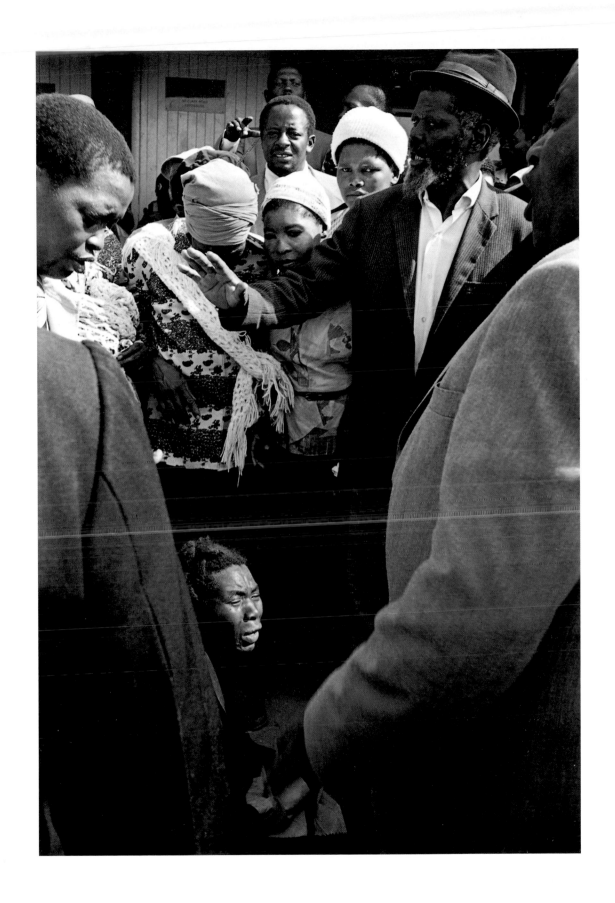

Widow pleads for assistance at residents' meeting, Amouti 1983 **109**

For many years, officials have shown hostility to the presence of Africans in the western Cape. Although Africans were working in the Cape Town docks in the 1830s, before the time of the Great Trek, a fundamental tenet of South Africa's ruling National Party, which came to power in 1948, has been that in so far as possible Africans should be kept out. The western Cape was declared a "coloured labour preference area," which meant that Africans could only be employed, even as labourers, if no so-called "coloured" person was available to do the work.

Every effort was made to keep out from Cape Town those Africans who were not actually required for work. The result of this policy was that, by 1970 according to official statistics, African men in Cape Town as a whole outnumbered women by three to one. In the old established African township of Langa, where thousands of workers were housed in barracks, the male:female ratio was eleven to one.

But the economy continued to grow and, with it, the demand for labour. Not only were more workers drawn to the city, but the internal population of Cape Town swelled, putting increased pressure on the existing stock of housing. When the housing pressures became intolerable in the mid-1970s, people took the law into their own hands. A number of squatter settlements sprang up. Thousands of houses were built by families long established in Cape Town who could find no place to live as well as by migrants and their families who could not bear to be separated or tolerate life either in the barracks or in the reserves.

The authorities reacted harshly. Pass law raids were stepped up; employers were threatened with massive fines if they hired "illegal" labour, and finally the houses themselves were demolished. First several hundred shacks along the Modderdam Road were torn down in the cold winter of 1977; then another thousand or more in Unibel. Altogether the homes of some twenty-five thousand people were bulldozed out of the way and the people told to go. Crossroads, it was threatened, would be the next squatter settlement to be destroyed.

But in Crossroads the residents were building a community. Despite the absence of adequate infrastructure and proper housing, conditions were considerably better there than in other places. Crime rates were low, and employment in both the formal and informal sector was high. Even cows, which provided milk but whose presence in built-up urban areas broke a dozen laws, were kept. The nutritional status of the children was perhaps three times better than that of children living in the country.

After much struggle, the people of Crossroads won a stay of execution in an interim agreement made early in 1979 with the minister of the Department of Cooperation and Development. But victory was not yet certain, and Crossroads remained under threat of removal as the government vacillated. In February 1985, there was a pitched battle between stone-throwing youngsters in Crossroads and armed police that left twenty-two people dead. The government finally gave way. The relevant minister made an unequivocal statement that Crossroads would stay and be upgraded. The apartheid dream of sweeping all Africans out of the southern tip of Africa was finally dead.

Crossroads

Photographs by
Paul Alberts and Chris Ledechowski

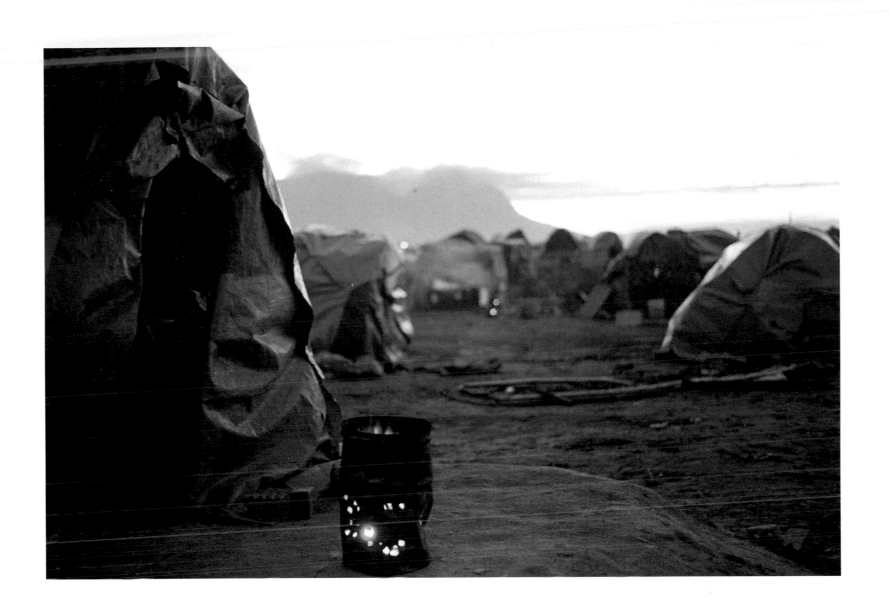

Plastic shelters 1983 *Chris Ledechowski* **111**

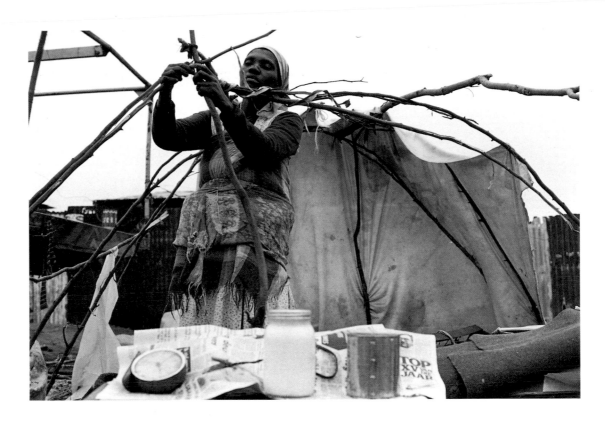

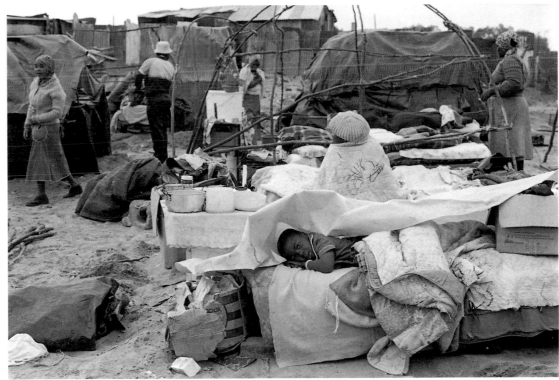

Dismantling shelter before daily morning police raid 1983 *Chris Ledechowski* **113**

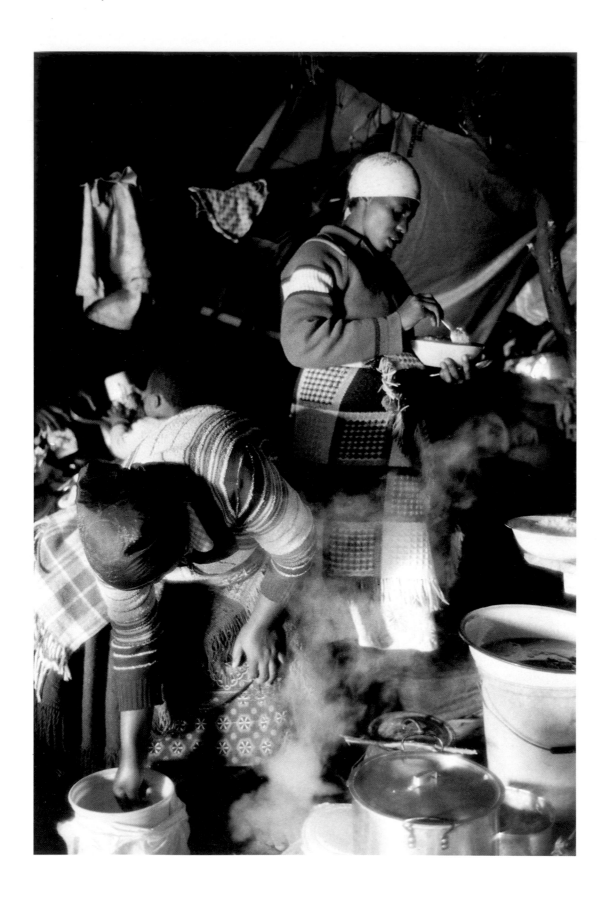

114 Inside plastic shelter 1982 *Paul Alberts*

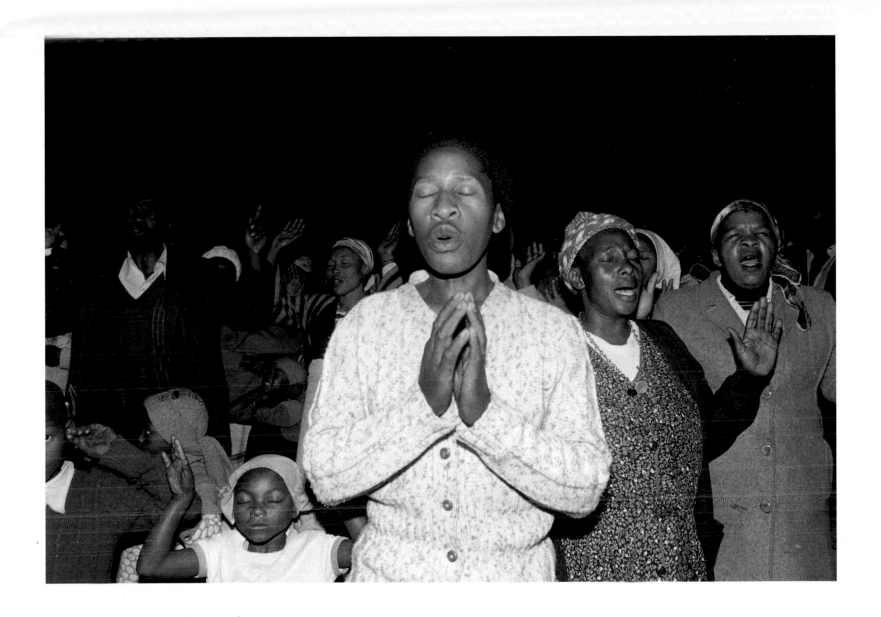

Hout Bay, just south of Cape Town, is one of the loveliest fishing villages in South Africa; it has also rapidly become one of the prime residential areas for wealthier people working in the nearby city of Cape Town. Most local fishermen live in the "coloured" township or in the single-sex barracks for African migrant workers. But not enough homes have been built to accommodate everyone, and the people are forced to live in shacks. Even if houses were built, few squatters could afford the rents.

From time to time the authorities set about clearing the bush of people, but, as elsewhere in the Cape, the people have nowhere else to go, and therefore they continue a fugitive existence in makeshift houses.

Three generations of people, the old man, his son, and his grandson, all shown here, have been squatters in Hout Bay all their lives. Since these photographs were taken, the powers-that-be have forced out more people. This family and others have moved out of Hout Bay, for the time being, at least.

Hout Bay

**Photographs by
Gideon Mendel**

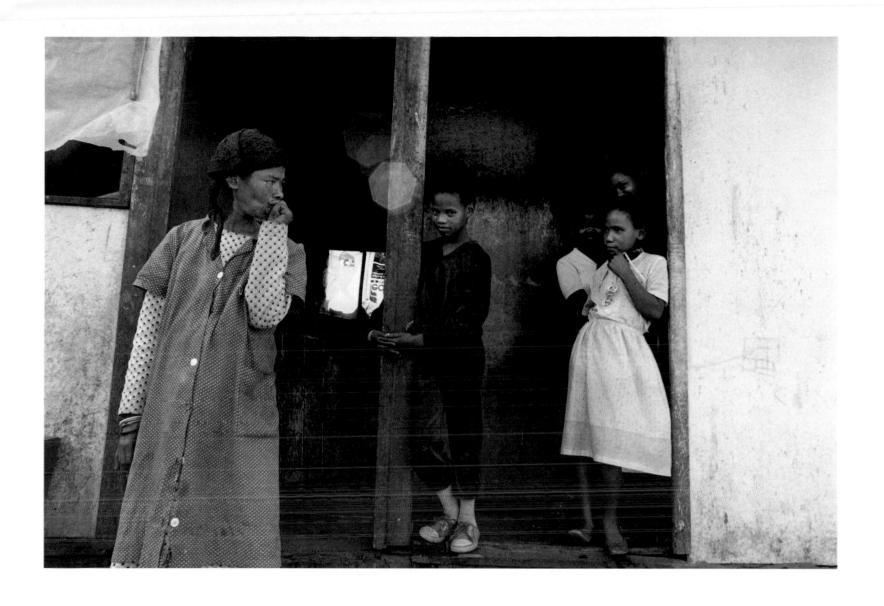

Mrs. Dorothy Moses with children from the squatter camps, Hout Bay 1984 **117**

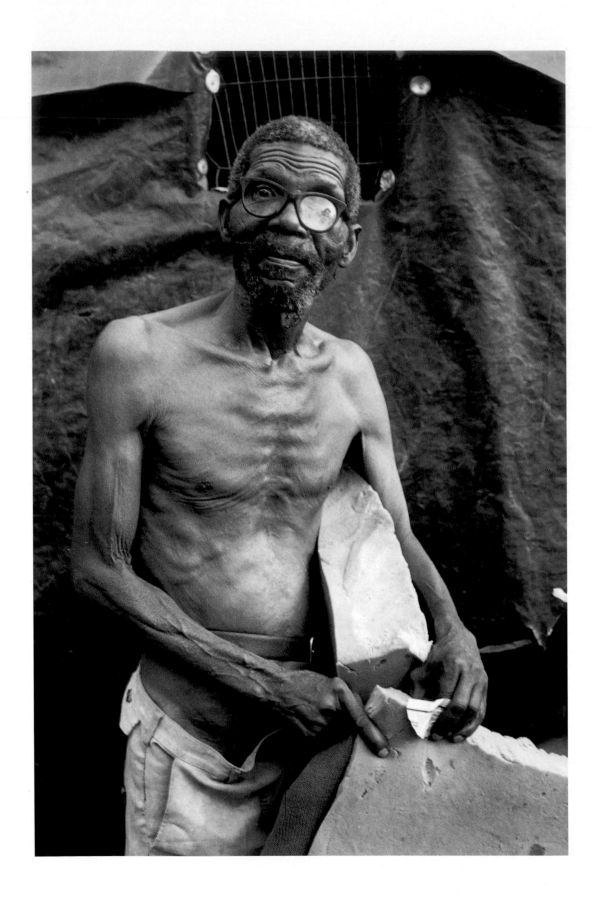

118 Mr. Fraser Anthony, who has lived in squatter camps most of his life, Hout Bay 1984

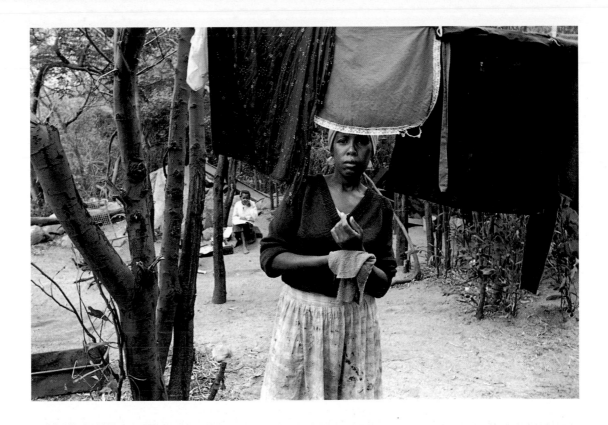

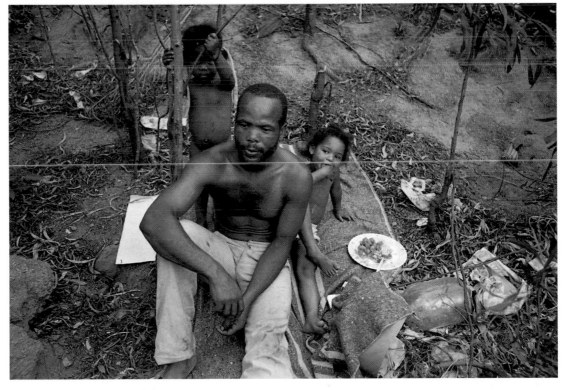

Above, Maria with her daughter, Hout Bay 1984 **119**
Below, Mr. Martin Anthony and his two daughters, Hout Bay 1984

"Nomadic trek-skeerders [shearers] are the true lumpen proletariat of the Karoo. Many have no permanent places of residence let alone houses: 'They are born and die under a donkey cart.' Besides them there are shearing gangs or teams living in Hanover but recruited to work in areas beyond the district boundaries" (34:49). This assessment by Archer and Meyer in their study for the Carnegie Inquiry of one remote area in the Karoo is backed up by other case studies done for the Inquiry.

"I was then a young man of twenty and travelled around with my uncle on the shear. That's how I learnt to shear, so that I was able to shear alone. Then I bought a bicycle and went around on that because we sold the donkeys and cart. . . . It was while going from farm to farm on the shear that I came to the Andrews. I worked for them for forty years. Old Mr. Andrews was a great speculator, buying sheep, selling sheep, sending them off to Johannesburg, Bloemfontein, Durban. . . . I used to herd his sheep to the auction in Richmond. When I returned the baas would send me to another auction, maybe in Carnarvon, where he'd buy sheep and then I would bring the sheep back. That is how you had to work for that baas. You had to do a full day's work. . . . Everywhere you went you had to go by foot and herd the sheep forward . . . Today the lorries transport everything. There are no longer such things as shepherds and sheep drivers. Yes, there are far fewer people on the farms than before. The shearer is just here during shearing. Then he goes. The baas fetches them in his bakkie [pick-up truck] and when they are finished he takes them back into town and pays them.

"Then the kleinbaas came here to live about four years ago. The oubaas left everything to him. He says to me that no, he can't keep me because I can't give nicely anymore. My legs are finished. The mountain finished them. You can't go with a horse in the mountains. You have to walk to watch the sheep there, checking for insects. So that's that" (35:40-42).

Sheep Shearers of the Karoo

**Photograph by
Jimi Matthews**

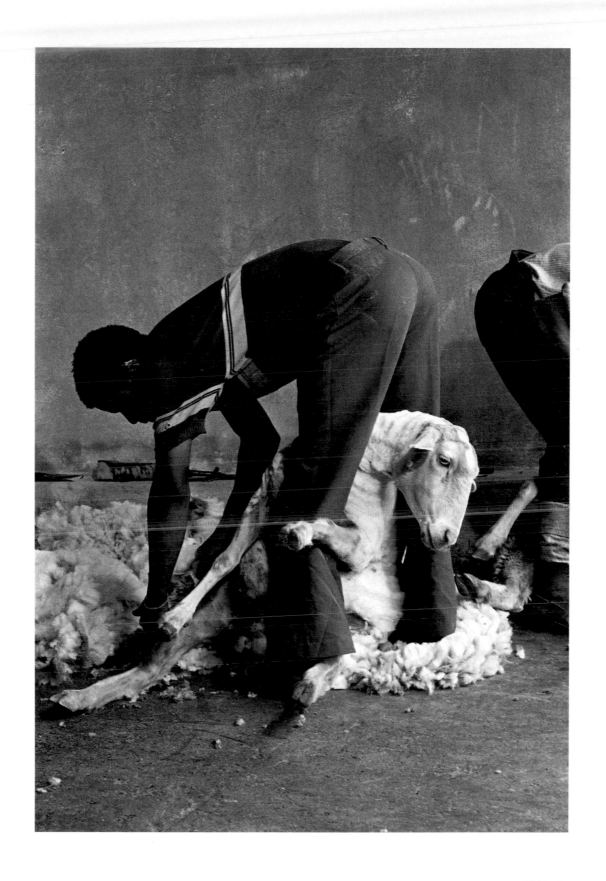

Beaufort West is primarily a railway town, important because it lies one-third of the way up the long thousand mile haul from Cape Town to the industrial heartland on the Witwatersrand. A large proportion of the men, both "coloured" and white, work for the South African Transport Services. The rest of the economy is centred on the national road as it passes through the town, where nine garages and five hotels serve the hurrying travellers.

On the farms in the magisterial district, population has been falling rapidly. Changing techniques of production, increasing size of farm, and the long years of drought have all exerted their pressure. In the town itself the "coloured" population increased by 40 percent over the ten years 1970-1980 as people poured off the land. A survey of the "coloured" township of Rustdene in 1983 found that nearly half of the male-headed, and nearly three-quarters of the female-headed, households earned below the minimum living level (35:21). And half the women were unemployed. Houses were overcrowded, with many families boarding with other households because of the housing shortage.

Until recently Beaufort West was legally a "coloured labour preference" area. Neither the railways nor the municipality employ many Africans, thus their unemployment rate is very high and their general circumstances are even worse than those of the "coloured" population. A municipal report in 1983 found that water and sanitary facilities in the old location were inadequate. "The houses are in a state of ruin. . . ." (35:33). A population estimated at between 4,000 to 6,000 was crowded into 600 dilapidated buildings, many of them consisting of only one room. Despite protests the administration board, responsible for the township, did nothing about these problems, which continued to fester.

But in 1985 the situation changed dramatically. In January Mandlenkosi Kratshi, the leader of a newly formed youth organisation, was shot by a policeman. His death seems to have been the catalyst that transformed people defeated by poverty and powerlessness into a cohesive community willing and able to act effectively. After quiet preparations they launched, in August, a consumer boycott of white businesses. Within three months the local chamber of commerce sent out a letter to all its members urging them immediately to drop all discriminatory practices. And the administration board pledged more than R4 million to upgrade the derelict township.

But the police continued to try and crush all opposition. In the middle of November they blanketed the African township with tear gas, sjambokked youths in the street, and shot at people, injuring a few, one of whom died. Two policemen were also hurt. "Now," declared one of the residents, "it's war."* Power remains overwhelmingly on the side of the state. But Goliath is still vulnerable. One day in October 1985 the police were monitoring the township by helicopter when a young boy climbed on the roof of a house with his catapult. "He fired, and amid a fearful clatter the chopper staggered off, one of its rotor blades damaged."* It is not every day that a helicopter is brought down from the sky by a young boy armed only with a pebble.

*Tony Weaver, "The day 'Bantu Location' saw the light," *Cape Times,* 21 November 1985.

Beaufort West

**Photographs by
Berney Perez**

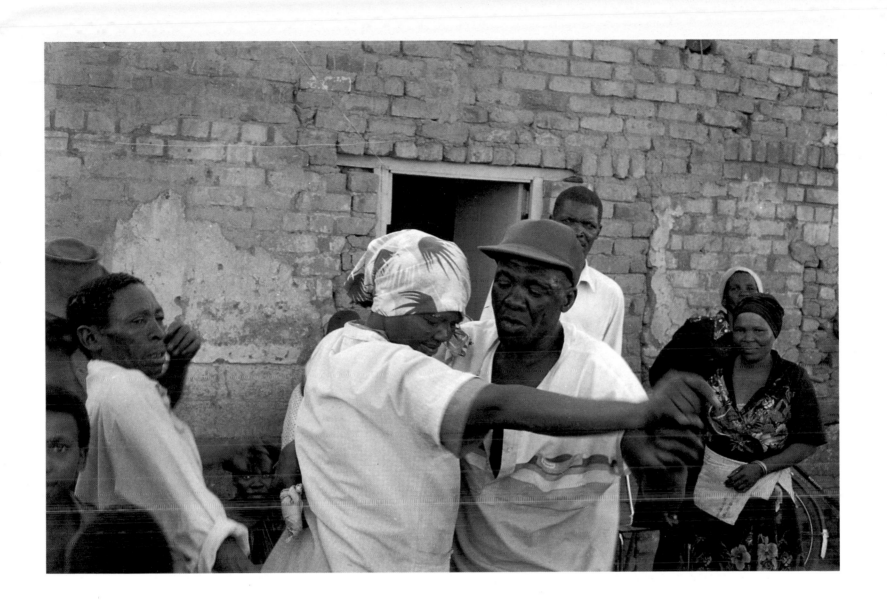

Saturday afternoon, Beaufort West 1983 **123**

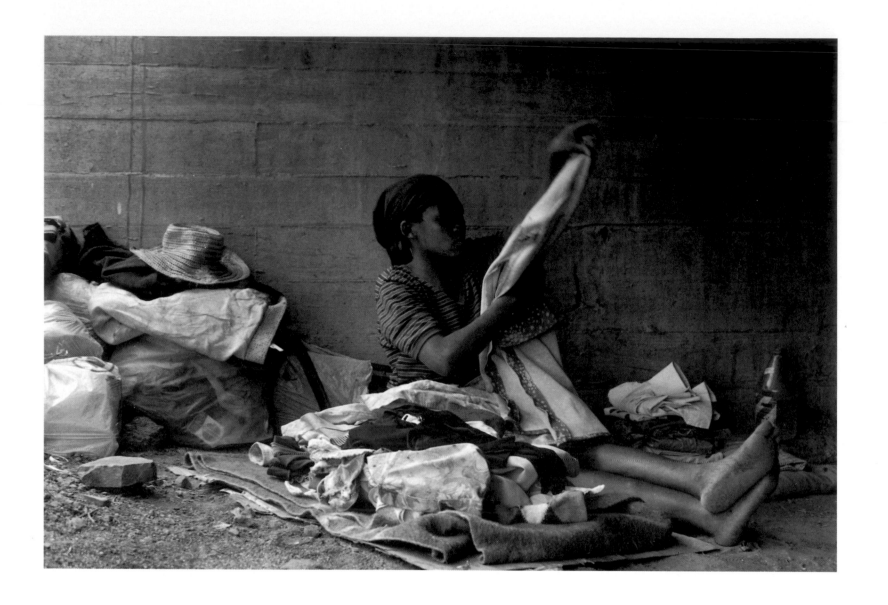

Women living under highway, Beaufort West 1983

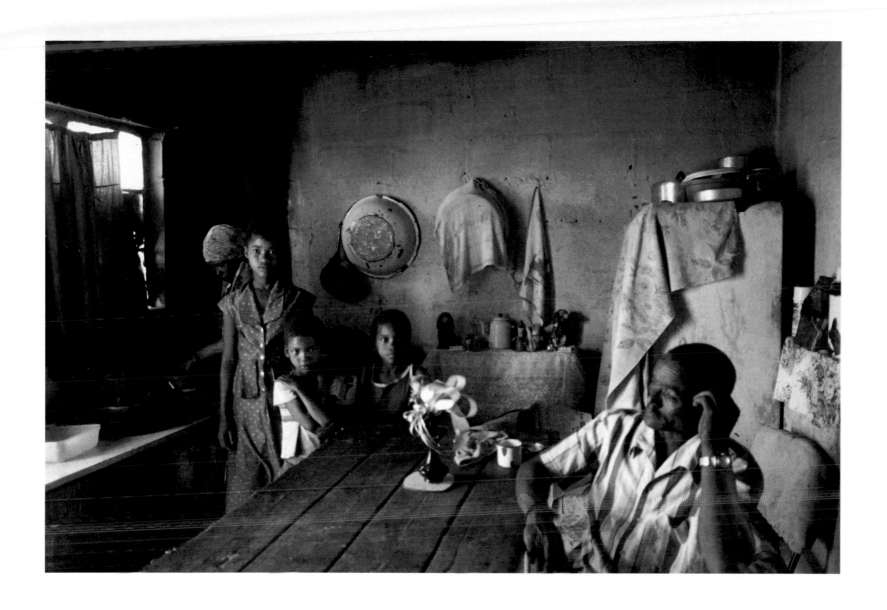

Family at home, Beaufort West 1983 **125**

Situated roughly half-way between Cape Town and Port Elizabeth, a few miles inland from the coast, the town of George, and the magisterial district that surrounds it, is one of the most beautiful places in South Africa. It is also one with a long history of poverty, not least among whites, whose destitution fifty years ago was eloquently described in the Carnegie Commission on the Poor White Problem. The woodcutters and their families in the indigenous forests of the district became symbols for white South Africa, of good people trapped by economic forces too strong for them. Given the need at that time for special state help to poor whites, it is not surprising that the National Party has dominated the politics of the district, or that it has been represented in parliament since 1948 by P. W. Botha, who, in 1984, became the country's first executive state president.

Under the surface of white prosperity, generated in part by the policies of the National Party, lie many other people, both "coloured" and African, submerged in a sea of poverty. During the decade of the 1970s, total population in the district increased only marginally, but the urban:rural ratio changed dramatically as people poured off the surrounding farms into George and other smaller centres. This process reduced the absolute number of people in the rural areas by one-third (39:19), but at the same time led to overcrowding and slum conditions in the towns, where neither housing nor employment expanded fast enough to absorb all those being squeezed off the land by mechanisation and other changing techniques of production.

The local economy is based mainly on agriculture and forestry, including, in more recent years, the growing and processing of vegetables. Tourism is also important, and there is some light industry. With this base there is a relatively high seasonal demand for casual labour. The main burden of this stop-go type of economic activity is borne by the poor. One of the characteristics of poverty in George is that a large proportion of jobs in the district are of a casual nature. Those who are poor tend to have casual, rather than full-time, jobs. It is difficult for those who are poor to make ends meet on wages that cannot be relied upon through every week of the year, especially if they have a large number of dependents (39:89).

George

**Photographs by
Bee Berman**

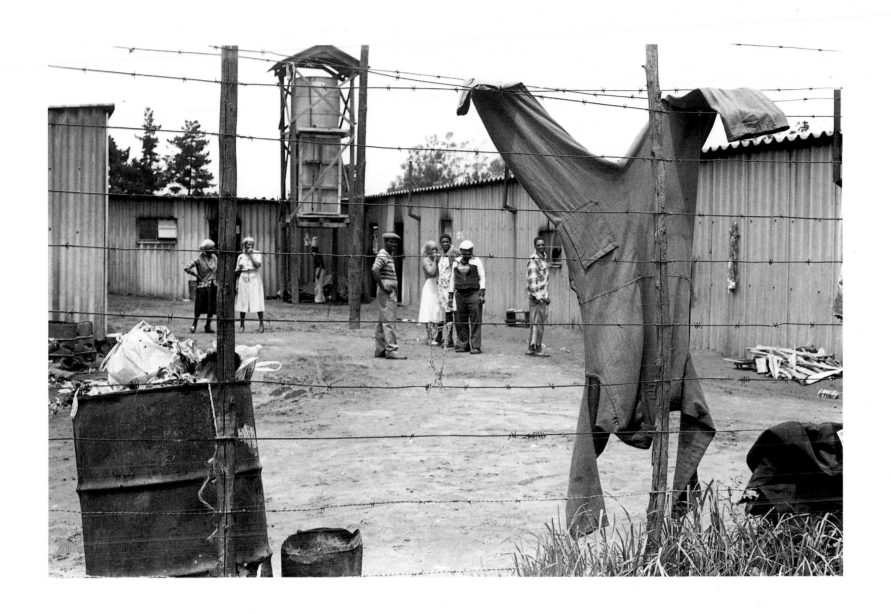

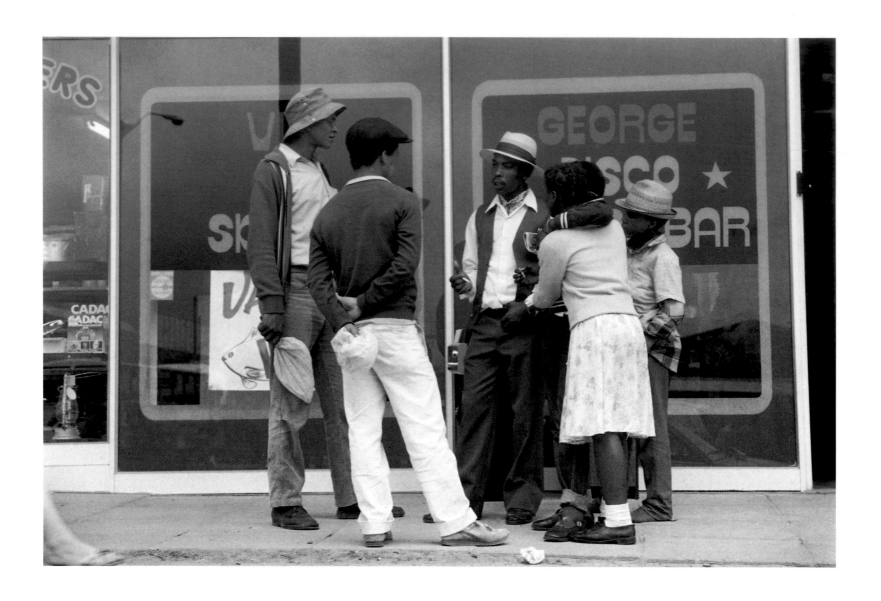

128 Saturday morning in the city centre, George 1984

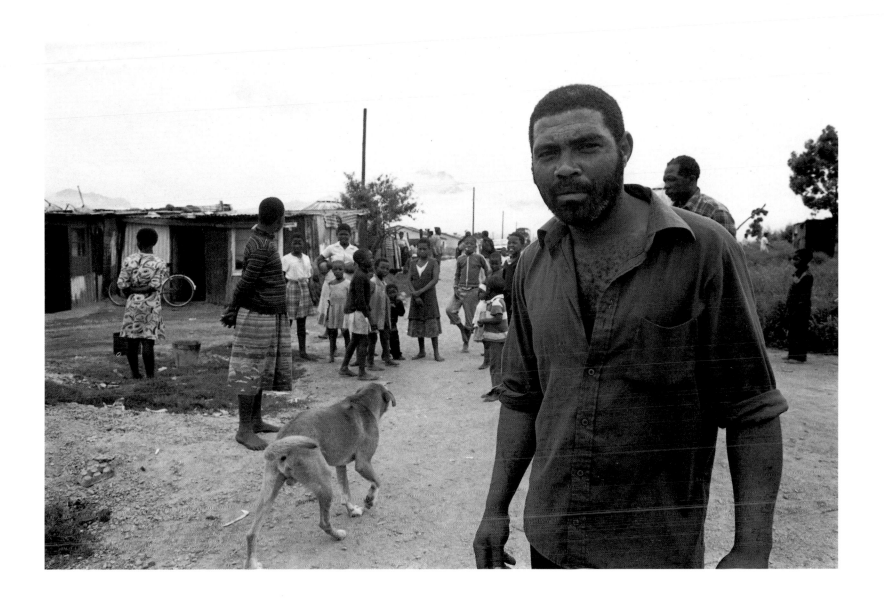

Blanco Township 1984 **129**

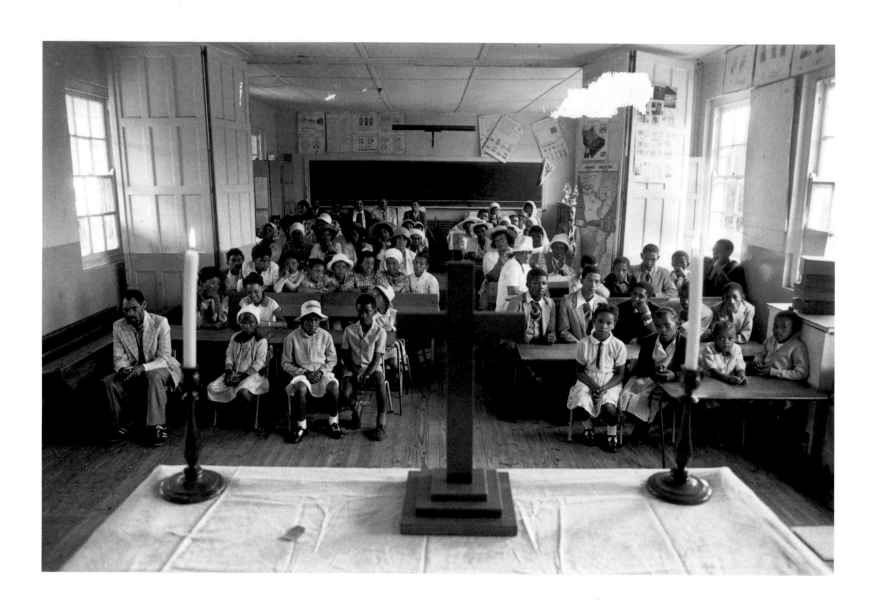

130 Anglican church service in classroom, George 1984

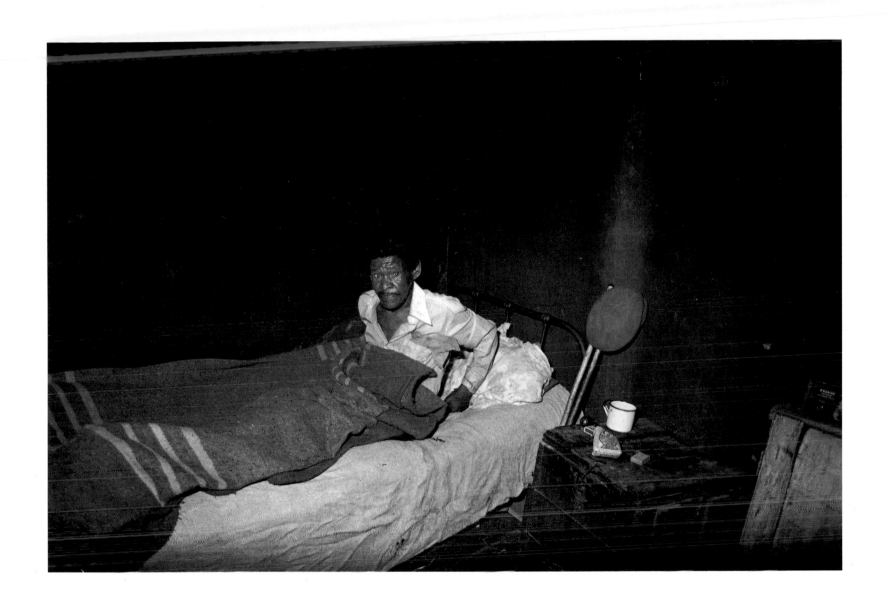

Disabled farm labourer, Glentana 1983 **131**

The Cape Flats is the name given to the sprawling housing estates built on the windswept sands on the outskirts of Cape Town, in areas demarcated by law for the "coloured group." This is one of the most violent urban centres in the world. The rate of murder and rape is double that in the country as a whole and eight to ten times higher than in West Germany (93:2). Uprooted from long-established urban communities by the Group Areas Act, or thrust off the land by drought and changing techniques of production in agriculture, the people of the Flats find themselves thrown into the cauldron of apartheid urban planning.

"The overwhelming impact of most low-income environments in South African cities is sterility. In large part, they are simply dormitories rather than living areas. People stream out in the morning and back at night. For those who stay there is little. Children play in the streets but it is not pleasant: the streets are usually exposed to the elements, scaleless and unsafe. The old have nowhere to sit or meet – it is difficult to find shade to escape the sun. A few hawkers attempt to scrape a living but, because of the ubiquitous spread of people and houses, it is difficult to find places that offer a brisk trade. Every township, every part of a township, looks the same. Above all, the public spaces are miserable" (163:31). "If the spaces are rich and vibrant, poverty does not become a badge: all people can experience the benefits of collective resources and all are equal in relation to those benefits. In these spaces, the poor have a chance to escape the poverty imposed by the inadequacy of their private means: the spaces act as extensions to the private dwelling units. When these spaces are poor, however, the total environment will be poor, regardless of the quality of individual dwellings (163:42).

Kew Town was one of the early organised housing schemes on the Flats. It is at the core of the "coloured" area and its social characteristics – its poverty, its fatherless homes – are similar to the rest of the townships on the Cape Flats (13:23). These characteristics include dense overcrowding – with an average of more than two persons to a room (compared with less than one half of one person in the more affluent white suburbs) – high levels of shared accommodation due to the chronic housing shortage, and soul-destroying lack of privacy.

Kew Town

Photographs by Paul Alberts

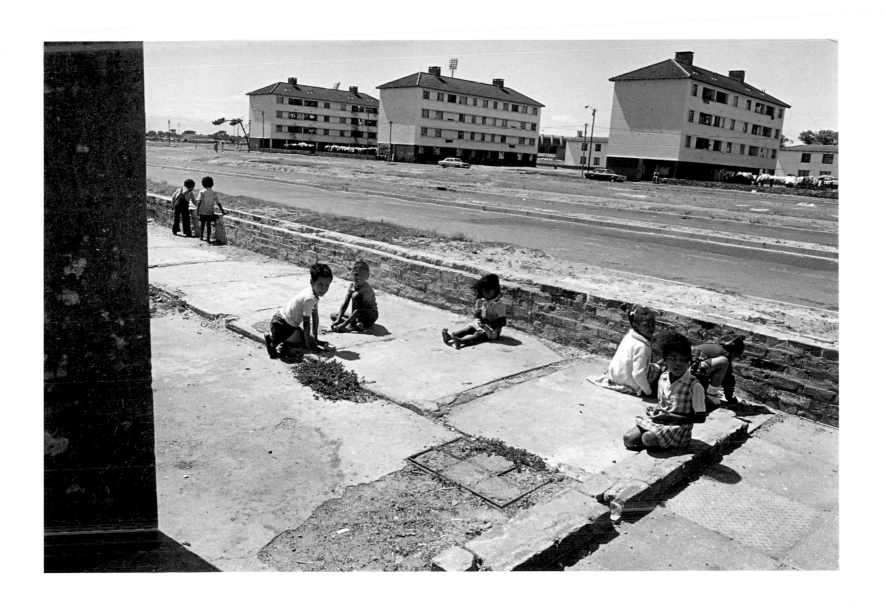

Council Flats, Kew Town 1979 **133**

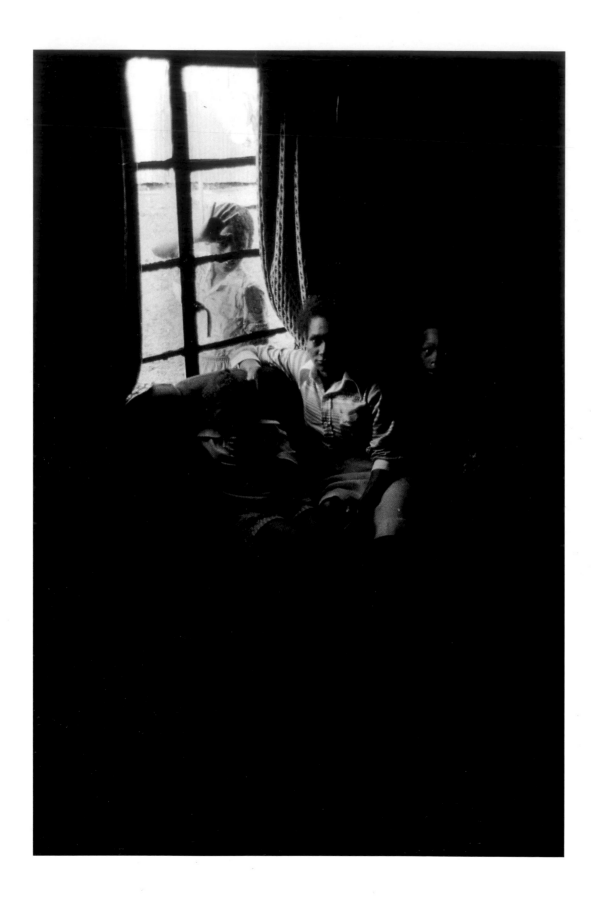

134 Kew Town 1979

Vagrants are found in every city of the world. Clearly their existence is partly a function of unemployment and lack of housing facilities. When times are hard, our society tends to throw many people out onto the streets.

In 1979 a local welfare organisation in Cape Town opened a night shelter in the centre of town where, for a nominal sum, people could get a bed for the night, a protein-enriched supper, bathing and washing facilities, and the opportunity to see a social worker. Much of the money to open the Haven came from public subscription, and the relevant cabinet minister was persuaded to grant a concession allowing "coloured" people to sleep in an area designated a white residential area.

Jan Duimpies lives at the night shelter:

"I was born in 1943 in the old location in Beaufort West (see p. 122). I was at the St. Matthews school. I went as far as Standard Six, but then, unfortunately, my mother could not afford it any more. I then began to work on construction. We built that scheme, the new location. Rustdene. That's my childhood. The only jobs you can get are actually labourer jobs. If you don't have work on the railways or on a contract then the life is very hard. You go and work there and you don't even get ten rand a week sometimes. What can you do with ten rand? That's why people come mostly to Cape Town . . . for a better salary. I'm a long time here already, though every year I go back home and then come back to my job. My mother and whole family are there. . . ."

"Jan is unmarried. He has no children. He has lived in the dormitory at the night shelter more than three years. He works for building contractors. When I spoke to him he had just been laid off. 'Especially now in the winter, you can't actually get work. They have to lay lots of us off because there is only inside work. . . .' " (35:45-46).

The Haven Night Shelter

Photographs by Michael Barry

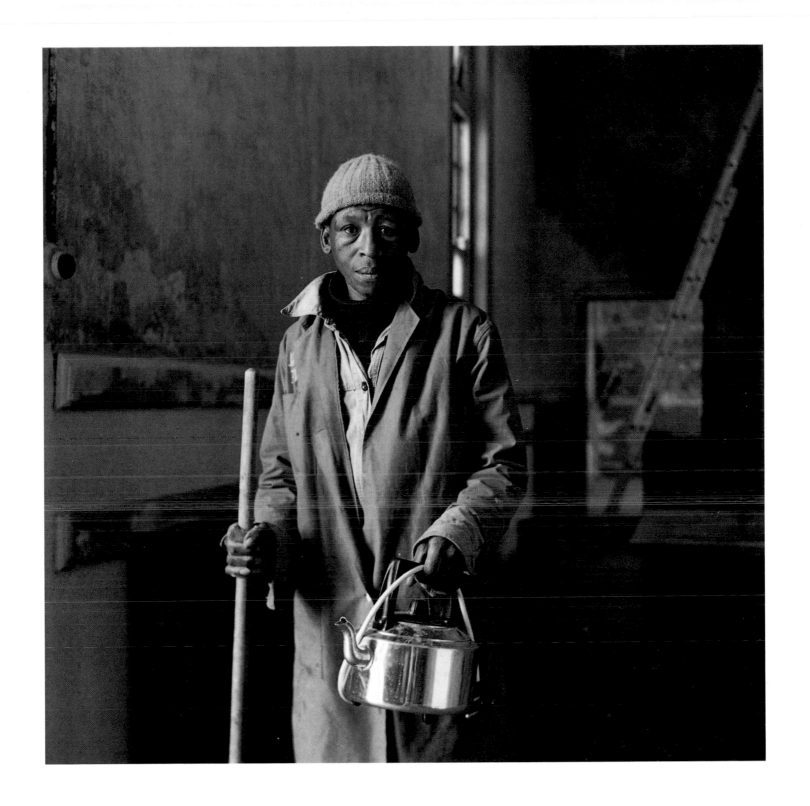

Mr. Peter Oliphant, The Haven Night Shelter 1981 **137**

138 The Haven Night Shelter 1980

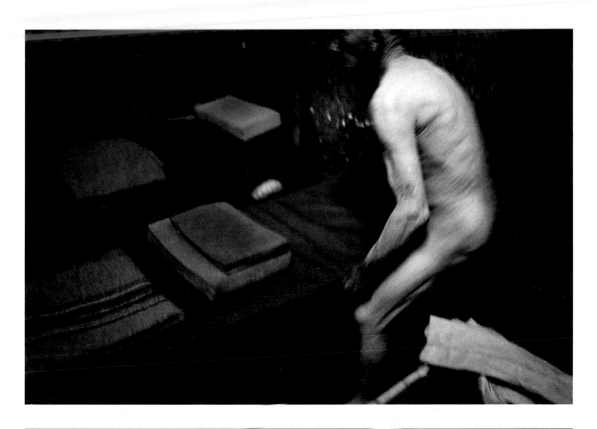

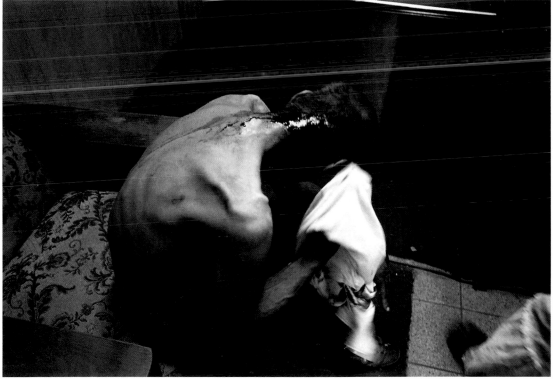

The use of child labour highlights one of the central dilemmas of poverty. Should parents, or society, prohibit a child from working if that work is vitally necessary in providing income, in cash or kind, which helps a poor family to survive? Everything depends, of course, on the conditions under which the child must labour. The outlawing of the employment of young children in the coal mines of nineteenth century England or in the Dickensian factories was generally agreed to be necessary. However, there were, even then, proponents of free enterprise who argued that the market should be allowed to regulate these matters and that the state should keep out. On the other hand, children helping their fathers to herd cattle in the evenings or fetching water for the household or spending an hour or two delivering morning newspapers on their bicycles before school to help pay for textbooks are all seen to be engaging in legitimate activities. What, then, of the five hundred newspaper vendors working on the streets of Cape Town? At the beginning of 1983, it was found that their average age was sixteen years. Most were sons of Xhosa-speaking workers living in the sprawling squatter communities of the city. Consider this profile of one of them at that time.

Sixteen-year-old Vusumi was typical of the workers. He lived in Crossroads with his mother, father, and unemployed elder brother in a six-room corrugated iron and wood shack that they shared with two other families. Since 1960, his father had been a migrant worker and had lived in one of the "bachelor" compounds at Langa. But in 1980, he decided to call his wife and son Vusumi to come from the Transkei so that they could live as a family in the squatter settlement. Four other children stayed with relatives in the Transkei. Vusumi and his father were the only ones working in the family. His mother, a domestic worker, had lost her job after being arrested for living in Cape Town illegally.

Vusumi left school when doing Standard Two, on the grounds of ill health. He started work as a vendor in November 1982, and he earned in the region of R35 a week. He got up at 3:00 a.m. to get to his beat. He carried, he said, one hundred thirty to one hundred forty newspapers a day. The money he earned was handed by him to his father, who gave him R5 a week for food at work.

Because of the great deal of publicity given to the conditions of this child labour, partly as a result of this selection of photographs, and the work of social welfare and trade union organisations, the vendors' lives began to change. They are now members of a union, and by the end of 1985 they had won a number of major victories.

Newspaper Vendors

**Photographs by
Paul Alberts**

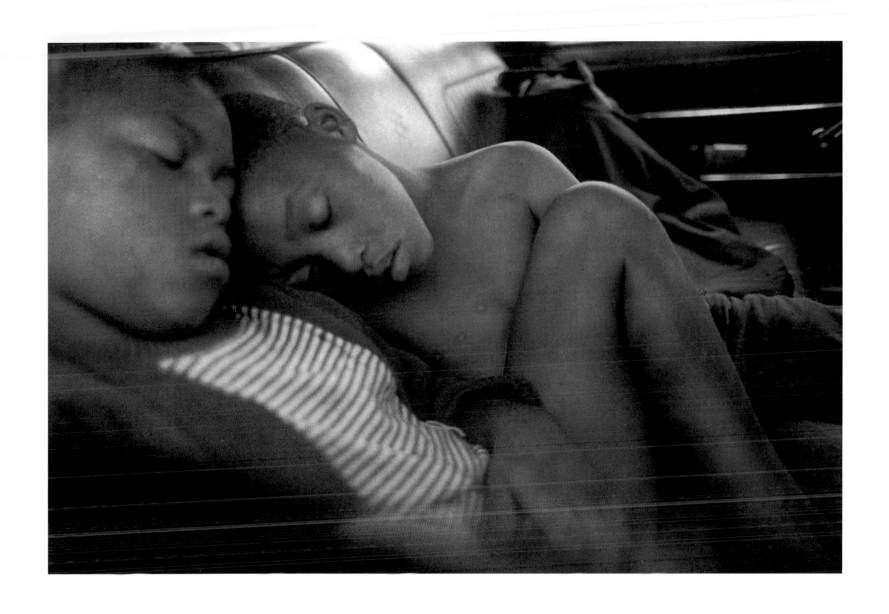

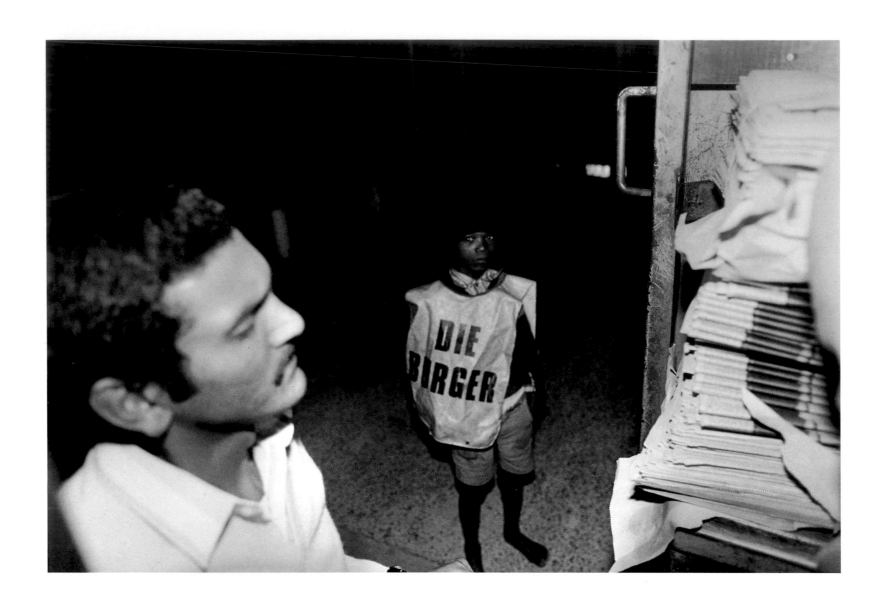

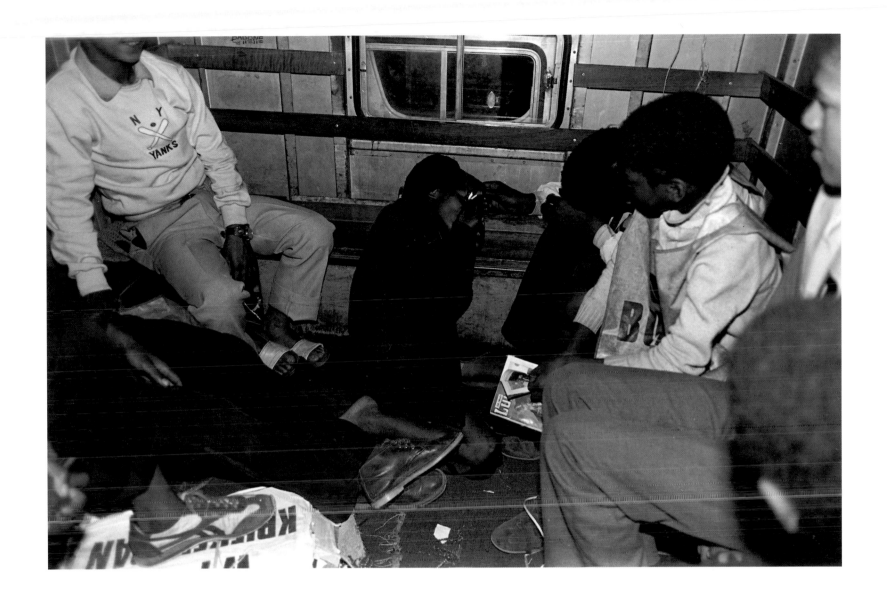

A striking feature of the Carnegie research reports on poverty in South Africa is how many of the respondents mention the lack of recreational facilities, not only in the cities but also in the small towns and on farms. Boredom can be one of the most deadly aspects of being poor – and a major cause of alcoholism.

In Hanover, a small town in the Karoo, ''The lack of recreational facilities adds to the feeling of frustration about employment, housing, etc. The park in the dorp is for white people, although a plot of ground in Tornadoville is supposedly earmarked for a playground. There are two rugby fields and one tennis court virtually unused. Besides the lack of organisation there is no money for equipment like rugby balls, tennis racquets, balls, and other items. Black inhabitants relax in their gardens or sandy yards; children play in the sandy 'streets' or veld until sunset. There are no cinemas in any of the townships although occasionally one of the churches arranges an evening of films for fund-raising. Disco-dancing is held once in a while in an old dilapidated building which served as a church before. The intake of alcohol and drugs increases over the weekends when people have more leisure time as '. . . the need for some means of escape from an unacceptable condition, grows' '' (34:20).

Throughout the country there are three difficulties with regard to recreation. Individuals may themselves be too poor to afford access to amenities that exist. The community itself may be too poor and powerless to have those playing fields, parks, and other public amenities that people use in order to have fun. And third, in the South African context, the facilities may exist but the poor are kept out by racist regulations that decree that certain cinemas or clubs or beaches are for whites only. During recent years some of these racial barriers have begun to crumble. But even in the 1980s many beaches remain segregated. During the December holidays, when the (white) Transvaalers come to the coast, police continue to enforce the law by evicting black holiday-makers off the ''white'' beaches.

Despite the meanness of a society that excludes so many because they are poor or because they are black, people still manage, as these photographs show, to have fun.

Segregated Weekend

**Photographs by
Joseph Alphers and Michael Davies**

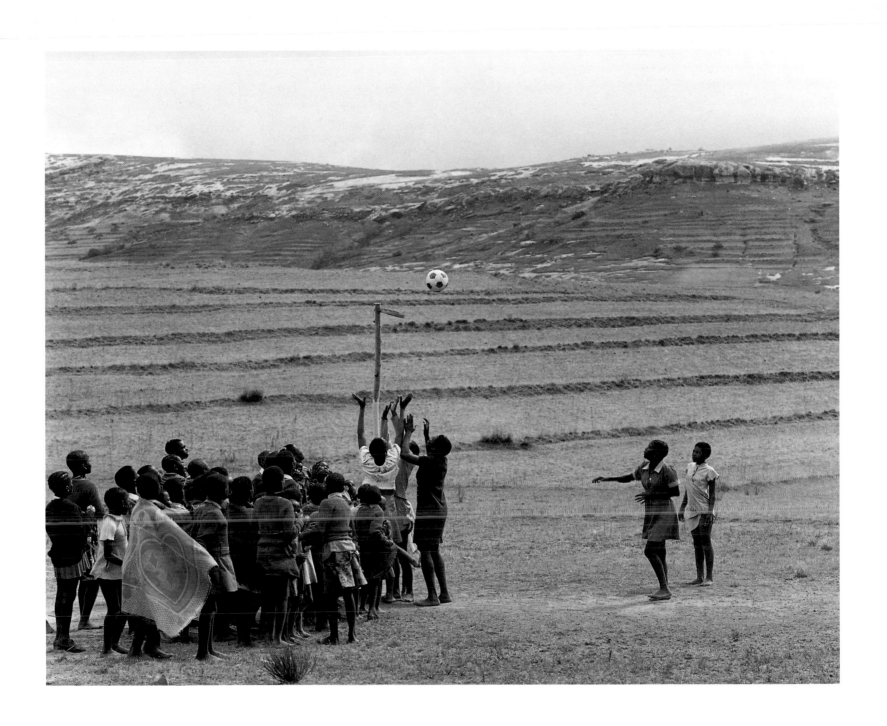

Silwerstroomstrand, Cape 1984 *Michael Davies*

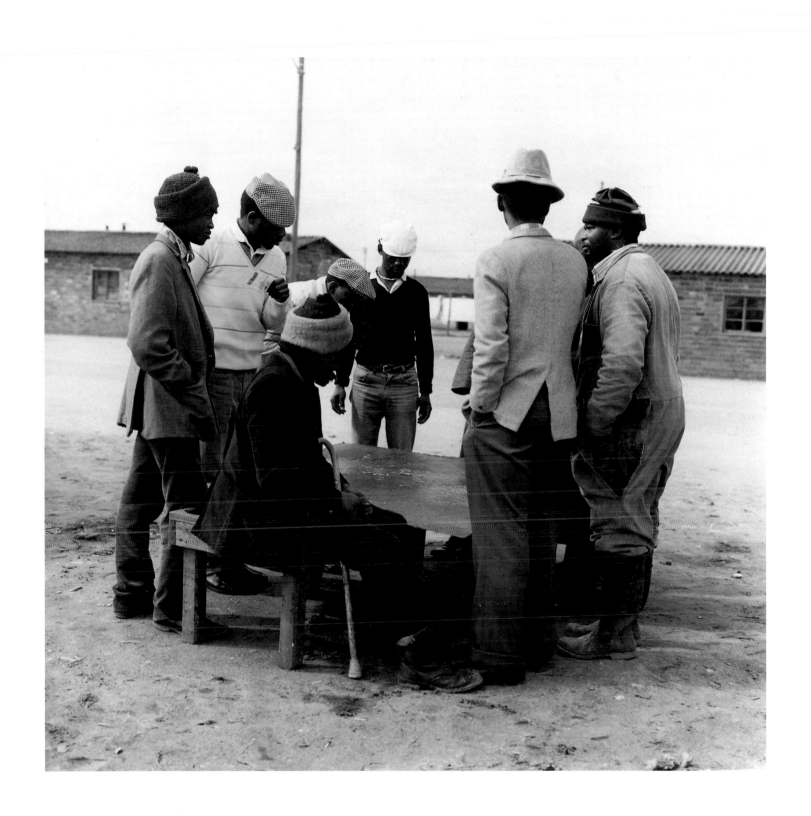

Gambling, Guguletu 1983 *Michael Davies* **147**

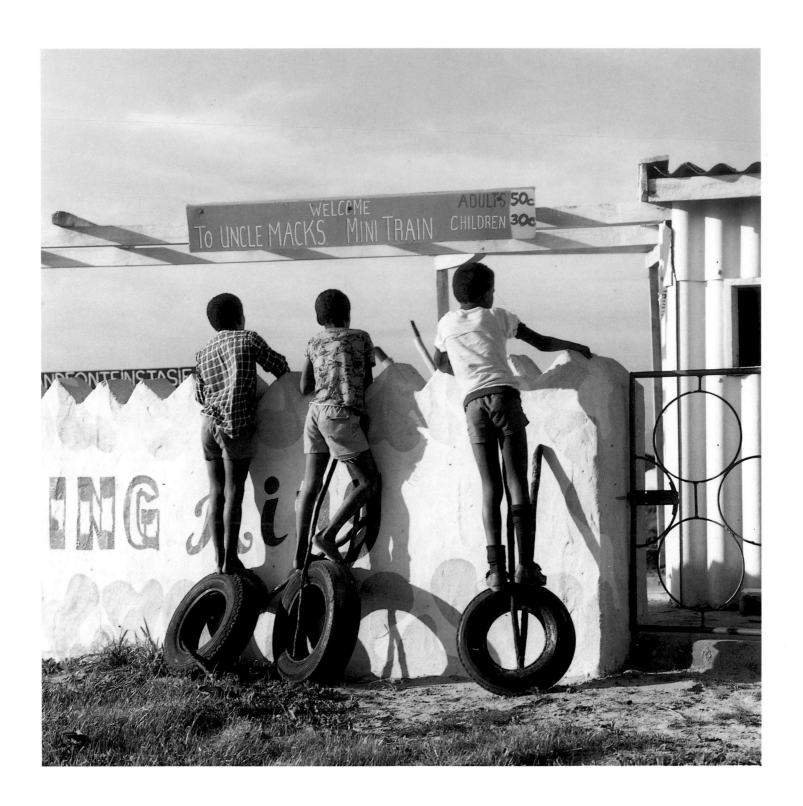

148 Amusement park, Strandfontein, Cape 1983 *Michael Davies*

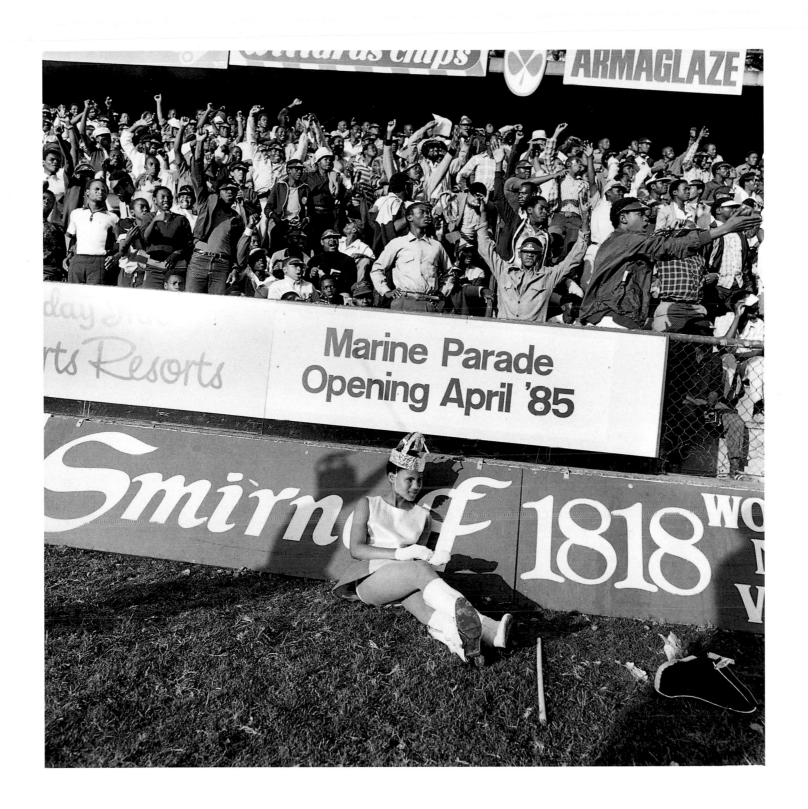

Soccer stadium, Durban 1984 *Michael Davies* **149**

One in three African women workers in South Africa does a service job, including domestic work. Conditions of service vary widely, but, in general, domestic workers, together with women in agriculture, "earn the lowest wages, work the longest hours, suffer bad working and living conditions and have little job security. Furthermore they have low status occupations and are in extremely vulnerable positions in relation to their employers" (114:3).

Trade unions for domestic workers are beginning to emerge, but there are no laws or regulations governing overtime, general conditions of work, or minimum wages. Indeed, industrial legislation specifically excludes domestic workers from its ambit. Thus there is little legal protection against abuse by employers of the power they wield over workers, who are often constrained, by pass laws or absence of alternative accommodation, from trying to change their jobs. Not only does the law fail to protect domestic workers adequately; at times it is used specifically to harass them. "The 'key-law' (recently applied in parts of Cape Town) reduces domestic workers to common criminals. The police have use of duplicate keys, which enables them to enter the rooms of domestic workers at any time. This makes it nearly impossible for domestic workers to have their husbands and/or children with them" (114:14).

But domestic work remains one of the few options open to "unskilled" black women needing to earn money. Through domestic service, young rural women can "break away from the poverty and monotony of rural life" (114:13). They can get a place to stay, earn some money, and (if they are African) hide from the police seeking to arrest those who have moved from rural areas to town without special permission.

But their illegal status and the absence of alternative jobs leave them very vulnerable to exploitation by those, both white and black, with more security. "A growing problem area is the practice of middle-class black families employing domestic workers at ultra-low wages" (114:23).

At the other end of the service sector, however, important changes are taking place. As Lesley Lawson explains, "In the 1970s new service jobs became increasingly important in city life. These were jobs like office cleaning, hairdressing, cooking in fast food shops, waitressing, and tea-making. Before, many of these jobs were done by women in the home. For example, housewives or domestic workers cooked all the meals and washed all the clothes a family would need. But as more women went out to work, this began to change. Small businesses outside the home began to offer these services. Many black women moved out of domestic service into these new jobs in the service sector."*

Earnings from service sector jobs are generally better than they are in domestic service, but the work is often arduous, and the workers remain subject to the special vulnerabilities that affect those who are women and black in the South African economy.

* Lesley Lawson, *Working Women,* prepared by Sached, Johannesburg, Ravan Press, 1985.

Service Workers

Photographs by Lesley Lawson

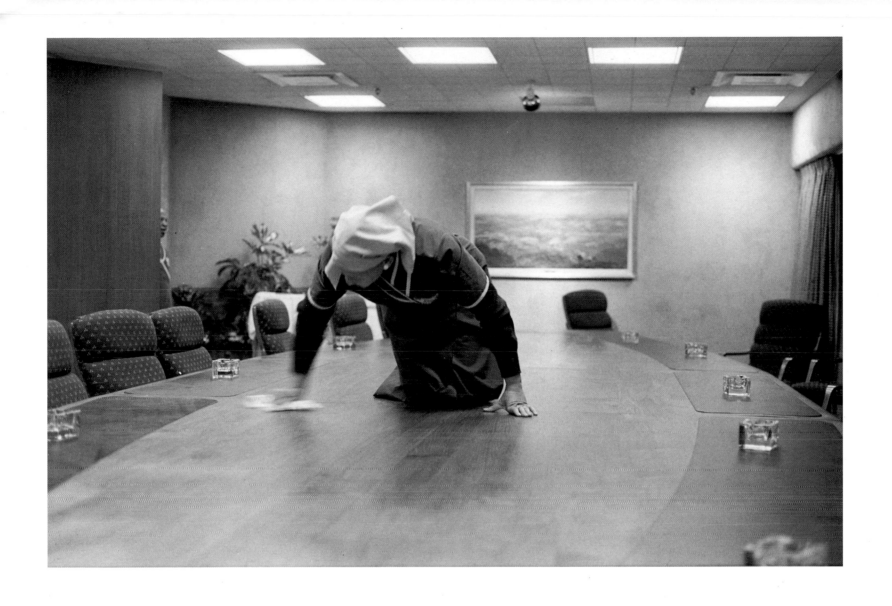

Office cleaner, Johannesburg 1984 **151**

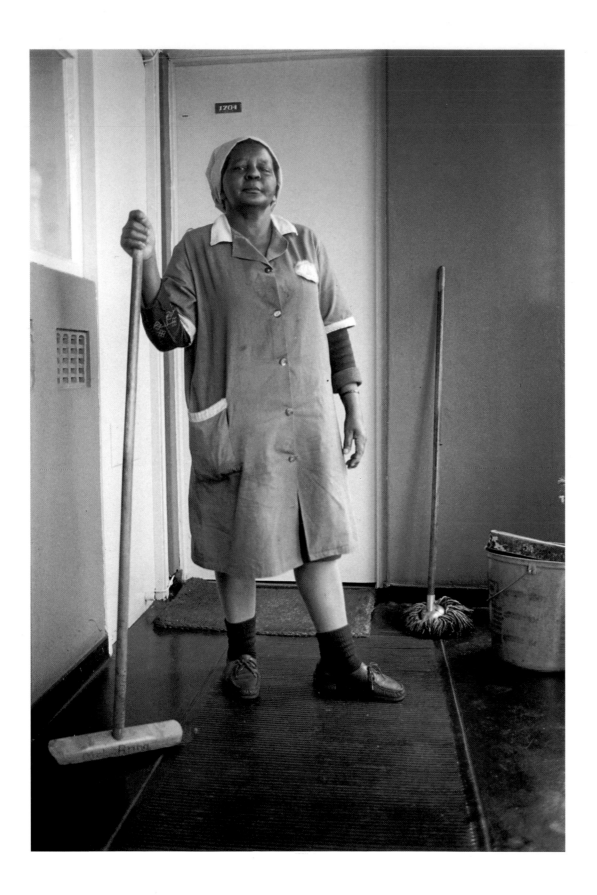

152 Mrs. Anna Moloi, apartment cleaner, Johannesburg 1980

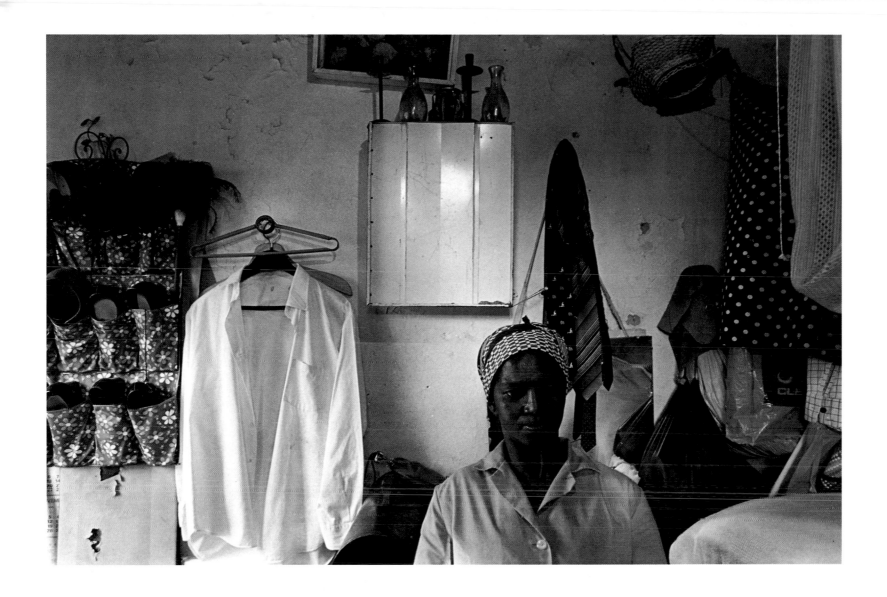

Domestic worker in her khaya, Johannesburg 1985 **153**

"Asinamali" – "We have no money" – has become one of the rallying cries of the black working class trade union movement. The turbulent history of that movement down the years has now culminated in the creation of the most powerful national nonracial federation since the crushing of the South African Congress of Trade Unions in the early 1960s. The formation, in December 1985, of COSATU, the Congress of South African Trade Unions, was a major achievement, although it is too early to tell whether it will live up to the high hopes vested in it. More than thirty unions with a total paid-up membership of almost half a million workers, most of them black, were brought together in the country's biggest labour federation. Although some black trade unions refused to join the new body, it nevertheless remains true that black workers in the South African economy are probably more organised and more united than they have ever been.

This achievement is all the more remarkable considering the assaults by the state on the labour movement, many of whose leaders have, down the years, been banned. (They are thus prohibited from meeting more than one other person at a time, barred from all factory premises, forbidden to address any gatherings, not allowed to prepare anything for publication. In effect they are declared nonpersons and social lepers, whose very words may not be quoted during the period of banning, which might last five years or more in terms of an order that cannot be challenged in any court of law.) Others have been jailed or exiled. Some, including Luke Mazwembe and Neil Aggett, have even died while in detention.

Against this background, then, the recent growth of the independent trade union movement is all the more remarkable when measured by the criteria of membership, organisational strength, and political demands. Sparked off by a wave of strikes, which began in Natal late in 1972 and spread rapidly to other parts of the country, the establishment of a vigorous trade union movement rooted in the black working class is the single most significant shift in the balance of power between black and white in South Africa since the National Party gained control of the country in 1948.

The impact of the unions can be measured at a number of different levels (108:43). The evidence suggests that through the 1970s the unions played an important role in pushing up real wages without unduly affecting employment. Moreover, the growth of the unions and the threat of worker action did much on the factory floor to alter the balance of power. Hence relations between workers and management have changed, compelling management to give more emphasis to the welfare of the workers.

Also, at a national level, the presence of the trade unions has helped to shift the balance of power within the political economy. Stoppages or stay-aways in support of wider political goals have been used sparingly but effectively to communicate the message to the economic and political establishment that the old order will have to change.

In the struggle against poverty, for economic justice, and for full political participation by all those living in South Africa, the trade union movement has a crucial role to play.

Asinamali

**Photographs by
Omar Badsha and Paul Weinberg**

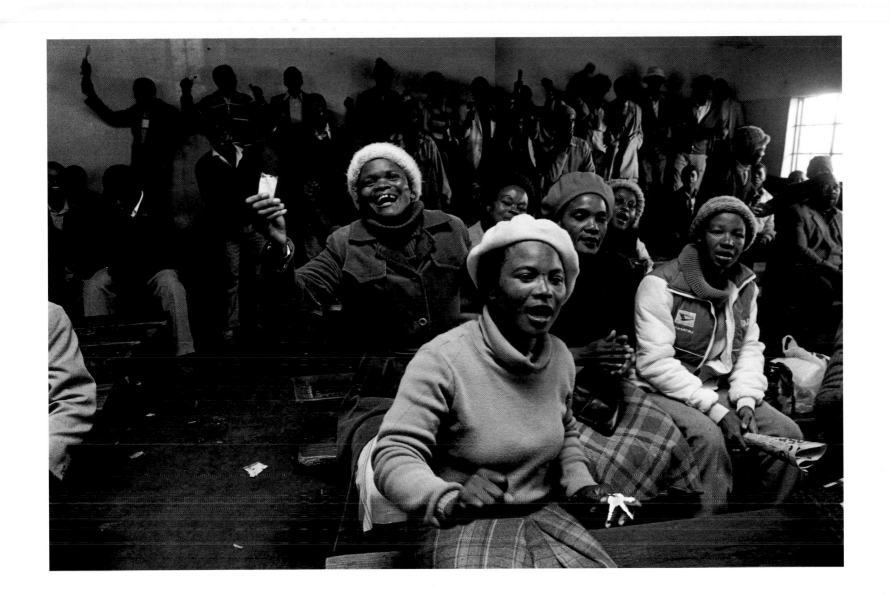

BMW workers on strike, Pretoria 1984 *Paul Weinberg* **155**

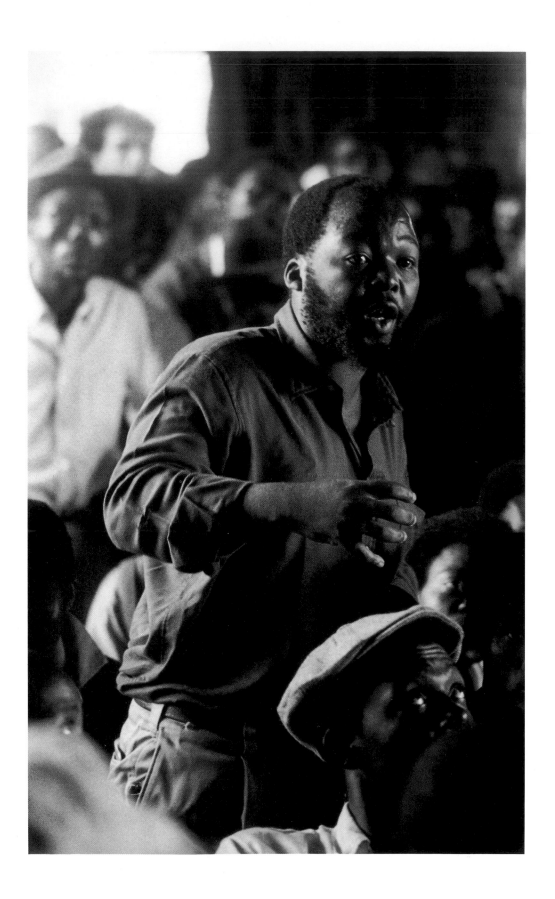

156 Alfa Romeo workers on strike, Johannesburg 1984 *Paul Weinberg*

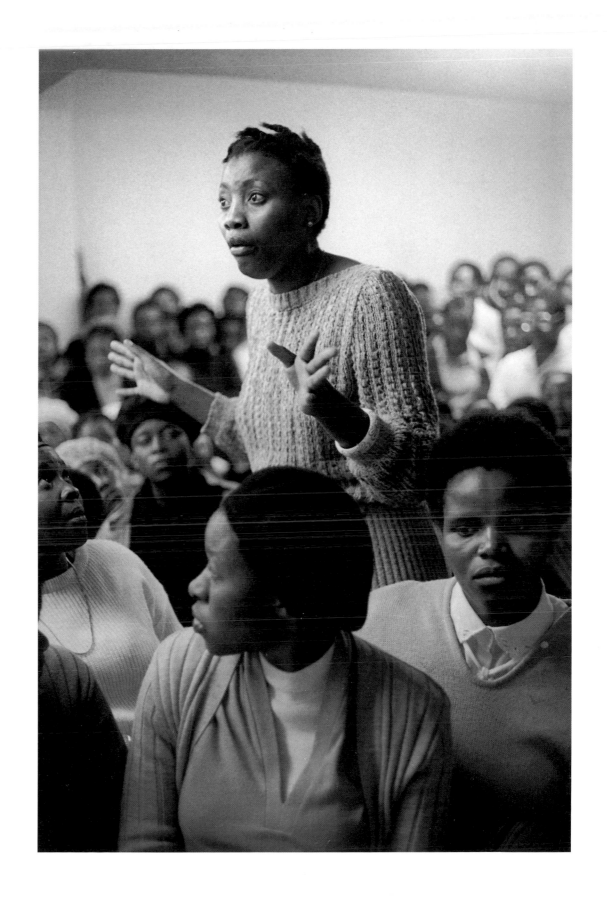

OK Bazaar workers on strike, Johannesburg 1982 *Paul Weinberg* **157**

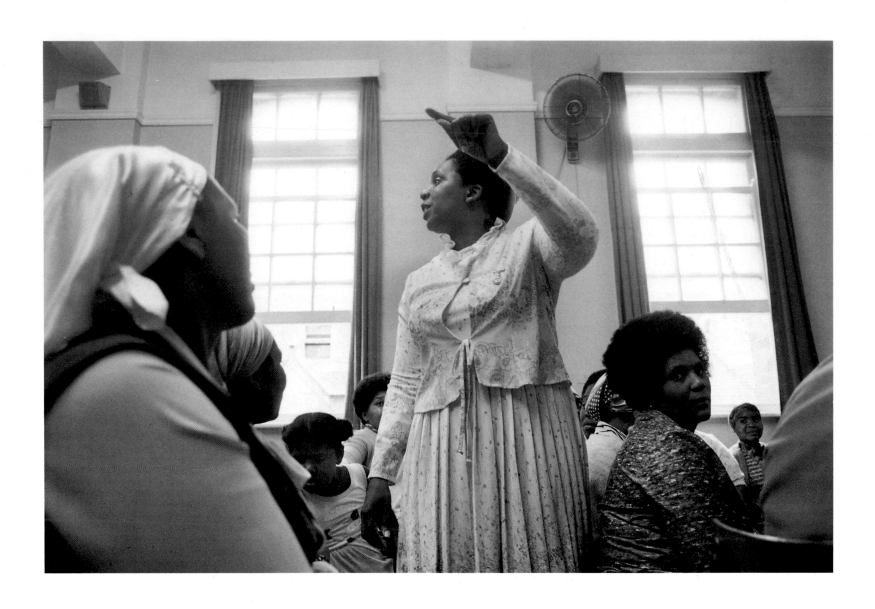

158 Shop workers discuss strike action at Parish Centre, Durban 1984 *Omar Badsha*

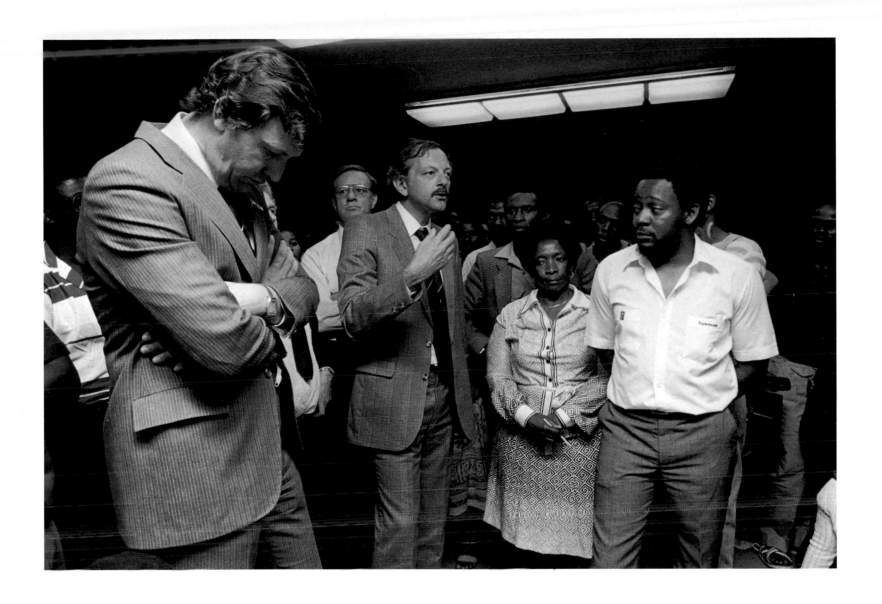

Negotiations between management and workers,
Pick 'n Pay strike, Johannesburg 1984 *Paul Weinberg*

A necessary condition for coming to grips with poverty in any society is that the poor must have political power and be able to participate effectively in the decisions that affect their lives. This is especially true in a country like South Africa, where the majority of people are denied the basic democratic right of voting for or against the government that not only rules their lives, but also exercises enormous power over the economy and the decisions that shape its structures.

The potential power of blacks in the political economy is immense, but it is only by organisation that such potential can be transformed into an effective power. This is clearly understood by the all-white ruling party, which acts ruthlessly to tame, or even break, any organisation that threatens to contribute to this transformation.

In South Africa, down the years, political movements, trade unions, and student organisations have been banned, their leaders harassed, some even killed. In 1985 the banning of the Congress of South Africa Students (COSAS) and the crackdown on the leadership of the United Democratic Front (UDF) was but one more stage in a long line of state action over decades. The repression stretches back from the crackdown on the black consciousness movement in the 1970s, through the banning of the major African political movements in 1960 and the removal of Africans from the common voters' roll in 1936, to the wars of conquest in the nineteenth, eighteenth, and seventeenth centuries.

The introduction of the 1984 tricameral constitution, and the exclusion of Africans from participation in it, provided the focus for the emergence of a whole new range of political activity that found expression in a number of new movements, including the National Forum and the United Democratic Front. During 1985, education continued, as it had for the past decade, to be the centre of debate and of renewed action by pupils determined to change the structures of an authoritarian, inferior, and racist educational system.

But 1985 was qualitatively different from any previous year in the country's history. Perhaps it is best summed up in the words of a white South African trying to interpret to fellow whites his experience of attending the funeral of Andries Raditsela, the trade unionist who died of a head injury soon after being detained by the police in Tsakana township near Boksburg. "There were, by my reckoning, between 25,000 and 30,000 people at that funeral — a river of humanity as it made its way . . . to the cemetery. From all [whom] I spoke to that day the response was the same: 'Freedom is coming. They may kill some of us but there are lots more to take their places. . . .' Another huge funeral was held in Tsakana two days later, and yet another in the neighbouring Duduza two days later. To blacks they were two more important occasions in an evolving process. White South Africa doesn't even know they took place."*

For the majority of South Africans, 1985 was a year of funerals. But looking back, it will surely be seen that these deaths marked the beginning of an altogether new mood that, in turn, heralds the birth of a new society.

*Allister Sparks, in the *Eastern Province Herald*, 23 May 1985.

The People Organise

**Photographs by
Omar Badsha and Rashid Lombard**

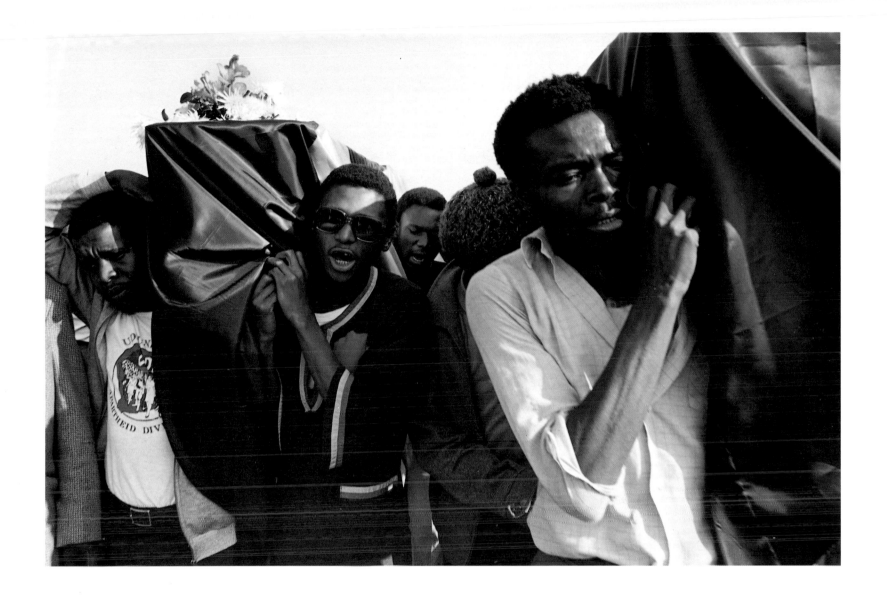

Funeral in KwaMashu of two ANC soldiers killed in clashes **161**
with the police outside Stanger 1984 *Omar Badsha*

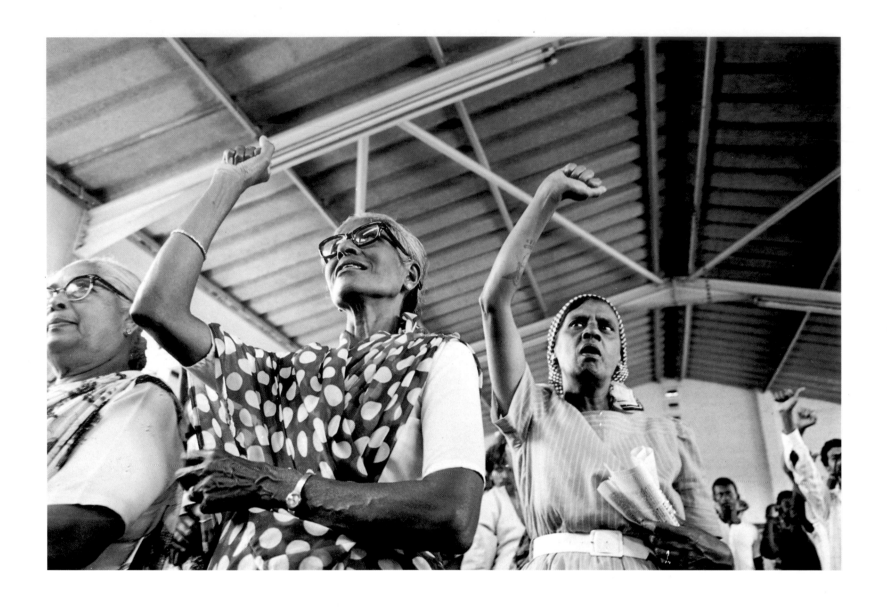

162 Commemoration meeting in Merebank for ANC members killed in
South African military raid into Maputo 1982 *Omar Badsha*

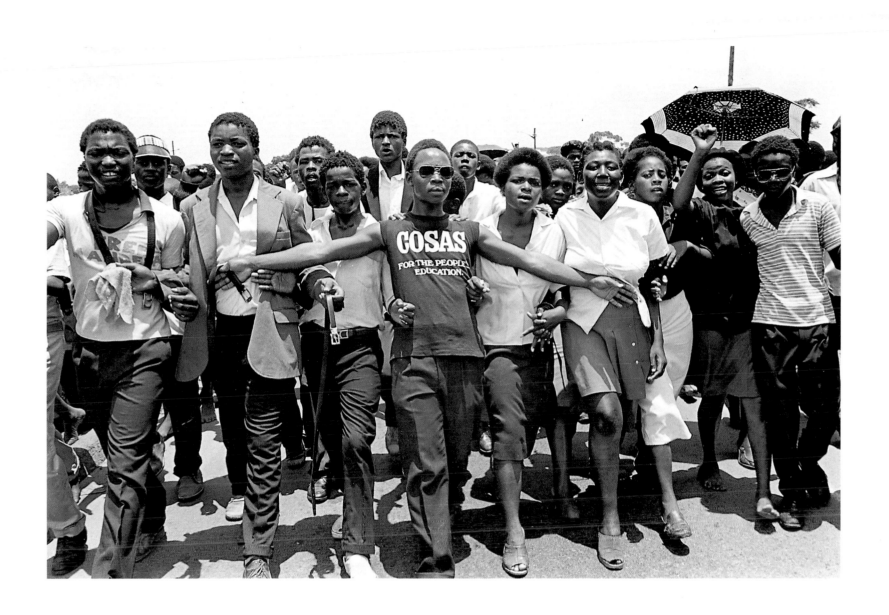

Students marching to funeral of COSAS member, **163**
KwaMashu 1981 *Omar Badsha*

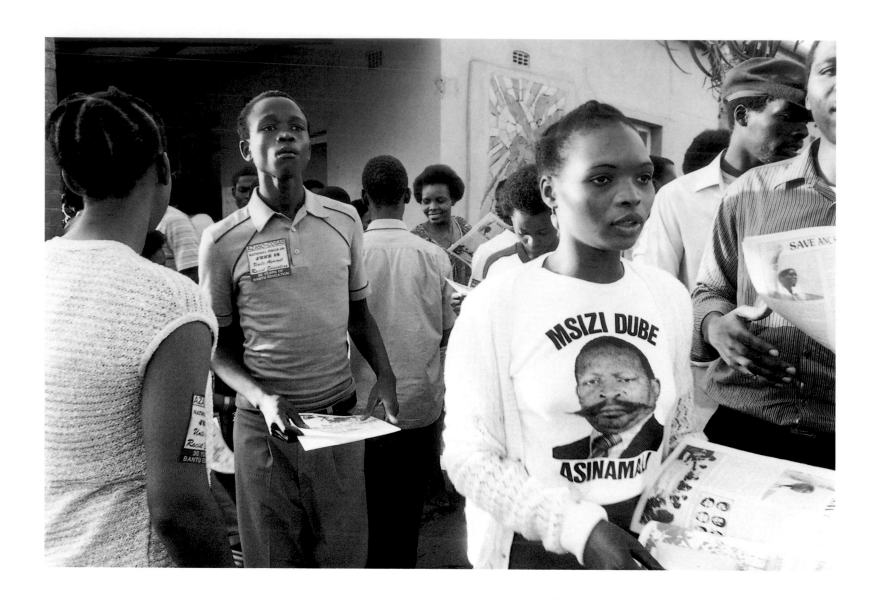

164 June 16th commemoration of 1976 Soweto uprising,
Phoenix Settlement 1983 *Omar Badsha*

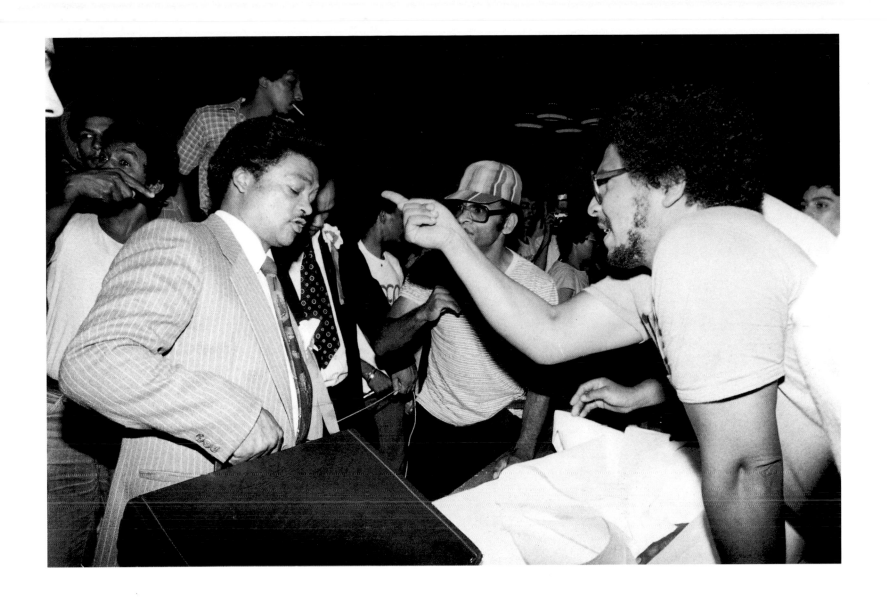

Students confronting a candidate for "coloured" parliament, **165**
Cape Town 1983 *Rashid Lombard*

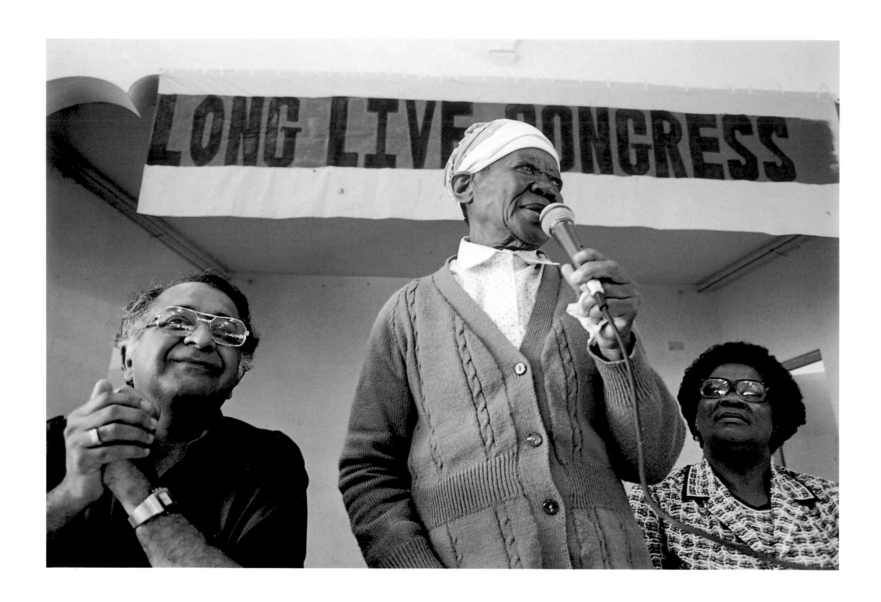

166 Dr. Essop Jassat, Mrs. Nokukhanya Luthuli, and Mrs. Albertina Sisulu
at a political conference, Durban 1983 *Omar Badsha*

Dr. Allan Boesak and Mrs. Helen Joseph at UDF meeting, **167**
Cape Town 1984 *Rashid Lombard*

Mr. Paul David, member of Natal Indian Congress, arriving at the airport **169**
after his release from detention, Durban 1982 *Omar Badsha*

GLOSSARY

Afrapix. Afrapix is a photographers' collective set up in 1982 to serve as a resource centre for community, student, and labour organisations. Today it runs a photo-library and agency and organises workshops and exhibitions.

African. The word is currently used to categorise those whose mother tongue is one of the Bantu languages.

African National Congress (ANC). Formed in 1912 and banned in 1960, the African National Congress is South Africa's major democratic political organisation. Its leaders have included Nobel Peace Prize winner, Albert Luthuli, and Nelson Mandela, imprisoned for life in 1964. The ANC is led by exiled leader Oliver Tambo.

Afrikaans. The mother tongue derived primarily from Dutch of nearly two-thirds of white, and the majority of "coloured," South Africans.

Afrikaner. Current usage refers specifically to whites whose mother tongue is Afrikaans.

Anglo-Boer War (1899-1902). The war that was waged between the British Empire and the two Afrikaner republics of the Transvaal and the Orange Free State over the question of hegemony in southern Africa. At issue was the mineral wealth of the Transvaal.

Antiurbanisation policy. The attempt by the apartheid planners to halt and reverse the pattern of African urbanisation. This is being implemented through Influx Control, housing policy, and the homelands policy. (See Reserves, Influx Control.)

Asian. See South African.

Baas. Afrikaans word for "boss," or "lord." Has connotations of servility. "Kleinbaas" refers to a "junior boss."

Bakkie. Afrikaans word for a pick-up truck.

Bantustans. See Reserves.

Blacks. A term used by the oppressed, under apartheid, to include as one African, Indian, and so-called "coloured" people.

Black Sash. An organisation, mainly of white women, set up in the 1950s to protest against attempts by the government to amend the constitution on the question of representation of "coloured" people in parliament. To distinguish themselves, members take part in public demonstrations wearing a black sash. The Sash, as it is commonly known, runs nationwide advice offices helping African people with problems encountered with pass laws and other aspects of apartheid.

Boer. Afrikaans, lit. farmer. Usually refers specifically to Afrikaners.

Borehole. Well sunk for underground water, using handpumps or windmills to extract the water.

Cape Flats. Beyond the fertile areas around the base of Table Mountain lie the sandy, windy stretches of the Cape Peninsula called the Cape Flats. Now covered by vast segregated housing estates and squatter camps for "coloured," Indian, and African people.

Chalumna. Region of the eastern Cape in Ciskei, west of East London.

Chamber of Mines. The controlling and co-ordinating body created by the gold- and coal-mining industries to regulate wages, working conditions, and recruitment of its workforce.

Coloured. See South African.

Congress Movement. An alliance of political organisations that adopted the Freedom Charter as a common platform and that was active in South Africa, particularly during the 1950s. Includes the African National Congress (ANC), the South African Indian Congress (SAIC), the Congress of Democrats (COD), the "Coloured" Peoples' Congress (CPC), and the South African Congress of Trade Unions (SACTU).

Compounds/hostels. As migrant labourers are not allowed to bring their wives and families with them, the accommodation they are given is in large single-sex hostels or barracks, or well-guarded compounds, erected as much to keep women and children out as to provide quarters for the workers.

Congress of South African Students (COSAS). An organisation for high school students, which was banned (declared to be an illegal organisation) in 1985. It was affiliated to the United Democratic Front.

Contract labourer. Under the migrant labour system, a man in the reserves enters into a contract for a maximum of twelve months. Some employers obtain their labour through private recruiting organisations, others apply directly to the state-run labour

bureaux. In some instances, the employer (or a recruiting organisation) sees to the remittance of a portion of the worker's wage to his family living in the rural area.

Crossroads. A squatter camp adjoining Cape Town's black townships.

Dagga. Marijuana.

Department of Cooperation and Development. That department of the government dealing with African people and their affairs. Initially the Department of Native Affairs, it has been renamed the Department of Bantu Affairs, then the Department of Plural Relations and Development, and now Cooperation and Development.

District Six. An area of Cape Town adjacent to the city centre, which was largely occupied by "coloured" people until 1966 when it was proclaimed a white area in terms of the Group Areas Act (1950). All the "coloured" people were moved out by the 1980s. Today the area stands unoccupied.

Dongas. Great gullies in the countryside caused by soil erosion.

Dorp. Afrikaans, lit. town. Usually refers to small rural towns.

Exchange rate. The dollar value of the rand has fallen dramatically in recent years. In January 1981, the rand was worth $1.34. By January 1985 it had fallen to 46 cents and by the end of the year was down to approximately 37 cents. These dramatic changes make conversion of rand values of wage rates or pensions into dollar terms virtually meaningless.

Forced removals. In terms of the Group Areas Act and land legislation, South Africa was divided into areas for different "racial groups." Where black people had been living, sometimes for generations, on land now regarded by law as allocated to white people, they would be forcibly removed and relocated to the reserves.

The Great Trek (1834-1854). A migration of white, mainly Dutch, farmers from the Cape Colony into the interior of southern Africa which resulted in the formation of the Boer republics (Transvaal and the Orange Free State). The Great Trek is regarded by the Afrikaners as the beginning of their group identity.

Group Areas Act (1950). One of the major cornerstones of the Nationalist government's apartheid policy. This act consolidated the principle of establishing geographically separate areas, particularly in the towns, for the different population "groups" as defined in the Population Registration Act of 1950, i.e., virtually all urban areas were demarcated into separate African, Asian, "coloured," and white areas.

High Commission Territories. When the Union of South Africa was established in 1910, by uniting the two British colonies of the Cape and Natal with the Boer republics of the Orange Free State and the Transvaal, the three adjacent British protectorates of Basotholand, Bechuanaland, and Swaziland were not included. In the 1960s they each gained independence from Britain and are now the independent states of Lesotho, Botswana, and Swaziland.

Homelands. See Reserves.

Hostels. See compounds.

Induna. In traditional African society, the induna was an advisor to a chief. Occupying a respected position, he acted to restrain the theoretical absolute power of the chief. Large employers used indunas to supervise their workforce. Today foremen or supervisors in many workplaces are still referred to as indunas.

Influx Control, pass laws. A huge body of laws that restrict the movement of the African people from the rural to the urban areas and within the urban areas themselves. These laws also determine where Africans should work, and they lay down the conditions for the

right to live and work in white urban or rural areas. The movement of the African people is regulated by a system of passes. All adult Africans (i.e., over the age of sixteen) are required to carry at all times a pass on their person, which provides the proof of the bearer's right to be in a white area, to work there, or to live there.

Inkatha. A largely Zulu cultural/political organisation, led by Chief Mangosuthu Buthelezi, chief minister of the semi-independent homeland of KwaZulu.

June 16. Now regarded as a day of remembrance for the 1976 students' revolt in Soweto and other parts of South Africa. 16 June 1976 was the first day of protest against Bantu education, which lasted sporadically for a year and cost the lives of 800 people.

Kaffirs. Derogatory term for Africans.

Karoo. The inland plateau stretching from north of Cape Town almost to the Orange Free State and east toward Port Elizabeth. Good sheepfarming country, but arid semidesert, and inhospitable for human habitation.

Khaya. Originally the Nguni word for "home," the term is now sometimes also used for "servants' quarters."

Kwashiorkor, marasmus, pellagra. Protein energy malnutrition manifests itself in kwashiorkor and marasmus. Kwashiorkor arises from a relative deficiency of protein in the diet, and marasmus is due to an absolute deficiency of energy intake. Kwashiorkor is marked by failure to thrive, weight loss, and eventually oedema, hair-curl loss, dermatitus, change in pigmentation, and persistent diarrhoea. Marasmus involves a wasting of subcutaneous fat and muscle, often gastroenteritis, and the infant has a "wizened monkey" face. Pellagra is a Vitamin B complex deficiency state, characterised by dermatitus (photosensitivity), diarrhoea, and, if prolonged, dementia.

Marasmus. See Kwashiorkor.

Meneer. Afrikaans word, lit. "Mister."

Mielies. Maize, corn.

Migrant labour system. The system of labour supply whereby Africans from the reserves or "homelands" are allowed to work in white areas for limited periods of time and then have to return to their homes to renew the labour contract. A migrant labourer is not allowed to bring his wife or family with him to the urban areas.

National Forum. A forum to which a large number of progressive organisations adhere. In 1983 the first National Forum formulated the Manifesto of the Azanian People.

National Party (NP). A political party formed in 1914 to give expression to the political aspirations of the nationalists among the Afrikaner people. The National Party held office from 1924 to 1933, when a section of the NP combined with the South Africa Party to form the United Party. This led to a split among the Nationalists, and a reformed or "purified" National Party was established. This party took office in 1948 and has been in power since then. It is currently led by President P. W. Botha.

National States. See Reserves.

Ntate. The Sotho word for "grandfather," "old man," a term of respect.

Sir Ernest Oppenheimer (1880-1957). Founder and first chairman of the Anglo-American Corporation, South Africa's major industrial giant.

Pass laws. See Influx Control.

Pellagra. See Kwashiorkor.

Platteland. The platteland is generally regarded as those parts of white-owned South Africa outside of the major metropolitan areas. It includes all of the rural areas and the small towns (or "dorps").

Poverty Datum Line, (PDL). The Poverty Datum Line is the theoretical minimum amount of money calculated to purchase a family's basic requirements for maintaining health and welfare in the short term only. The effective PDL is approximately 50 per cent more than this. It takes account of further vital expenditures including recreation and pension contributions that have to be made in the longer run. In 1985 the PDL for a black family of five, living on the Witwatersrand, was approximately R350 per month.

Real wage. The term is used to indicate that the wage is being valued after allowance has been made for inflation.

Reference Book, passbook. The identity document that all Africans are required by law to carry with them at all times. It contains, among other things, the necessary authorizations under the Influx Control laws for blacks to be in urban areas.

Reserves, Bantustans, homelands, or national states.
Reserves: When the Union of South Africa was established in 1910, it included the four provinces of the Cape, Natal, the Orange Free State, and the Transvaal, within which were scattered African reserves that comprised some 22.7 million acres or 7.8 percent of the land area of the Union. A process of defining the right to own land by race began and was achieved in the 1913 Land Act, which prohibited Africans from acquiring land outside of the reserves. In 1936, this Land Act was complemented by the Native Trust and Land Act, which provided for an increase in the size of the reserves so that the total set aside by the parliament for the reserves was 13 percent of the land area of the Union. Homelands and Bantustans: The Nationalist government stimulated by Dr. Verwoerd passed the Bantu Authorities Act in 1951, which among other things began to segregate the reserves along strict ethnic lines and shifted the power in the reserves from elected councils to the traditional chiefs. By the late fifties, the Nationalists had developed the concept of "national units" or "states"

defined on the basis of language and culture and began dividing the various ethnic units into "homelands."
National states: By 1976 the Nationalists began the last stage of their solution for resolving the question of African political rights. By setting up independent national states based on the former homelands, the Nationalists had hoped to bypass the question of political rights for Africans within South Africa. In 1976 the Transkei was the first of the homelands to become independent. Since then, Bophuthatswana, Venda, and the Ciskei have done the same.

Resettlement. See Forced Removals.

Rhodes, Cecil John (1853-1902). Mining magnate, imperialist, and politician, Cecil John Rhodes built a mining and industrial empire based on control of the diamond marketing industry (De Beers) and a large stake in the Reef gold mining (Consolidated Gold Fields). He was prime minister of the Cape from 1890 to 1896, when he was forced to resign after the scandal of the Jameson Raid, which sparked off the Anglo-Boer War. He helped colonise the land north of the Boer republics, which was then named after him.

Sharpeville. Now a symbol of resistance, Sharpeville is the township on the Witwatersrand where a protest against the pass laws in 1960 outside the Sharpeville police station resulted in the police opening fire on a peaceful protest, killing 69 people and wounding 178.

Sjambok. A long leather whip that acquired international notoriety in 1985 when used extensively by South African police.

Sotho. See South Africa.

South African. Southern Africa's indigenous people were hunters and gatherers. Subsequently, Bantu-speaking pastoralists and agriculturalists moved south from central Africa. Two major streams of migration were the Nguni, (Xhosa, Zulu, and Swazi) and the

Sotho (North, South Sotho, and Tswana). The Venda made up a third group to migrate and settled in the northern parts of Transvaal. Much later immigrations to southern Africa came from Europe and from India.

In terms of the Population Registration Act of 1950, all South Africans had to be registered as belonging to one of a number of ethnic classifications, viz. white, "coloured" and "native" (later called "Bantu"). Subsequent amendments added the category, "Asian" and various subcategories of "coloured."

South African Indian Congress (SAIC). The SAIC was made up of the Natal Indian Congress (NIC), established by M. K. Gandhi in 1894, the Cape Indian Congress, and the Transvaal Indian Congress (TIC). The SAIC was a leading member of the Congress Alliance in the 1950s. Today the NIC and TIC are leading organisations in the United Democratic Front.

Surplus People Project. The Surplus People Project was established in 1979, and funded by nongovernmental agencies as a national research project to investigate forced removals under the Nationalist government's policy of relocation of people. A five-volume report, *Forced Removals in South Africa,* was published in 1983, and a one-volume condensation of the full report was published by Ravan Press in 1985.

Suppression of Communism Act. Passed by the Nationalist government in 1950, aimed primarily at suppressing the South African Communist Party and any other parties furthering the aims of the Communists as defined by the government. This act was used extensively to crush opposition (whether communist or not) to the government in the 1960s.

United Democratic Front (UDF). A non-racial popular movement, drawing together over six hundred democratically based community, student, trade union, and church organisations in opposition to the 1984 constitution and, since then, a major legal oppositional force within the country against apartheid.

Vaal Triangle. The urban and industrial conglomerate of the areas of the Witwatersrand extending up to Pretoria and down to the Vaal River.

Veld. Afrikaans, lit. countryside.

Venda. See South African.

West Rand Administration Board. Administration boards were set up in the early 1970s as part of the government's restructuring of its control over the administration of the affairs of African people. The country was divided into various regions and the affairs of African people were controlled through administration boards in each region.

White. See South African.

Witwatersrand. Afrikaans for White Waters Ridge — the ridge in the Transvaal along which gold was discovered in 1886. The Witwatersrand now is the centre of South Africa's industrial and commercial activity.

Xhosa. See South African.

Zulu. See South African.

BIOGRAPHICAL NOTES

Paul Alberts was born in 1946 in Pretoria. He spent his youth in Botswana and northern Transvaal. Alberts has worked as a writer and photographer on various newspapers in South Africa, including a five-year period as arts editor of *Die Burger.* In 1981 he founded The Gallery Press and currently serves as its director. He lives in Cape Town and works as a freelance photojournalist.

Alberts's photographs are published in major magazines in South Africa and overseas. He has published four photographic books: *Die Klein Karoo,* Tafelberg, Cape Town, 1977 (with text by Abraham H. de Vries); *In Camera: Portraits of South African Artists,* H.A.U.M., Cape Town, 1978 (with text by Andre Brink); *Children of the Flats,* Reijger, Cape Town, 1980 (with text by George Gibbs); and *The Borders of Apartheid,* The Gallery Press, Cape Town, 1982.

Alberts has exhibited extensively in one-man shows in Cape Town and Johannesburg. He has contributed to a number of group shows including "Culture and Resistance," Botswana, 1982 and the Staffrider exhibitions in 1983, 1984, and 1985, and to the book and exhibition, Dieter Koeve & Tim Besserer, *Nichts Wird Uns Trennen* [Nothing Will Separate Us], Benteli Verlag, Bern, 1983.

Joe Alphers was born in 1949 in Umbumbulu and spent his childhood in Zululand. He has a Law degree from the University of Natal. After Law School, Alphers was employed as a photographer in a commercial studio in Pietermaritzburg and from 1978 to 1980 worked on the *Natal Witness* as a photojournalist. From 1980 to 1984, Alphers documented rock paintings in Lesotho for the University of Lesotho. He is currently the chief photographer for the University of Bophuthatswana and is a member of Afrapix.

Alphers' photographs have been used in South African newspapers and magazines including the *Rand Daily Mail* and *Reality.* His work was included in "Culture and Resistance," Botswana, 1982, and in the book and exhibition, Dieter Koeve & Tim Besserer, *Nichts Wird Uns Trennen* [Nothing Will Separate Us], Benteli Verlag, Bern, 1983.

Michael Barry was born in 1954 in Port Elizabeth. After schooling in Port Elizabeth, he worked as a computer operator and in 1976 moved to Cape Town to work as a sailor for Safmarine, a merchant shipping company. From 1978 to 1981, Barry studied at the Michaelis School of Fine Art at the University of Cape Town and in 1985, completed his Higher Diploma in Education there. While at Michaelis, he worked part-time at The Haven Night Shelter in the dock area of Cape Town and became the supervisor at the Shelter for one year.

Currently, Barry is pursuing painting and photography as well as teaching art in a state high school in Port Elizabeth. Barry is a member of "Vukalisa" ("Enlighten" in Xhosa), an artists' collective that works in communities to encourage cultural activities.

Barry's photographs have been included in numerous group shows in the Cape Peninsula including an exhibition organised by The South African National Gallery, "Young South African Photographers," 1981.

Omar Badsha was born in 1945 in Durban. He is a self-taught artist who turned to photography in 1976. Badsha was active in the Trade Union movement and helped establish the Chemical Workers Industrial Union in 1974. He is a founding member of Afrapix, a South African photographers' collective, and serves on the editorial board of the Staffrider Photographic Exhibition. Badsha is currently involved with the planning of the proposed Centre for Documentary Photography at the University of Cape Town.

Badsha's awards for painting include the Sir Basil Schonland Award, Art S.A. Today, 1965, and the Sir Ernest Oppenheimer Memorial Award, Art S.A. Today, 1969.

His photographs are published extensively by South African newspapers, community organisations, and the alternative press. He has published a book on children entitled *Letter to Farzanah,* Institute of Black Research, Durban, 1979 (which is banned in South Africa), *Ninety Fighting Years, A Pictorial History of the Natal Indian Congress,* NIC, Durban, 1984, and a book on forced removals entitled *Imijondolo,* Afrapix, Johannesburg, 1985 (with text by Heather Hughes).

Badsha has exhibited widely internationally and in South Africa where his photographs have been included in numerous group exhibitions including "Culture and Resistance," Botswana, 1982, and Stockholm Cultural Centre, 1984, and in the book and exhibition, Dieter Koeve & Tim Besserer, *Nichts Wird Uns Trennen* [Nothing Will Separate Us], Benteli Verlag, Bern, 1983.

Bee Berman was born in 1949 in Cape Town. After schooling she worked as a stage designer at The Space Theatre in Cape Town. Since 1980 she has worked as a theatre and news freelance photographer.

Berman's photographs are used extensively by community organisations and the alternative press. Her photographs were included in "Culture and Resistance," Botswana, 1982, the Staffrider exhibition, 1983, and the book and exhibition, Dieter Koeve & Tim Besserer, *Nicht Wird Uns Trennen* [Nothing Will Separate Us], Benteli Verlag, Bern, 1983.

Michael Davies was born in 1955 in Johannesburg where he spent his youth. After schooling he served his one-year call-up in the South African Airforce as a medical orderly. He then studied civil engineering at the University of the Witwatersrand for over three years before deciding to study at the Michaelis School of Fine Art at the University of Cape Town. Davies is currently completing a Master's degree in photography concerning the leisure activities of South Africans and working as a freelance photographer in Cape Town.

Davies has contributed to *Frontline* magazine and to various group exhibitions in South Africa including the Staffrider exhibition, 1985, the Festival of the Arts Exhibition, Grahamstown, 1985, and the Michaelis Staff and Senior Students Exhibition at the Market Photo Gallery, Johannesburg, 1985.

David Goldblatt was born in 1930 in Randfontein where he spent his youth and later worked in the family business, a men's outfitting shop. He has a Bachelor of Commerce degree from the University of the Witwatersrand. In 1963, Goldblatt sold the family business and began working full-time as a freelance photographer. He currently lives in Johannesburg and serves as the Director of Photography and Associate Editor of the magazine *Leadership S.A.*

Goldblatt's photographs are included in the permanent collections of the South African National Gallery, Cape Town; the Durban Art Gallery; the Bibliotheque Nationale, Paris; the Museum of Modern Art, New York; and the National Gallery of Victoria, Melbourne.

His publications include *On the Mines,* Struik, Cape Town, 1973 (with text by Nadine Gordimer); *Some Afrikaners Photographed,* Murray Crawford, Sandton, 1975; *Cape Dutch Homesteads* with photographer Margaret Courtney-Clarke, Struik, Cape Town, 1979; *In Boksburg,* The Gallery Press, Cape Town, 1982; and *Lifetimes: Under Apartheid,* Knopf, New York, 1986 (with text by Nadine Gordimer).

Goldblatt's photographs have been exhibited nationally and internationally and a retrospective exhibition of his work was organised by the South African National Gallery in 1984. Goldblatt contributed to "Culture and Resistance," Botswana, 1982, the Staffrider exhibitions, 1983, 1984, and 1985, and to the book and exhibition, Dieter Koeve & Tim Besserer, *Nicht Wird Uns Trennen* [Nothing Will Separate Us], Benteli Verlag, Bern, 1983.

Paul Konings was born in 1958 in New Zealand. He came to South Africa in 1975 to study at the Michaelis School of Fine Art at the University of Cape Town. He is currently working as a freelance graphic artist and photographer in Cape Town.

A selection of Konings's photographs was published in Don Pinnock, *The Brotherhoods: Street Gangs and State Controls,* David Philip, Cape Town, 1984. His photographs were also published in *Estate Wines of Southern Africa,* David Philip, Cape Town, 1976, revised and enlarged, 1983.

Konings contributed to "Culture and Resistance," Botswana, 1982,

and to the book and exhibition, Dieter Koeve & Tim Besserer, *Nicht Wird Uns Trennen* [Nothing Will Separate Us], Benteli Verlag, Bern, 1983.

Lesley Lawson was born in 1952 in Durban. She is a graduate of the University of Natal and received a Master's Degree in Science from the University of Manchester. On return to South Africa, Lawson moved to Johannesburg and worked as a writer and photographer for the South African Council for Higher Education (Sached). Currently, she works as a freelance photographer, writer, and audio-visual producer in Johannesburg.

A collection of interviews and photographs by Lawson was published as *Working Women,* Sached, Johannesburg, 1985. Her work has been published in national and international newspapers and magazines and is used extensively by community organisations and the alternative press.

Lawson had a one-woman exhibition entitled "Survivors" at the Market Photo Gallery in Johannesburg in 1982. Her photographs were included in "Culture and Resistance," Botswana, 1982, and the Staffrider exhibition of 1983, and in the book and exhibition, Dieter Koeve & Tim Besserer, *Nicht Wird Uns Trennen* [Nothing Will Separate Us], Benteli Verlag, Bern, 1983.

Rashid Lombard was born in 1951 in Port Elizabeth. In 1962, he moved with his family to Cape Town. Lombard is trained as an architectural draughtsman and currently works in the audio-visual department of a large construction company in Cape Town. Lombard also is a freelance photographer for national and international newspapers and is a member of "Vukalisa" ("Enlighten" in Xhosa), an artists' collective that works in communities to encourage cultural activities.

Lombard's photographs are used extensively by community organisations and the alternative press, such as *Grassroots.* He has contributed to various group exhibitions in southern Africa including University of Zimbabwe, 1983, and the Staffrider exhibitions, 1984 and 1985.

Chris Ledechowski was born in 1956 in Pretoria and spent his youth in Johannesburg. He attended Waterford kaMhlaba, a private boarding school in Swaziland, and is a graduate of the Michaelis School of Fine Art at the University of Cape Town. Ledechowski worked as a cameraman/director for Afroscope, an alternative film and video collective in Johannesburg. He is currently working as a freelance video cameraman and photographer in Cape Town and is a member of Afrapix.

Ledechowski's hand-tinted black and white portraits were exhibited in 1986 at the Market Photo Gallery in Johannesburg. His photographs were also included in the Staffrider exhibition of 1983.

Jimi Matthews was born in 1955 in Cape Town, where he spent his youth. He trained at the London Film School. Matthews has been a

freelance photojournalist and cameraman in Cape Town, working primarily for foreign television networks. He is a member of "Vuka-lisa" ("Enlighten" in Xhosa), an artists' collective that works in communities to encourage cultural activities.

Matthews has exhibited in various one-man shows in Europe including the Barcelona exhibition commemorating the International Year of the Youth, sponsored by UNESCO, 1985, and the photographic exhibition in London illustrating black resistance in South Africa, 1985. His work was included in "Culture and Resistance," Botswana, 1982, the Staffrider exhibitions of 1983 and 1984, and the book and exhibition, Dieter Koeve and Tim Besserer, *Nicht Wird Uns Trennen* [Nothing Will Separate Us], Benteli Verlag, Bern, 1983.

Ben Maclennan was born in 1956 in Edinburgh, Scotland. In 1958, he moved with his family to South Africa and spent his youth in Grahamstown. Maclennan briefly studied journalism at Rhodes University and then worked as a photographer on *The Daily Dispatch*. In 1977 he went to Rhodesia as a photographer on the *Rhodesia Herald*. Later he returned to South Africa and worked for a number of newspapers, including the *Eastern Province Herald* as a reporter and photographer and *The Sunday Post* in Johannesburg as chief sub-editor . In 1982, Maclennan taught newswriting at Rhodes University and produced a series of photographs of Resettlement Camps in the Ciskei for the Surplus People Project. Currently, he lives in Cape Town and works as a parliamentary reporter for the South African Press Association (SAPA).

Maclennan's photographs were included in "Young South African Photographers," organised by the South African National Gallery in 1983, the "Culture and Resistance" exhibition in Botswana, 1982, and the book and exhibition, Dieter Koeve & Tim Bresserer, *Nicht Wird Uns Trennen* [Nothing Will Separate Us], Benteli Verlag, Bern, 1983.

Gideon Mendel was born in 1959 in Johannesburg, where he spent his youth, and is a graduate of the University of Cape Town. He has worked as a junior editor on a number of television productions and as a schoolteacher. Currently, Mendel lives in Johannesburg and works for Agence France Presse (AFP) Photo Service as the South African photographic correspondent.

Mendel's photographs are used in international and national newspapers and magazines including *Frontline, Time,* and *The New York Times.* His work is also published by the alternative press in South Africa.

Mendel's photographs covering the violence and confrontation in South Africa during 1984 and 1985 were exhibited in 1986 at the Market Photo Gallery in Johannesburg. His work was also included in the Staffrider exhibitions of 1984 and 1985.

Cedric Nunn was born in 1957 in Nongoma, Zululand. After schooling, he worked as a boilermaker at the Amatikulu sugar mill. He began photographing in 1981. Nunn is currently working at his family's store in Mangete, KwaZulu. He is a member of Afrapix.

Nunn's photographs have been published nationally and internationally in magazines. His work was also included in a book on South African women entitled *Vukani Makhosakazi,* CIIR, London, 1985, and in the book and exhibition, Dieter Koeve and Tim Besserer, *Nicht Wird Uns Trennen* [Nothing Will Separate Us], Benteli Verlag, Bern, 1983.

He contributed to "Culture and Resistance," Botswana, 1982, to the Staffrider exhibitions of 1983 and 1984, and to the "Year of the Woman" exhibition in 1984.

Myron Peters was born in 1954 in Durban and studied at the University of Durban-Westville. After leaving university he became active in a corporate buying scheme in Merebank where he lives. Currently he works as a librarian and is active as a photographer in the local community organisations and labour movement.

Peters's photographs are used by the alternative press. His photographs were published in Fatima Meer, *Factory and Family: The Divided Lives of South Africa's Women Workers,* Institute for Black Research, Durban, 1984.

He contributed to "Culture and Resistance," Botswana, 1982, to the Staffrider exhibitions of 1983 and 1984, and to the book and exhibition, Dieter Koeve and Tim Besserer, *Nicht Wird Uns Trennen* [Nothing Will Separate Us], Benteli Verlag, Bern, 1983.

Berney Perez was born in 1948 in Cape Town. He worked as an office machine technician while studying photography with Michael Barry. Perez is currently a freelance photographer working mainly in the Karoo.

Perez contributed to the Staffrider exhibition of 1985.

Jeeva Rajgopaul was born in 1952 in Dundee, Natal. Since 1961, he has lived in Chatsworth, where he teaches in a secondary school. He is currently working on a documentary project on Chatsworth, the largest Indian township in South Africa. Rajgopaul is a member of Afrapix.

Rajgopaul's photographs are used extensively by community organisations and the alternative press.

He contributed to the Staffrider exhibitions of 1983, 1984, and 1985 and to the book and exhibition, Dieter Koeve and Tim Besserer, *Nicht Wird Uns Trennen* [Nothing Will Separate Us], Benteli Verlag, Bern, 1983.

Wendy Schwegmann was born in 1954 in Zululand, where she spent her youth. She has a diploma in Interior Design from Natal Technical College and is a graduate of the Michaelis School of Fine Art at the University of Cape Town. She lives in Johannesburg and works as the South African photographic correspondent for Reuters wire service.

Schwegmann had a one-woman exhibition in 1980 at the Market Photo Gallery in Johannesburg. Her photographs were included in

the Staffrider exhibitions of 1983, 1984, and 1985, and she exhibited at the Witwatersrand History Conference, 1984.

Her work is in the permanent collection of the South African National Gallery, Cape Town.

Paul Weinberg was born in 1956 in Pietermaritzburg. He is a graduate of Natal University. Weinberg has worked on a number of films, including "Mayfair," and serves on the editorial board of the Staffrider Photographic Exhibition. He is a founding member of Afrapix and currently coordinates its library and agency work in Johannesburg.

Weinberg's work is used extensively by community organisations and the alternative press. His photographs were included in Julie Frederickson, *None But Ourselves: An Alternative Look at the Press in Zimbabwe,* Johannesburg, Ravan Press, 1983; James North, *Freedom Rising,* Macmillan, New York, 1985; and Dieter Koeve and Tim Besserer, *Nicht Wird Uns Trennen* [Nothing Will Separate Us], Benteli Verlag, Bern, 1983. A selection of his photographs of the hunters and gatherers ("Bushmen") in Namibia was published in *Leadership S.A.,* First Quarter, 1985.

Weinberg has contributed to numerous group exhibitions including "Culture and Resistance," Botswana, 1982, the Staffrider exhibitions of 1983, 1984, and 1985, the "Year of the Woman" exhibition, 1984, and the Witwatersrand History Conference, 1984. His photographs of the hunters and gatherers ("Bushmen") were exhibited at the Market Photo Gallery in Johannesburg in 1986.

Francis Wilson was born in 1939 in Northern Rhodesia (now Zambia) but grew up in the eastern Cape of South Africa. After completing his Ph.D. on labour on the South African gold mines at Cambridge, he returned to the University of Cape Town as a lecturer in Economics. In 1974 he started the Southern Africa Labour and Development Research Unit (Saldru), of which he is still the director, and in 1984 he was appointed head of the School of Economics, having received a personal Chair in Labour Economics in 1979. In 1981 he was appointed director of the Second Carnegie Inquiry into Poverty and Development in Southern Africa.

Wilson has published two books: *Labour in the South African Gold Mines 1911-1969,* Cambridge, Cambridge University Press, 1972, and *Migrant Labour In South Africa,* Johannesburg, South African Council of Churches/SPROCAS, 1972; numerous chapters in books and articles in leading publications. He is the editor of the *South African Outlook* and has held visiting fellowships at the University of Virginia, Charlottesville; the University of Sussex; Jawaharlal Nehru University, New Delhi; and Balliol College, Oxford.

LIST OF PAPERS

The Second Carnegie Inquiry into Poverty and Development in Southern Africa

* There are no papers with numbers marked by an asterisk.

Poverty: Perceptions and Definitions

1. Chabani Manganyi, "The worst of times: A migrant worker's autobiography."
2. C. Ntoane and K. Mokoetle, "Major problems as perceived by the community."
3. Wilfred Beckerman, "Measuring poverty in rich and poor countries."
4. G. F. R. Ellis, "The dimensions of poverty."
5. Pamela Reynolds, "Men without children."
6. V. Møller, L. Schlemmer, H. G. Strijdom, and colleagues at the HSRC, "Poverty and quality of life among blacks in South Africa."

General Overviews

7. Charles Simkins, "What has been happening to income distribution and poverty in the homelands?"
8. Paul Streeten, "Basic needs: Some unsettled questions."
9. Steve Tollman, "Thoughts on planning for basic needs in South Africa."

Area Studies

10a. Dinga Sikwebu, "Profile of Nyanga."
10b. W. Naidoo and W. Dreyer, "Vrygrond and Lavender Hill."
10c. Pieter Jansen, Ashley du Plooy, and Faika Esau, "Elsies River."
10d. D. Maralack and A. Kriel, "A Streetless wasteland: A preliminary report on Ocean View."
10e. Lucy Edwards, "Profile on Philippi."

11. B. H. Kinkead-Weekes, "A history of vagrancy in Cape Town."
12. Di Bishop, "Poverty experienced by black (African) residents of Cape Town: The views of some social workers."
13. N. Riley, C. Schuman, P. Romanovsky, and R. Gentle, "Spatial variations in the levels of living in the Cape metropolitan area."
14. G. Hewatt, T. Lee, N. Nyakaza, C. Olver, and B. Tyeko, "An exploratory study of overcrowding and its relationship to health at Old Crossroads."
15. M. M. Gonsalves, "A community in bondage: A case study."
16. Jane Prinsloo, "A description of income, expenditure, and earning patterns from households in Cape Town and Durban."
17. Vish Suparsad, "Socio-economic status of selected communities in the Durban metropolitan area."
18. P. N. Pillay, "Poverty in the Pretoria-Witwatersrand-Vereeniging area: A survey of research."
19. P. N. Pillay, "Alexandra: An analysis of socioeconomic conditions in an urban ghetto."
20. David Webster, "The reproduction of labour power and the struggle for survival in Soweto."
21. Caroline White, "Poverty in Port Elizabeth."
22. David Simon, "The end of apartheid? Some dimensions of urban poverty in Windhoek."
23. Debbie Budlender, "Agriculture and technology: Four case studies."
24. *
25. Charles Simkins, "African population, employment, and incomes outside the reserves, 1923-1969."
26. Debbie Budlender, "Mechanisation and labour on white farms: A statistical analysis."

27. Michael de Klerk, "Mechanizing farming: Implications for employment, incomes, and population distribution."
28. Michael de Klerk, "The incomes of farm workers and their families: A study of maize farms in the western Transvaal."
29. Mandla Seleoane, "Conditions on eight farms in Middelburg, eastern Transvaal."
30. C. W. Manona, "Migration from the farms to towns and its implications for urban adaptation."
31. Martin West, "Vulnerability, isolation, and apartheid: A case study of Port Nolloth."
32. Jeff Yosslowitz, "A study of poverty among the 'coloured' community: A general analysis and a case study of Worcester."
33. Mary-Jane Morifi, "Life among the poor in Philipstown."
34. Sean Archer and Eileen Meyer, "Hanover: A profile of poverty on the Eiselen line."
35. David Schmidt, "Beaufort West has many windmills: A look at poverty in the town and district of Beaufort West."
36. Dudley Horner and Graham van Wyk, "Quiet desperation: The poverty of Calitzdorp."
37. Peter Buirski, "Poverty in Oudtshoorn: Some impressions."
38. Wilfred Wentzel, "Hard times in the Karoo: Case studies and statistical profiles from five periurban residential areas."
39. Laura Levetan, "Structural shifts in the George economy: Underemployment and unskilled labour as conditions of impoverishment."
40. Sally Damana, "Rendering welfare and development services with special reference to Grahamstown."
41. Christine Walwyn, "Survey of aspects

of rural poverty in Clarens and the surrounding areas and of certain aspects in the black townships of Bethlehem and Harrismith."

42. *

43. N. D. Muller, "The labour market and poverty in the Transkei: Special reference to the implications of the changing spatial division of labour."

44. Carol Cragg, "Estimated household subsistence levels for the Transkei urban and rural areas 1983."

45. J. Baskin, "Access to land in the Transkei."

46. N. D. Muller and C. P. G. Tapscott, "The face of rural poverty in the Transkei: Two village socioeconomic profiles."

47. Terence Moll, "A mixed and threadbare bag: Employment, incomes and poverty in Lower Roza, Qumbu, Transkei."

48. R. J. Haines, C. P. Tapscott, S. B. Solinjani, and P. Tyali, "The silence of poverty: Networks of control in rural Transkei."

49. Julia Segar, "Social inequality in a Transkeian 'Betterment' village."

50. Wolfgang Thomas, "Financing rural development – with particular reference to the Transkei."

51. Andrew Spiegel, " 'Internal' Migration and rural differentiation: A field report from the Matatiele/Qacha's Nek region."

52. John Sharp and Andrew Spiegel, "Vulnerability to impoverishment in South African rural areas: The erosion of kinship and neighbourhood as social resources."

53a. Elisabeth Ardington, "Poverty and development in a rural community in KwaZulu." (Part 1: Chapters I-III)

53b. Elisabeth Ardington, "Poverty and development in a rural community in KwaZulu." (Part 2: Chapters IV-V)

54. *

55. David Robbins, "What's the matter with Msinga?"

56. M. V. Gandar and N. Bromberger, "Economic and demographic functioning of rural households:
Mahlabatini District, KwaZulu."

57. Catherine Cross and Eleanor Preston-Whyte, "Modelling poverty on household dynamics: A data approach through per capita income."

58. Matthew Cobbett, "Sugarcane farming in KwaZulu: Two communities investigated."

59. Paul Colvin, "Cattle sales in KwaZulu: Wealth vs. Income. Implications for an improved marketing strategy."

60. J. F. deV Graaff, "Villagers without land: The household subsistence level in a Lehurutshe resettlement village."

61. *

62. Sue Parnell and Alan Mabin, "Poverty in Mafikeng."

63. E. F. J. van Nieuwenhuizen, "A socio-economic survey in Tzikundamalema (Venda): An interim report."

64. A. G. Schutte, "Poverty and rural deterioration: Two case studies from post-'Independence' Venda."

65. Moses Bopape, "Social welfare services in Lebowa and poverty related problems."

66. Catherine Schneider, "Microstudies in Gazankulu: Study of 8 villages in two districts of Gazankulu."

67. Patrick Harries, "Aspects of poverty in Gazankulu: Three case studies."

68. Emile Boonzaier, "Economic differentiation and racism in Namaqualand: A case study."

69. John Sharp, "Rural development schemes and the struggle against impoverishment in the Namaqualand reserves."

70. *

71. John Sharp and Martin West, "Controls and constraints: Land, labour and mobility in Namaqualand."

72. *

Relocation

73. Laurine Platzky, "Relocation and poverty."

74. Aninka Claassens, "The myth of 'Voluntary removals.'"

75. Ian Donald, "Removals of a quiet kind: Removals from Indian, 'coloured', and
white-owned land in Natal."

76. Ben Maclennan, "Mr Mapapu: A life history."

77. Anne Templeton: "Bendell."

78. Buntu Mfenyana, "Among the discarded."

Law and Poverty

79. Wallace Mgoqi, "Law, poverty, and development in the context of South Africa."

80. F. C. Bam, "Land, law, and, poverty."

81. A. Chaskalson and S. Duncan, "Influx Control: The pass laws."

82. Joanne Yawitch, "Tightening the noose: African women and Influx Control in South Africa 1950-1980."

83. Helen Zille, "Political power and poverty: An examination of the role and effect of Influx Control in South Africa."

84. Nicholas Haysom and Clive Thompson, "Farm labour and the law."

85. The Black Sash, "Influx Control and poverty: Case studies."

86. Nicholas Haysom and Amanda Armstrong, "Population relocation and the law: Social engineering on a vast scale."

87. S. B. Burman and J. Barry, "Divorce and deprivation in South Africa."

88. S. H. Christie, "Aspects of legal aid in divorces."

89. *

90. Dennis Davis and Hugh Corder, "Poverty and cooption: The role of the courts."

91. Geoff Budlender, "Lawyers and poverty: Beyond 'access to justice.'"

92. Wallace Mgoqi, "Legal education and the needs of the poor."

93. Roy Gentle, "Crime and poverty."

Education and Poverty

94. Bill Nasson, "Education and poverty: Some perspectives."

95. P. N. Pillay, "The development and underdevelopment of education in South Africa."

96. Linda Chisholm, "Redefining skills:

The Southern Africa Labour and Development Research Unit (Saldru) is part of the School of Economics at the University of Cape Town. Established in 1974, it aims to stimulate and publish research and to train young research workers to gather and assess information. Saldru has been responsible for organising the Second Carnegie Inquiry into Poverty and Development in Southern Africa.

A Centre for Documentary Photography is being planned, at the University of Cape Town, out of the collaborative efforts of those involved in the photographic working group of the Carnegie Inquiry. These photographers recognise the need to make available to the public the important social documentary work being done in South Africa. When it is established, the Centre will sponsor seminars, exhibitions, and publications that use photography as a way of informing the public and providing a forum for discussions of critical issues concerning all South Africans.

The Center for Documentary Photography at Duke University, established in 1980 by the university's Institute of Policy Sciences and Public Affairs, grew out of the institute's long-term interest in photography and, more broadly, in the relation between the humanities and public policy. Among its educational programs, the center sponsors undergraduate courses, exhibitions, symposia, lectures by visiting photographers, and opportunities for independent field work by outstanding students. The publications of the center include *Understandings: Photographs of Decatur County, Georgia,* and *Gertrude Blom – Bearing Witness.* In making a serious commitment to documentary photography in the university, the center intends to show the value of visual language in a highly verbal place. Through study of the documentary tradition and through use of the camera, students are encouraged to see more deeply into facts and ideas. As *South Africa: The Cordoned Heart* so clearly teaches us, education is more than the accumulation of knowledge. It is, or ought to be, the development of sensibility, of capacities for discernment and reflection, and of a readiness to act on what is believed.

The International Center of Photography (ICP) is New York's museum-school of photography. Its changing exhibitions number over two hundred to date and show the range of photography – from the nineteenth century to the present, from photojournalism to vanguard artistry, from masters of the camera to emergent photographers. Among its various educational offerings are a Master of Arts program in conjunction with New York University and a full-time program in photojournalism and documentary photography. The permanent collection and archive specializes in twentieth century photographs and documents and, with the library, serves professionals, the public, and some 3,000 students annually. From its inception in 1974, ICP has championed "concerned photography", that photography which, in the words of Lewis Hine, shows "the things to be corrected . . . and the things to be appreciated." Made to inform and move its viewers, *South Africa: The Cordoned Heart* shares the spirit of such ICP exhibitions as *"El Salvador: 30 Photographers"* and *"Minimata: W. Eugene Smith."* This project is ICP's third collaboration with the Duke University Center for Documentary Photography involving a travelling exhibition and publication.